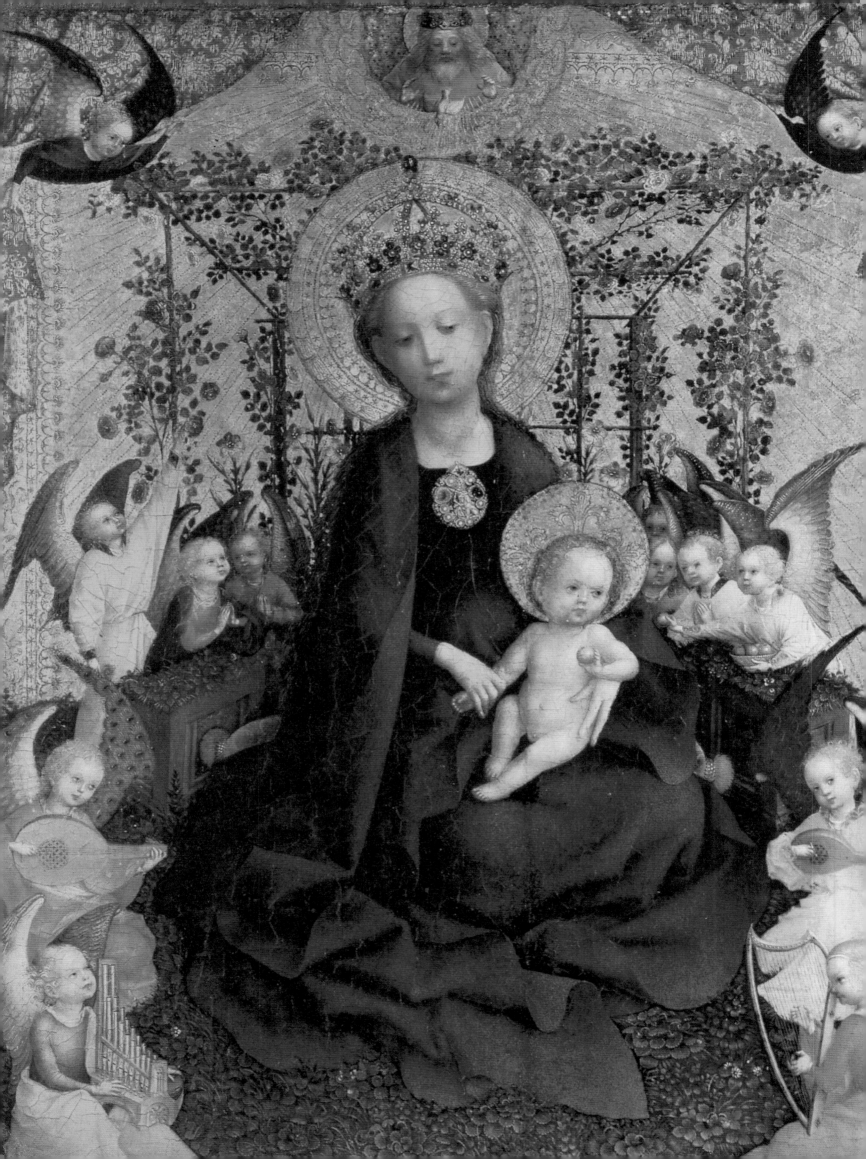

SACRED IMAGERY

Representations of Faith and Worship

JUDITH MILLIDGE

JG PRESS

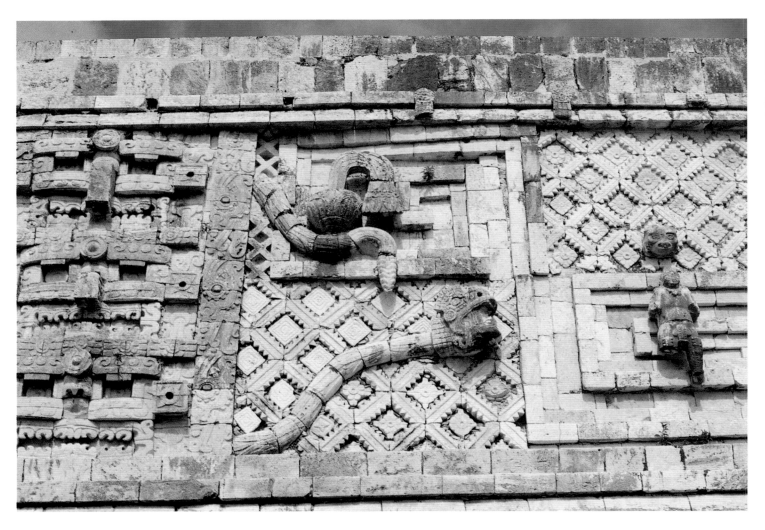

Above: Stylized symbols from nature adorn this Mayan temple in the Yucatan.

Page 2 photograph: *Lochner's* The Virgin of the Rose Garden*, 1448.*

Published in the USA in 1998 by JG Press
Distributed by World Publications, Inc.

The JG Press imprint is a trademark of JG Press, Inc.
445 Somerset Avenue
North Dighton, MA 02764

Produced by
Saraband Inc, PO Box 0032, Rowayton, CT 06853-0032

Copyright © 1998, Saraband Inc.

ISBN 1-57215-252-4

Design © Ziga Design

Printed in China

10 9 8 7 6 5 4 3 2 1

For Alfredo

Contents

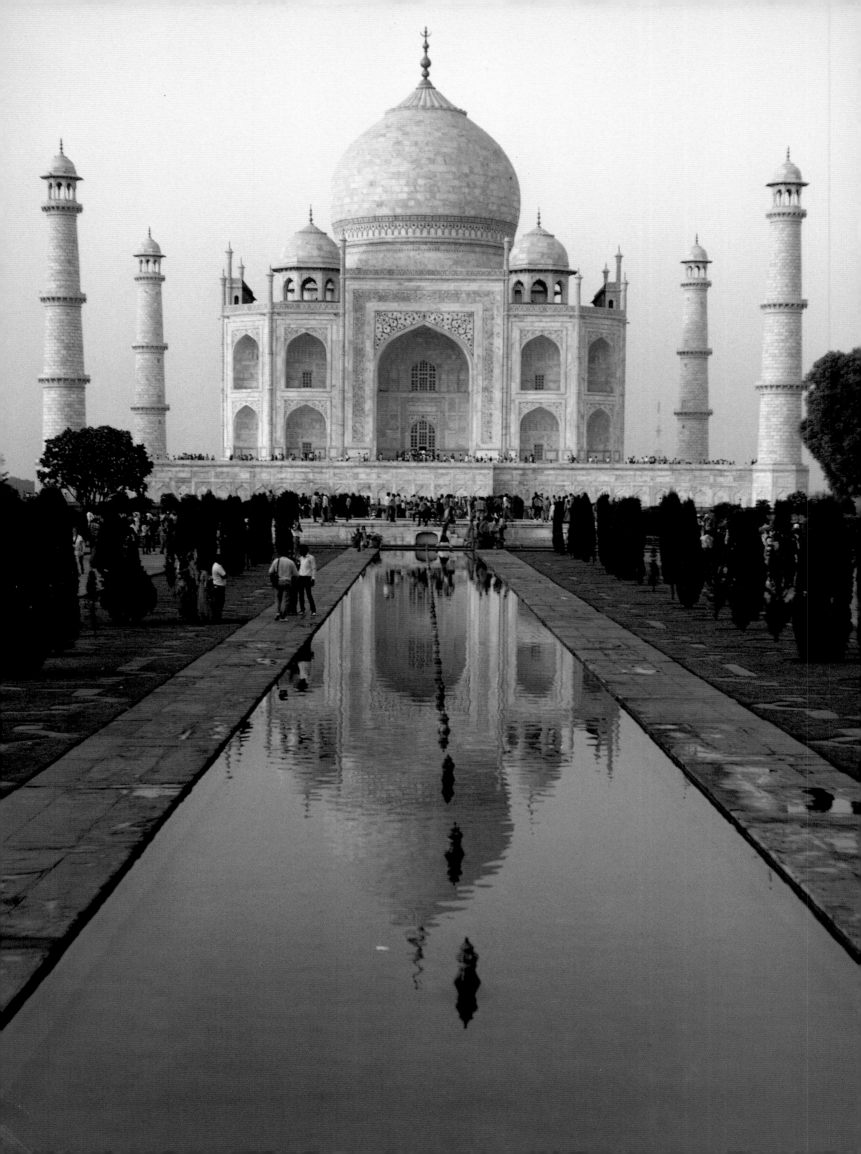

Introduction

"Looking upward the sage contemplated the images in the heavens;
looking downward he observed the patterns on earth."

Fu Hsi, *First Chinese Emperor*

Ultimately, the purpose of religious symbolism, and therefore of sacred imagery, is to explore and explain humanity's relationship with its gods. It is often comparatively easy to assess what ancient societies held sacred, and why. Surviving artefacts, paintings, sculptures and religious buildings provide insight into the beliefs and fears of most culture groups. The lives of earlier generations may have been shorter and more difficult, but they were also simpler: people were concerned about the very basics of existence and worshipped the forces that governed their survival.

Many sacred symbols are derived from nature; others are created to remind people of critical events, ceremonies or people in their religion's history. Some are simply representations of gods and can be worshipped as such. They appear in many different forms—as statues, carvings, paintings (on anything from rock to canvas), engravings, even buildings. All represent an optimistic belief that mankind is not alone, a humble, almost childlike faith that unknown forces beyond our control are watching over us.

As civilizations became more complex, so, too, did their gods. The first evidence of human ritual or ceremonial belief in an afterlife is evident from Neanderthal graves. Fifty thousand years ago, a people who scratched out an existence at the mercy of the elements buried their dead with flowers and artefacts. This suggests that they were concerned about what happened after death, and perhaps believed in some sort of supernatural power who would be appeased by their offerings.

The great standing stones of western Europe, epitomized by Stonehenge, show that the Bronze Age people of Europe worshipped the sun; several millennia later, the Greeks had acquired a pantheon of gods whom they consulted about their future and who protected them in both life and death. This philosophical leap changed the nature of religious imagery dramatically. Perhaps less concerned than their ancestors with the forces of nature, and more impressed by rational human achievements, the Greeks endowed their gods with human forms. Most of their deities had perfect bodies and beautiful, unblemished faces. In short, they were divinized humans, not amorphous spirits of an unpredictable Nature.

THE DERIVATION OF SACRED IMAGES

Carl Jung's anthropological studies convinced him that for generations, from earliest recorded history until the present day, the same archetypal symbols have occurred in the myths and legends of almost every civilization. If Jung was correct, and every society has drawn from the same universal well of images and archetypal symbols, why are the images of different cultures dissimilar, and why have they changed so much over time? The answer appears to lie in the endlessly fertile human imagination. Every culture must, to some extent, adapt a faith to suit society's needs and enable adherents to understand the basis of belief. Similarities do occur, however, as in the earliest sacred images, drawn from nature. All primitive religions developed among illiterate people wholly dependent upon hunting, gathering and later, agriculture for

Opposite: A monument to grief and the need for spiritual solace in the face of death, India's immortal Taj Mahal was built by Mughal emperor Shah Jahan to enshrine the body of his wife Arjumand, known as Mumtaz Mahal—*Chosen of the Palace. Its soaring minarets and domes are flanked by a mosque and a symmetrical* jawab—*an identical structure added for aesthetic balance.*

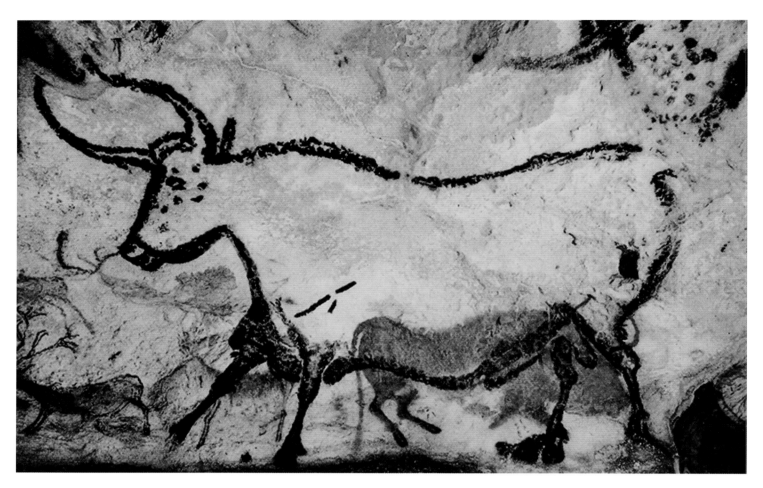

Above: *Among the earliest sacred images are the cave paintings by prehistoric people like those who drew the animals they hunted at Lascaux, in present-day France.*

Right: *Tribal shamans carve their own ritual rattles, whose hypnotic sound helps them to achieve the ecstatic trance state in which they can commune with the spirits.*

survival. Early human beings were awed and baffled by the forces of nature, and it is not surprising that the rain, wind, sun and moon were deified. Depictions of these gods were firmly rooted in the visible world: powerful birds and animals lent themselves to sacred images, as did the human body.

Throughout history and across cultures, the same basic forces inspired imagery used in ritual worship, including the sun, moon, water and fire, but the symbols acquired new meanings through syncretism and social change. The sun, for example, was once worshipped as the force of all life in Mesopotamia, ancient Egypt, India, China and Japan. Early Christians absorbed and altered pagan attitudes, and the sun

appeared in Christian art, often associated with the Virgin Mary and the Risen Christ. The Japanese equated the sun with the feminine principle, and the Shinto shrine of Amaterasu, the sun goddess, is still important in Japan today, while the Japanese flag bears the image of the rising sun.

Nighttime was perceived as a period of mystery and danger, when the moon was worshipped as a source of light and a mysterious mirror of such Earthly cycles as female menstruation and the tides. In Aztec culture, however, the supreme Tezcatlipoca, god of the moon, was also associated with destruction and evil-doing, reflecting the unease generated by darkness. The crescent was a common symbol

for the moon in many cultures, and pre-Hellenic Greeks worshipped the moon as a cow, because of the similarity between the crescent shape and the cow's horns: Io, the moon goddess, was endowed with small horns.

Water, the primeval element from which everything emerged, is identified with life itself and serves as an agent of purification in rituals of many belief systems. Christians are baptized with water both as a symbol of cleansing and as a symbolic rebirth, as seen in the many images of John the Baptist baptizing Christ. Ritual cleansing is also central to Judaism and Islam.

Fire is another purifying agent, and a flaming heart symbolizes religious fervor in Christianity. God spoke to Moses from the burning bush, and other deities have manifested themselves through flames. In the earliest Buddhist art, the Buddha himself was represented by a flaming pillar, which symbolized the wisdom spread by his enlightenment. In Islam, great haloes of fire surround figures like the angel Gabriel and the Prophet Muhammad.

Animal forms have been worshipped as representations of gods by many cultures, and are still used symbolically to represent aspects of belief. Long held to personify human emotions and desire, animals appear in the earliest known sacred art, the Paleolithic cave paintings of Lascaux, France, dating from between 15,000 and 10,000 BC. These images of bison and horses were probably used as part of a hunting ritual, to ensure the success of the hunters. Hybrid figures with the attributes of several animals, or an animal and a human, are common. The Greek god Pan, for example, had the legs, feet and horns of a goat, and the torso and head of a man, symbolizing his lusty animalistic instincts conjoined with human intelligence. The Australian aborigines' "sky father" Altjira is perceived as a man with emu's feet, and his wives and daughters have doglike paws. The ancient Egyptians deified animals, and their heads identify many gods associated with the lion, the jackal and other creatures of the Nile Basin. The scarab beetle, believed to generate spontaneously from a ball of dung, was

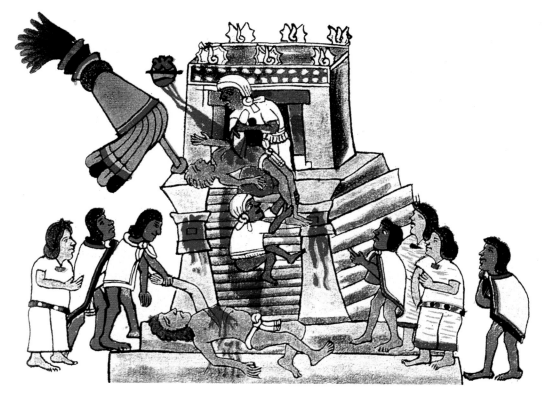

Left: The Aztecs of Middle America offered human hearts to their fierce, warlike gods, chief of whom was the sinister Huitzilopochtli, deity of conquest and of the sun.

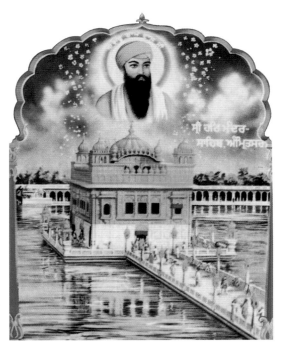

*Right: The Golden Temple
in Amritsar, which stands
in an artificially created
lake called the "pool of
immortality," is a symbol
of Sikhism and its most
important shrine. In this
representation, the shrine's
sixteenth-century founder,
Guru Ram Das, is
shown above.*

associated with the solar god Khepri of
Heliopolis. Its image appears on rings and
other artefacts placed in tombs to protect the
dead and win Khepri's favor when the soul
was judged after death. Hindus believe that
the god Vishnu "the Preserver" has manifested
himself on Earth in nine different guises, or
avatars, among them a giant fish, a turtle, a
boar and a hybrid man-lion.

Cultural influences have also been critical
in forming sacred imagery, and religious activ-
ities have been expressed through metaphors
of work, play, competition and victory. Both
Christians and Muslims are urged to take up
spiritual arms for their beliefs and fight for
salvation, and Christian art is full of armor-
clad saints like St. George battling the forces
of evil. Ceremonial objects like vestments and
vessels are adorned with sacred imagery.

Phallic symbols recur as signs of potency
and generativity around the world. In the
Shinto creation myth, the first gods, Izanami
and Izanagi, circled the Heavenly Pillar before
consummating their union to create the

islands of Japan. Many European folk tradi-
tions also centered on a pillar, and are still
celebrated today as Maypole dances. The
Hindu creator god, Shiva, is often represented
by a *lingam,* a phallic object that may be com-
bined with the female *yoni* to symbolize the
reproductive power of the god and goddess.
Images of fecund women have represented
fertility since Paleolithic times. The "Venus
figurines," small female statuettes believed to
represent the Mother Goddess, have been
found in Neolithic graves; they are among
the earliest human sculptures. The ancient
Egyptians worshipped Isis, the loyal wife of
Osiris and mother of Horus, and Christians
revere Mary, the Mother of Jesus, as the exem-
plar of maternal virtue.

Tribal societies use masks, totems and carv-
ings to commune with the spirit world. The
religious dance masks of ancient Tibet and
Buddhist Japan, and the drums of shamans,
are often ascribed supernatural powers of
healing or shape-shifting, or even the ability
to personify the gods. The Native American
Iroquois used "False Faces"—elaborately
carved basswood masks—in their traditional
healing ceremonies. Some represent the Great
Doctor, who lives on the edge of the world

*Right: The Mesopotamian
fertility goddess Ishtar
(Inanna in Sumerian) was
the patroness of both love and
war. When she descended to
the underworld to rescue her
lover Dumuzi, the earth bore
no new life until her return.*

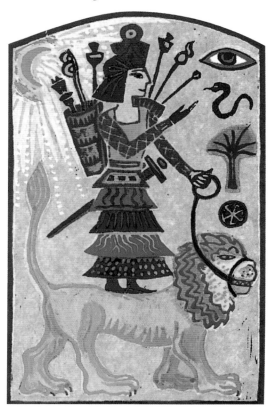

and has a broken nose and twisted mouth as a result of his struggle with the Creator for control of the world. Others caricature neighbors and friends, and all have distorted features, long hair and deep-set eyes. Usually life-size, such masks were also made in miniature for use as protective amulets.

Geometric shapes and numbers have assumed mystical importance in many religions. The disk—often used as a halo in Christian and Muslim art—derives originally from the sun and represents holiness, power, and the cosmos. With no end or beginning, it also stands for eternity. Transformed into the mandala (a circle enclosing a square with four "doors" on the sides) it may surround a sacred figure, and is used as the ground plan for Buddhist *stupas* and temples. The cross is familiar as a Christian symbol, but long before the Christian era, it represented the four cardinal points, or the winds that brought rain. It was also a symbol of the sky and of weather

gods. The *ankh*—a cross with a rounded top—was a symbol of eternal life in ancient Egypt. The *ankh* was held to the nostrils of a pharaoh after death to ensure his everlasting life, and was often inscribed on temple walls to give divine protection to the dead.

Trinities are central to several religions and the triangle may be used to represent them. The Egyptian trinity of Isis, Osiris and Horus is echoed by Hinduism's threefold aspects of Brahma as Creator, Preserver and Destroyer; by the Judaeo-Christian Father, Son and Holy Spirit, and by the Holy Family of Mary, Joseph and Jesus. In Hindu symbolism the triangle also represents gender: apex up, it is Shiva's *lingam*; apex down, it is the female *yoni*. The triangle is also used as a meditative aid in Tantric Buddhism to inspire psychic energy and heightened consciousness.

Possibly the most important use of numbers and shapes is in architecture. Buildings are the most tangible remnants of past cultures, and religious buildings are usually pro-

Left: From ancient Egypt to pre-Columbian South America, the pyramid has symbolized the cosmic mountain, where heaven and Earth are joined.

Right: The natural world is imbued with sacred significance in most Native American traditions: this Plains tipi is decorated with images of the bison that sustained many Plains tribes until the late-nineteenth century.

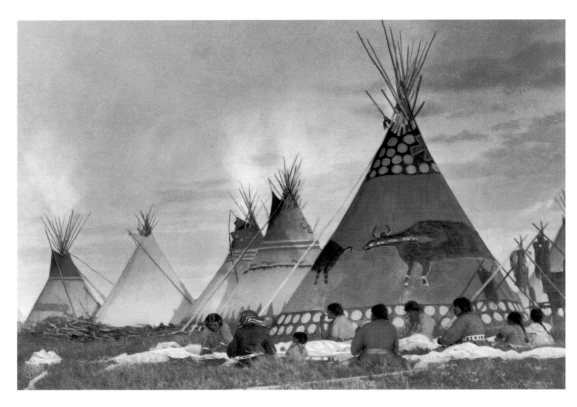

Right: The ancient Egyptian obelisk, both a phallic symbol and an axis mundi, was built as a monument to the sun-god, Re.

found expressions of their faiths. The form of such buildings was often based on geometrical and mathematical formulae held sacred by their designers. The mosques of Islam must face Mecca, the churches of Christendom are built on an east-west axis and ancient Greek temples faced the rising sun in the east.

SACRED ARCHITECTURE

Sacred architecture usually represents the cosmos. Humankind has moved beyond the worship of nature and the elements, but the domes of basilicas and mosques, the soaring vaults of cathedrals and the serene enclosures of Oriental temples clearly represent the relationship between humans and heaven. Before such buildings came into use, people worshipped at sacred sites, and mountains and rivers assumed mystical powers. Mountains reached up to the gods in heaven, and rivers or springs were associated with fertility and healing. Powerful legends surround places like Glastonbury Tor in

England, Mount Ararat in Turkey, or the site of the Ka'ba in Mecca, all of which have become the focus of spiritual energies. The earliest sacred buildings reflected the natural formations of sacred sites—pyramids and burial mounds are manmade mountains.

Early monuments were associated with particular gods or goddesses, or the supernatural and natural powers they represented. In some cultures, particular gods were worshipped only at one place: Japan's Mount Fuji, for example, is home to Sengen-Sama. Her shrine attracts many pilgrims, who climb to the top of Mount Fuji (called Fujiyama) at dawn to worship the rising sun and glimpse Sengen-Sama, who holds a magical jewel in her right hand and a branch of the sacred sakaki tree in her left. Other cultures built monuments as observatories from which to measure the movement of the stars and planets they worshipped. The megalithic monuments of Europe are probably the earliest sur-

viving examples, and demonstrate that such monuments were built according to certain mathematical, proportional and geometric rules, which themselves became sacred.

The purpose of a sacred building is to inspire awe and a sense of mysticism in the worshipper, and each religion has achieved this in its own way. Different cultures have also imposed their own aesthetics within the same religion. For example, many Buddhist temples in Southeast Asia incorporate rich gold decorations and a larger-than-life statue of Buddha, while Japanese Zen temples are studies in spaciousness, set in simple surroundings, with minimal decoration. There seems to be a world of difference between the Gothic glory of a medieval cathedral and the spartan interiors of many modern Christian churches, but they share the same essentials (an altar, a cross and a pulpit) and were built for the same purpose. Many interior features have symbolic functions: ceilings, domes and vaults may be ornamented

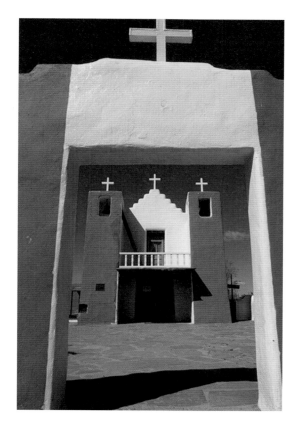

Left: This simple adobe church in New Mexico features the foremost sign of Christianity, the cross.

with stars or crowns to suggest heaven, and altars are often inset with mosaics or carvings symbolic of the Eucharistic bread and

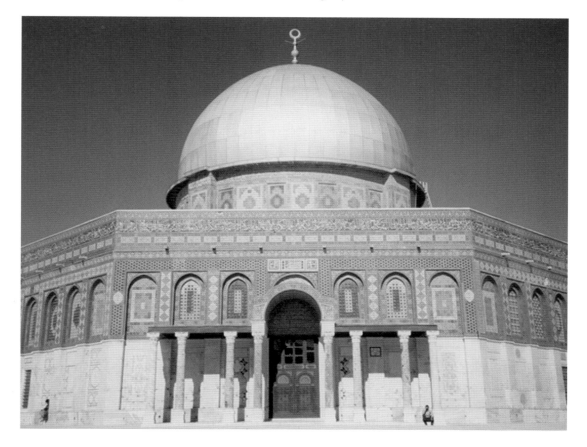

Left: The Dome of the Rock was built on the site in Jerusalem from which Muhammad is believed to have ascended to heaven.

wine. The approach to an altar may be marked with statues, carvings or the fourteen Stations of the Cross.

Exterior ornamentation, too, tells a story. Hindu temples are covered with carvings of scenes from myth and sacred history; most Christian churches have images of the saints and events from the Gospels; and mosques are decorated with beautiful patterns and calligraphy from the Qur'an.

ATTITUDES TOWARD SACRED IMAGERY

"Painting can do for the illiterate what writing does for those who can read."

POPE GREGORY THE GREAT, C.540–640

The style of sacred imagery is shaped, in part, by "period vision," that is, how the artist sees the world. Conditioning by his or her culture affects the form of the work. The Egyptians had a very regimented, conventionalized style that was highly symbolic, depicting every subject according to tradition. In Christian art, the stylistic differences between a flat, two-dimensional Byzantine mosaic of the Madonna and Child and a Renaissance sculpture like Michelangelo's *Pietà* are immense, but they are equally strong reflections of Christian faith and piety.

Ancient religions needed images to reinforce their message, to enable adherents to envisage the delights of heaven or nirvana, or to emphasize the eternal miseries of hell. However, Judaism, the first monotheistic faith, focused less on individual salvation than the redemption of the Children of Israel as a people and forbade the depiction of God to distance itself from pagan polytheism.

Given the strictures of the Bible's second commandment—"You shall not make your-

Below: A devout Jew prays at the western wall of the ancient Temple at Jerusalem, called the Wailing Wall because it is all that remains of the sacred structure destroyed by the Romans in AD 70. Judaism's martyrs are also mourned here.

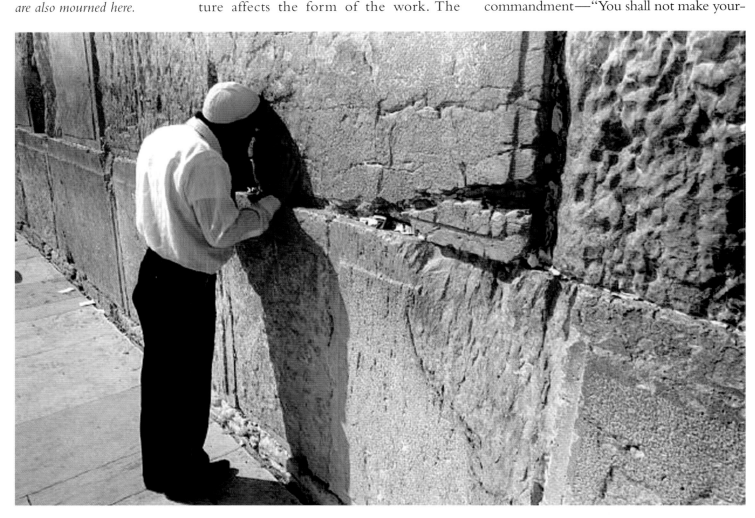

self a graven image, or any likeness of anything that is in heaven above, or that is in earth beneath, or that is in water under the earth"—it seems surprising that the Judeo-Christian tradition has produced any artwork at all. However, this prohibition was, according to Christians, addressed to the creation of iconic objects that could become the focus of worship, (so-called false gods like the Canaanite Baal or the Golden Calf). Thus, Christian artists have freely depicted Biblical scenes, while Jewish tradition interprets the second commandment more widely.

Islam, too, restricted its artists in representing the Prophet Muhammad, and, in some sects, prohibited all images of the human form. Muslim figurative art is evocative and ornamental, not representational.

Sacred images have also been important to secular societies, acting as powerful binding forces that have united people in times of trouble. Opportunist rulers have adopted and misused them to further their own ends. In the late eleventh century, for example, the powerful Norman knight Bohemond de Taranto had acquired all the land he could in southern Italy and was seeking a new theatre of operation. The preaching of the First Crusade in 1096 must have seemed like a gift from God: at once, he equipped his army with white tabards bearing a red cross and transformed his marauders into God's soldiers, whose brutal actions were now sanctioned by the Almighty. "Taking the Cross" became medieval shorthand for joining a crusade, and Bohemond's troops led the way by capturing the great city of Antioch, which would become the strongest of the Crusader states.

A far more complex question is what we hold sacred today, on the brink of the twenty-first century and a new millennium. In religious terms, the sacred symbols of the great faiths have barely changed, yet we live in an increasingly secular age, and, certainly in the

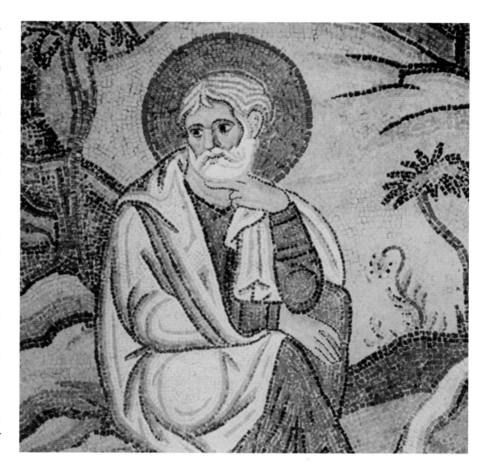

West, fewer and fewer people find solace in conventional religion. We are bombarded with more information in a day than our ancestors dealt with in a year—from newspapers, radios, televisions, computers and the other paraphernalia of modern life. We have more control over our everyday lives than our ancestors did, but are still at the mercy of the elements and the whims of the gods or fate. Despite the amazing medical advances made in this century, the phrase "In the midst of life we are in death" remains as true today as it did when the New Testament was written. Trains crash, storms destroy livelihoods, global warming alters weather systems, random acts of violence occur everywhere, and individuals have no power to stop them. For all these reasons, sacred images retain their power, whether as talismans, spiritual roots or the common focus of belief that orders the universe in ways beyond our limited comprehension.

Above: *This Greek mosaic of St. Joseph evokes the timeless and boundless human capacity for peaceful reflection and spirituality.*

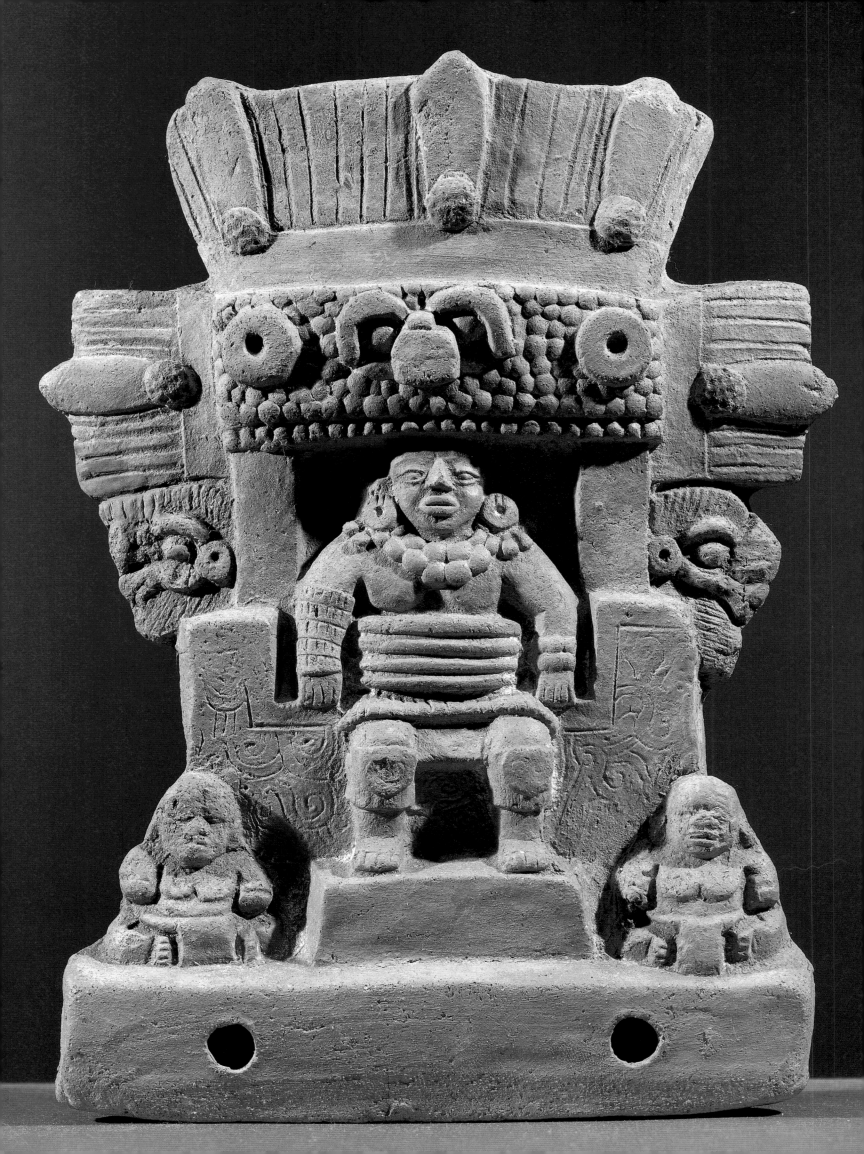

Ancient Civilizations

From the earliest times, humankind has been moved by the power of visual images. Pictures endowed with magical powers, and other icons were venerated at seasonal festivals. In tribal societies myths were not regarded as entertaining stories, but as real events with cosmic implications. They affected the lives of those who told them, and the images that emerged from such stories acquired mystical importance. The main symbols manifested in the relics of early humans relate to fertility and to shamanistic practices that sought to affect the natural world in ways that were favorable to survival.

An early manifestation of the mother goddess in Europe and western Asia was the female fertility figure. Neolithic "Venus" figurines like the Willendorf Venus show ample-bodied women with few facial characteristics, whose heads are entirely covered by hair. Such figures, which celebrate female fertility, represent the very basic need of a hunter-gatherer society to breed and reproduce itself. Prehistoric rock paintings like those found at Lascaux, in France, or Altamira, in Spain, may also have evolved from the need to control the environment. Primitive drawings of animals like the bison suggest the intention that such prey would fall to the hunter. Essentially, the sacred images of the first societies reflected the focus on survival.

The central artistic concern of the ancient Middle East was the creation of images appropriate to the relationship between humans and supernatural powers. The Mesopotamians made statues with larger-than-life features to stress the terrifying nature of their gods. The ancient Egyptian gods often appeared as hybrid human-animals, always depicted in a formal and stylized way that left little room for artistic license. Similarly, the classical art of ancient Greece and Rome was based on the ideas of order and regularity in the natural and supernatural realms that influenced many generations.

EVOLUTION OF THE GODS

It is fear that first brought gods into the world.

PETRONIUS, *Satyricon*, 1ST CENTURY AD

When the earliest agricultural societies developed their mythologies, the gods reflected the forces of nature. In the absence of scientific knowledge, phenomena like the weather, changes of season, floods and animal migration were unaccountable events that governed the lives of people who relied upon farming and hunting. Early Egyptian gods, for example, were endowed with life cycles related to the flooding of the Nile, the natural force that dominated the region. The purpose of Mayan religion was to ensure the fertility needed for the vital corn crop, so the most important deities included Chac, the rain god, and Ah Mun, the corn god, who was offered human sacrifices at harvest time. Chac is often depicted with two curling fangs and tears streaming from his eyes. The lord of wind, thunder, lightning and rain, he was sometimes worshipped as four separate gods, one aspect representing each of the cardinal points of the compass. The sun, of course, was crucial to agriculture, and Itzamna, lord of the Mayan heavens and identified with the sun and its great power, was never blamed for destruction or natural disaster: he was seen entirely as a force for good in Mayan cosmology.

Opposite: A classical eighth-century Mayan funerary gift showing a female ball player and two dwarfs. The figure may represent Coatlicue, "the serpent lady," or mother goddess, who is often depicted with a necklace of human hearts and a skirt of writhing snakes.

The Norse gods were also rooted in the powers of nature, and the need to explain events like the great storms of winter and the long dark nights of Scandinavia. The crash of thunder and bolts of lightning were attributed to the gods' behavior. The Norse cosmology revolved around powerful gods who were larger than life (even Thor's hammer had a name, Mjollnir) and reflected the heroic ideals of the Viking warrior society, which were shared by the Germanic tribes.

The pantheon of gods devised by the Greeks and Romans became increasingly sophisticated. The Greek gods began as deities of nature and the elements, but acquired new attributes with the growing complexity of Greek society, upon which the Romans based many of their institutions. Venus, for example, was a relatively minor goddess until Julius Caesar announced his descent from her son, the legendary hero Aeneas. Originally an ancient Latin goddess, Venus assumed the attributes of the Greek Aphrodite and became a major deity.

In the same way, many of the pagan Celtic gods merged with early Christian saints. Brigid, for example, the Celtic goddess of fire, fertility, cattle and poetry, eventually assumed the saintly attributes of the fifth-century St. Brigit. The Celtic festival of Imbolc celebrated the end of winter's harsh reign and the optimism of the coming spring. The goddess Brigid broke winter's spell, warming and softening the hard earth with her white wand. A major link between pagan and Christian beliefs, she became associated almost seamlessly with St. Brigit of Kildare, whose saint's day is celebrated on February 1, coinciding with Imbolc. A cross is blessed and placed in homes and outbuildings on St. Brigit's day to repel the forces of cold and hunger that may have established themselves and to invite God's presence into the house.

ICONOGRAPHY

The symbols and iconography of the gods fixed their purposes in the minds of the faithful. Ancient Egyptian religion developed an incredibly diverse and rich iconography whose majestic pyramids and colorful hieroglyphics still testify to an amazingly sophisticated culture. It is difficult to trace and categorize the vast number of Egyptian gods who evolved over a long period of time: new beliefs from surrounding regions were simply added to the old ones. Since the pharaoh was himself regarded as a god, religion and history were closely allied in Egyptian art, which is largely commemorative and monumental. Its symbolism combines mystery and actual events clearly delineated in hieroglyphic and architectural forms.

Ancient Egyptian civilization flourished for some 3,000 years, and religion was originally animistic. The nomadic tribes who settled in the Nile Valley around 3000 BC worshipped various local gods who were represented in animal form. These early, loosely organized societies saw the hierarchies of the animal kingdom and made them symbols of divine power. As people settled into towns, the gods gradually acquired human form, but often kept their original animal heads. By the late period (post-1000 BC), almost every animal known to the Egyptians was associated with one god or another, and sacred creatures ranging in size from beetles to bulls were mummified and ritually buried. A number of vast animal cemeteries were maintained at various centers of cult worship, and people expressed their devotion to a particular god by paying for the burial of its sacred animal. For example, Khepri, the god of the morning sun, was represented by the scarab beetle, which was believed to have created itself from its own matter as the sun created itself every morning.

Before 2000 BC, only the privileged few, including the pharaoh and his priests, actu-

ally had access to images of the gods; the people were encouraged to regard the pharaoh as the supreme being responsible for the unity and prosperity of Egypt. Symbols and images of the major gods adorned papyrus scrolls like the *Book of the Dead*, as well as tombs and monuments.

Re, the sun god, became important as early as the Second Dynasty (2700 BC) and was probably associated with the pyramids. From the time of the Fifth Dynasty, Re was the supreme state god, closely linked to the pharaoh, who took the title "Son of Re" and was believed to join his father in heaven after his death. In this guise, his imagery merged with that of Horus, the falcon-headed son of Isis and Osiris, who was god of the horizon. Horus lost an eye while avenging the death of his father Osiris. Thoth, the god of writing, replaced it, and the Eye of Horus became the sacred symbol of protection, warding off evil.

An alternative belief held that the sun god was born every morning, aged during the day and died at nightfall. He then traveled through the underworld in the hours of darkness and was reborn every morning. Re was usually shown with a human body and a falcon's head, which was often surmounted by a solar disk. Eventually, Re was linked with the minor Theban god, Amun, to become Amun-Ra, the Supreme God of the New Kingdom (1552–1069 BC).

Isis, the wife of Osiris, was the epitome of the devoted wife and mother and a popular goddess of magic, whom the Romans would worship throughout their empire. The Egyptian mother-goddess, she set out with her sister Nephtys to recover the dismembered body of Osiris after Seth had murdered him, assuming the form of a kite. As the mother of Horus, her crown and symbol is a throne; with her sister, she was sometimes depicted on coffins, with wings outspread to protect the dead.

Representations of these gods were used as decorative elements on household objects and jewelry. The sacred images were believed to have supernatural powers, and the Egyptians wore amulets to protect themselves and often placed small charms in coffins to see the departed person safely into the next world.

Greco-Roman gods, too, had symbols by which they could be identified. Each of the Olympians—the twelve great Greek deities later adopted by the Romans—was allotted a particular sphere of life as his or her domain. Surviving statues, jars and mosaics show Poseidon/Neptune, god of the sea, with his trident; Ares/Mars, the god of war, in his chariot; and Hermes/Mercury, the messenger of the gods, with winged heels. Unlike the Egyptian deities, the Greco-Roman gods were usually depicted in human form, although some had the power to assume the forms of animals. Zeus, for example, often pursued his amorous quests in such disguises: to seduce Europa, he transformed himself into a bull; for Leda, he became a swan.

Pre-Columbian Central American beliefs were those of an agricultural society. Nearly all pre-Columbian art is monumental and symbolic: few commemorative scenes or human portraits survive. The human form is treated in a stylized way, which reflects the communal focus of primitive societies.

Below: Venus and Cupid, painted by Vecchio in the classical style in 1520. Venus (the Greek Aphrodite) was a relatively minor Roman goddess until Julius Caesar declared himself a descendant of Aeneas, the son of Venus and Mars. April, when spring renewed fertility, was sacred to her as the goddess of love. Her son Cupid (or Eros) was often depicted by contemporary and later artists as a child who mischievously wounded human hearts with his arrows.

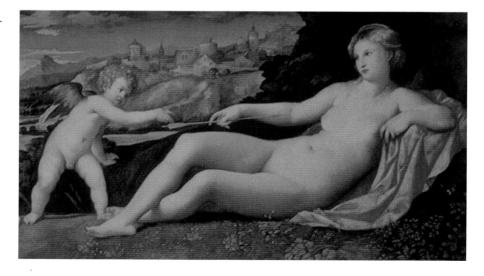

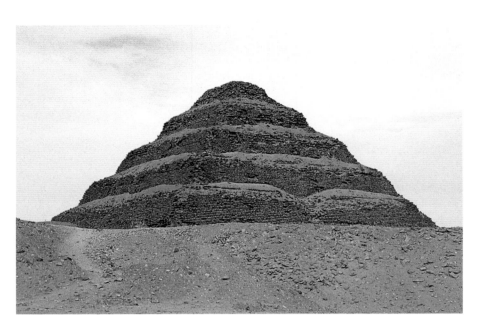

Above: *The Egyptian stepped pyramid of Zoser symbolized the passage of the pharaoh from Earth to reunion with his divine ancestors in the heavens.*

The main purpose of Aztec and Toltec religion was to ensure the fertility needed to grow the corn that was the staple food. Ears of corn were important fertility symbols that encompassed human generativity as well. The Mayan universe had thirteen higher levels of life-giving fertility gods and nine lower levels of the agents of disaster, including flood, famine and drought. These two realms were in perpetual conflict, and their interaction was symbolized by a ritual ball game played on a court designed to reflect the shape of the universe in Mayan cosmology.

The serpent, which represented both Earth and fertility, is a primary symbol in pre-Columbian art. Other prominent gods were those of the sun, rain and wind. Like their contemporaries, the Romans, the peoples of Central America had developed a sophisticated social organization by the second century AD, and many sacred symbols transcended local culture groups and were understood from the Mexican highlands south to Guatemala and the Yucatan. The Aztecs believed that their sun god, the warrior Huitzilpochtli ("blue hummingbird of the left") was born each day, valiantly defeated the stars at night and was helped on his way to death and resurrection by the souls of dead warriors. His symbols were the hummingbird and fire, and prisoners were sacrificed to propitiate him and to ward off the most dreaded of all cosmological events—the eclipse of the sun.

AFTERLIFE AND UNDERWORLD

Any society that concerns itself with the possibility of an afterlife has moved beyond the focus on mere survival in an unpredictable world to a preoccupation with metaphysical and supernatural matters. Ritual efforts to ensure a comfortable life in eternity suggest that people have the time and resources to look beyond the tasks of working the fields or finding water. Sacred images relating to death are common to many belief systems, and funeral practices were devised to prepare the dead for their journey to the underworld. The graves of Cro-Magnon society, which have revealed primitive weapons, pollen (indicating the presence of flowers) and other treasured artefacts, show that humans were thinking this way as long as 40,000 years ago.

The Egyptians made elaborate preparations for eternity, seeking to ensure that bodies were perfectly preserved through mummification. Osiris, king of the dead and judge of the underworld, was worshipped at Abydos, a major shrine where inscriptions and offerings were made. He was first represented in the Fifth Dynasty as a mummiform figure holding the royal insignia, the crook and flail. Wall paintings at Deir el-Medina show his skin painted green, symbolizing life and rebirth.

Greek worshippers of the powerful Hades, god of the underworld, averted their eyes when making sacrifices to him. He was also known as Pluto ("the giver of wealth"), to counteract the fear of mentioning his name, which was considered to bring misfortune. The Egyptians placed a coin in the mouth of the dead to pay Charon, the ferryman of the River Styx, waterway to the underworld.

The Vikings believed in Valhalla, "the hall of the slain," where warriors feasted for eternity with Odin, the god of death, magic and wisdom. Elaborate Viking funeral ships sent heroes on their way, surrounded by ritual objects, weapons and personal possessions. Humbler members of society were often buried in graves made partly from ships, although those who did not die in battle went to the underworld called Hel, the country of the dead. There, Balder, "the good god," killed by the malicious Loke, was honored as a lord.

TEMPLES AND PLACES OF WORSHIP

In many ancient religions, the temple was not only a shrine, but was regarded as the home of the gods. The earliest Egyptian temples, built of reeds from the Nile, were symbolic representations of the world, modeled on the creation myths. The sacred precinct, which became more elaborate over time, was surrounded by wavy tiers of mud-brick walls, signifying the primeval waters, and within the enclosure, rows of papyrus and lotus-shaped columns symbolized the earliest marsh vegetation. In some versions of Egyptian mythology, the marsh was the first piece of solid ground on which Re appeared to create the first pair of deities.

Unlike cathedrals or mosques, Egyptian temples were not intended for community worship. Their gateways, courts and halls were usually built around the sanctuary, a comparatively small room housing a statue used by the god as a resting place. The statues left the temple only during religious festivals— the only time when the common people could approach the images, although they were kept hidden in a shrine borne on a sacred boat. The Egyptians believed that the habits and rituals of daily life were also carried out in the afterlife. Thus daily offerings of incense and food were made in the shrine, and the clothing of the image was washed.

In temple carvings, the pharaoh is shown performing these chores, but in practice, they were carried out by the priests. The carvings that adorn Egyptian temples were not intended to inspire worshippers or even to decorate the building. Their purpose was entirely magical, and columns, ceilings and floors were all endowed with supernatural powers invoked by rituals.

Greek temples were more sparsely decorated than those of the Egyptians. Huge fluted columns supported the building, which housed a statue of the god, and sometimes incorporated other pieces of monumental sculpture and richly carved and painted friezes. One of the major differences between Greco-Roman religion and that of the Egyptians was that the Greek deities were accessible for all to worship. Any devotee could make an offering at a Greek temple, whereas Egyptian temples were the preserve of priests and pharaohs. The Greeks built temples from the ninth century BC onward: beautiful, symmetrical colonnaded structures worthy to be the abode of gods, they were the most important manifestation of sacred

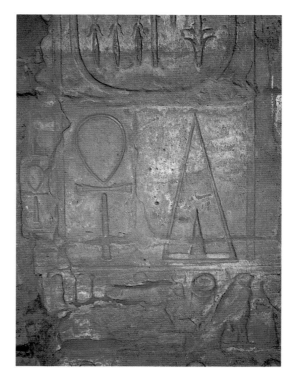

Left: Egyptian carvings showing a number of important sacred symbols. The keylike ankh (left), which combined the male and female symbols of Isis and Osiris, represented eternal life. When held to the nose of a mummified pharaoh, it ensured his everlasting life.

art. In religious terms, however, most rituals occurred outside the temple itself—within its precincts. The altar, where sacrifices were made to the god, was usually outside the building that housed the sanctuary. From the sixth century BC, most temples were built of stone, preferably marble. Other native stones were also widely used, as seen at Delphi and Olympia. The pre-eminent example is the Parthenon in Athens, dedicated to the city's patron goddess, Athena. The forty-foot-high image of Athena Parthenos by Phidias was made of ivory and gold. Sculpted friezes depict battles between the Olympian gods and giants, the Amazons and the Athenians, the Centaurs and the Lapiths.

In South America, Inca temples like the magnificent fifth-century site of Tiahuanaco, Bolivia, were covered with carvings and geometric designs, but archaeologists are still uncertain as to whether their primary purpose was decorative or ritualistic. The Inca city of Machu Picchu, high in the Andes Mountains, was undiscovered until 1911. Its impressive temples and houses are surrounded by agricultural terracing, and its primary gods included Viracocha, the creator, who was associated with the sun, Inti.

The Mayans, who flourished between 300 and 900 AD, built great temples crowning stepped pyramids representing the cosmic mountain. Their Mesoamerican temples reflected the concerns common to the region: cataclysmic events including flood, eclipse, eruption and hurricane. The Aztecs, their successors some 600 years later, decorated their temples and palaces with monumental stone carvings whose wide-ranging symbolic system was primarily based on fertility, solar worship and death. Nude female and male deities predominated, along with hybrid creatures of animal and divine origin. The Calendar or Sun Stone discovered at the Great Pyramid in Tenochtitlan (Mexico City) commemorates the past and present ages of the world. It bears such sacred images as serpents, jaguar claws and star symbols reflecting the Aztec cosmography. The cultural commonalities of this region have cut across tribal boundaries since pre-Columbian times, resulting in sacred beliefs and rituals whose effect is felt to the present day.

Right: The base of a Mayan temple on the Yucatan Peninsula. Stepped limestone pyramids are the remains of these great temples, guarded by the hybrid gods of a complex religious system.

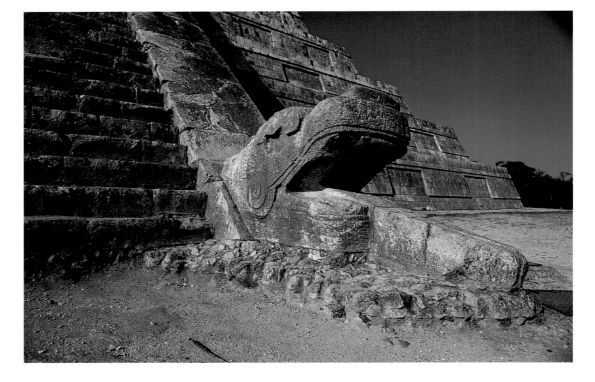

MANIFESTATIONS OF THE GODDESS

Although many religions have endowed their supreme creator and deity with male characteristics, ancient peoples venerated the Goddess, with her mysterious powers of fertility and apparently spontaneous generativity, which ensured human survival. *Below left:* A sandstone Egyptian goddess symbol, c. 700 BC. *Below right:* The Palaeolithic Venus of Willendorf, a voluptuous figure and powerful fertility symbol. She was carved some 30,000 years ago to emphasize aspects of life associated with birth and nurture, perhaps as the amulet of a fertility goddess who protected women in labor.

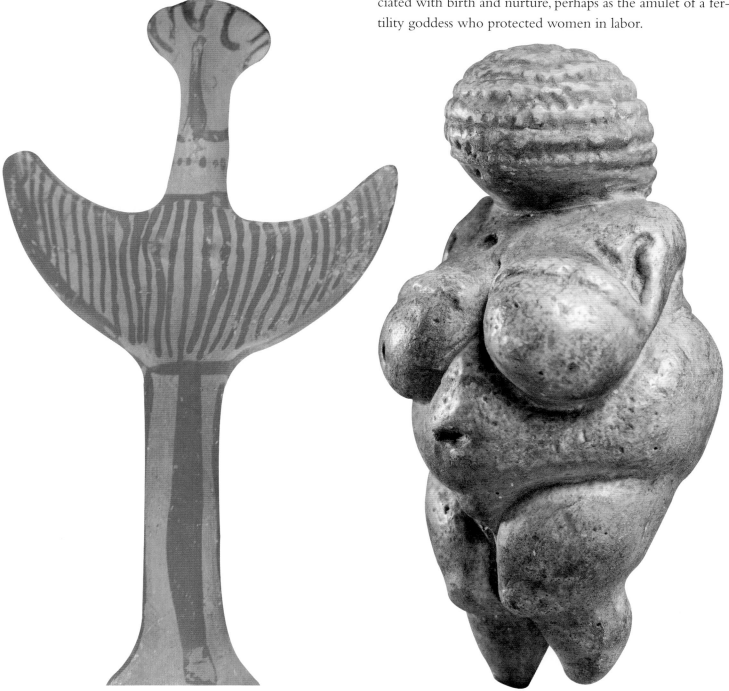

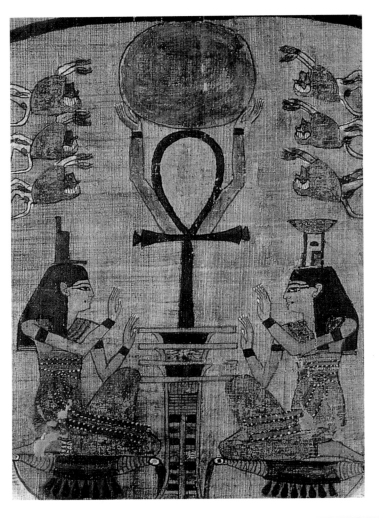

EGYPTIAN DEITIES

The Egyptian pantheon was large and constantly evolving. Consequently, the iconography of ancient Egypt is rich and diverse, with new beliefs simply assimilated into older ones. *Left:* Isis, wife of Osiris and the most powerful Egyptian goddess, with her sister Nephtys. Kneeling before the *djed* pillar, which represents Osiris's spine, they are exhorting the sun to rise from the armed ankh. Isis, the powerful mother goddess, is often depicted with a throne on her head, which is the hieroglyph of her name. Nephtys is sometime regarded as the dark side of Isis and does not seem to have been worshipped in her own right. *Below:* Isis, depicted with the wings of a kite, the form she adopted when she went in search of Osiris's body after he had been drowned in the Nile and dismembered by his evil brother Seth. Having embalmed him, she then revived him and produced a son, Horus, who would in time avenge his father's death. *Opposite:* Isis with her husband/brother Osiris. Originally a god of vegetation, Osiris was venerated as a legendary human king who had cheated death. He became god of the underworld and was associated with the deceased pharaoh, and his son Horus with the reigning successor. Here he grasps the royal crook of leadership and the flail of judgment.

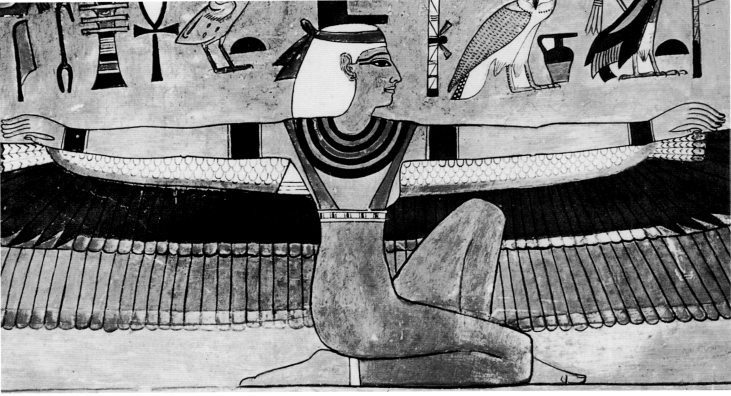

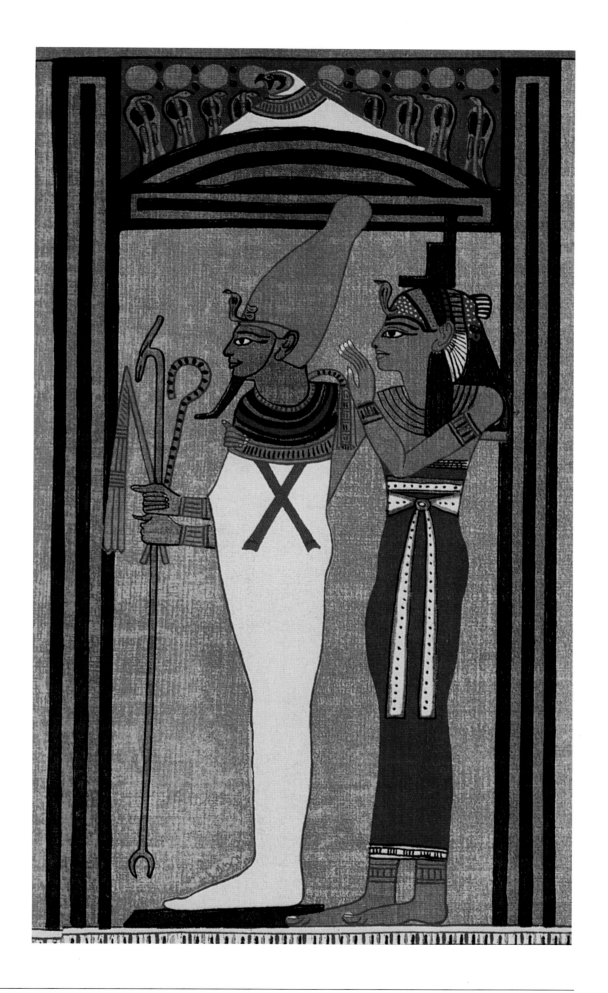

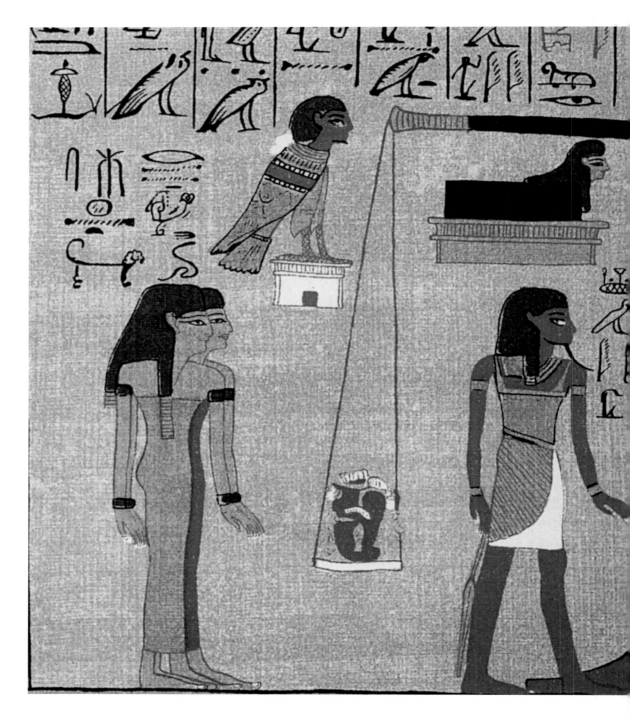

THE JOURNEY TO THE UNDERWORLD

Ancient Egyptians set great store by a comfortable eternity, and preparations for the soul's last journey were complex and ritualistic. At the hour of death, spirits were released: the *ka*, or life force, and the *ba*, the individual's soul. The corpse had to be preserved in a recognizable form in order for these spirits to survive and animate the deceased in the afterlife.

The image above shows the jackal-headed Anubis, guardian of the dead, weighing the hearts of the deceased against the feather that represented Ma'at, goddess of justice and truth. If good deeds outweighed bad, Osiris would welcome the spirit to the underworld. *Right:* During the night the sun god Re descended to the underworld, then returned to the east in his solar boat. He is seen here with the ram's head, symbolizing supremacy over the underworld.

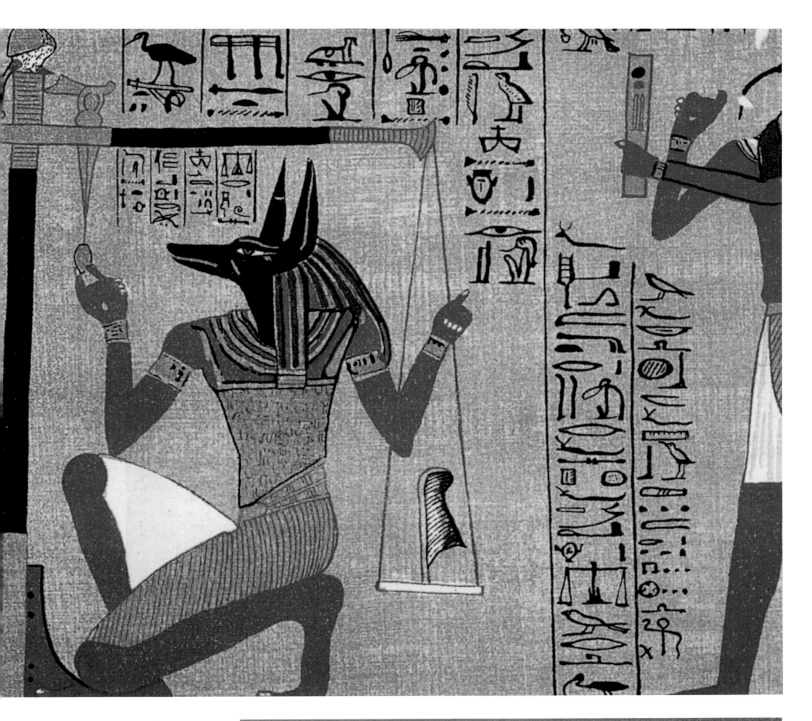

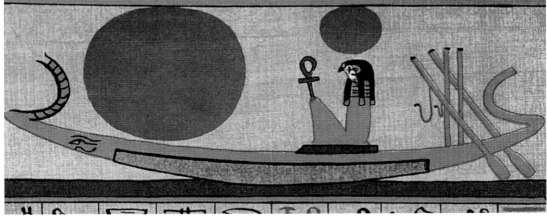

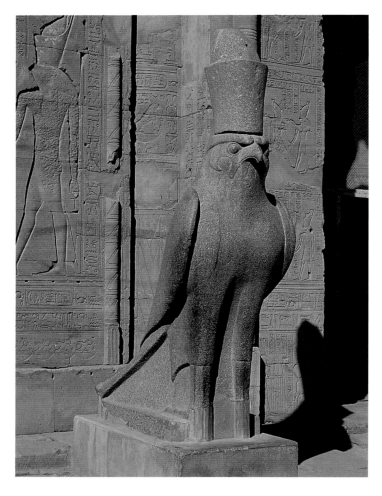

TEMPLES

The monuments and structures of ancient Egypt are particularly impressive because of their sheer size. Designed to glorify the gods and pharaohs, they are rich in imagery and important symbols.

Egyptian temples were massive complexes that symbolized the world. Built as models of the world's creation, their gateways, courts and halls surrounded a sanctuary that was used by the god as a resting place and housed his image. The sandstone Temple of Horus is the best preserved of all the ancient Egyptian temples. Its entrance is guarded by two magnificent granite statues of Horus in his guise as a falcon.

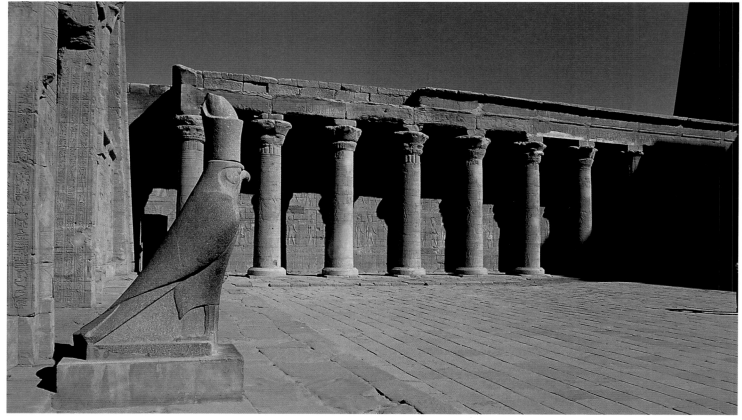

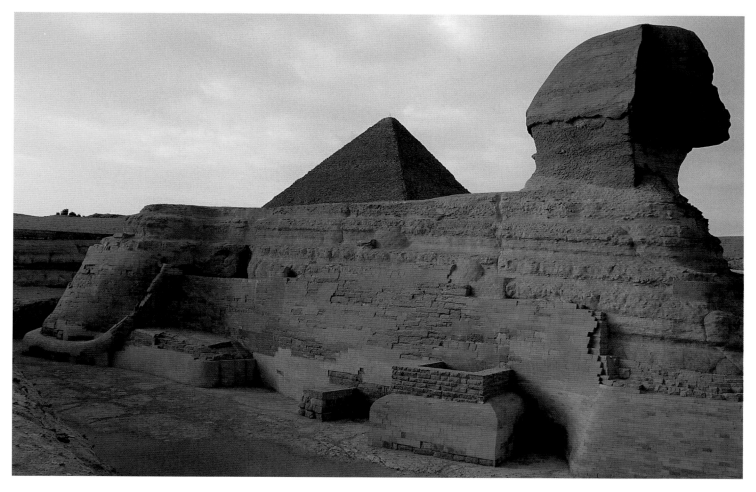

MONUMENTS

The Sphinx (*above*), with the body of a lion and the head of a pharaoh, symbolized protective authority, emphasized by the headdress and the cobra on the forehead. It may also have symbolized the junction of the constellations Leo and Virgo, which occurred in the fourth millennium BC. From the time of the New Kingdom (c. 1500 BC), the pharaohs were the chief mediators between mortals and the gods, and became gods themselves after death.

The Colossi of Memnon (*right*) are all that remains of an avenue that led to the temple of Amenhotep III. These mono-lithic structures were designed in the conventional form of the pharaoh enthroned.

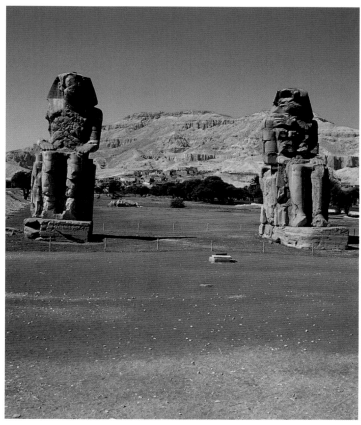

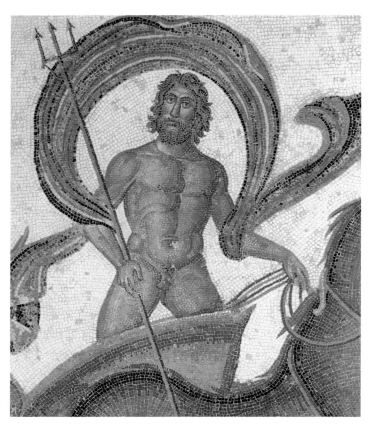

THE OLYMPIANS

The Romans believed that every culture worshipped the same gods under different names, so they readily transferred the supreme Greek gods who lived on Mount Olympus to the center of their own belief system.

Left: A mosaic of Neptune (Poseidon), the Greco-Roman god of the sea, holding his trident, which symbolized his power to raise storms. *Below: Apollo* by Girardon. The son of Jupiter and Juno, Apollo is always depicted as beautiful and forever young, and is linked with fertility, as well as music and poetry. *Opposite:* Two representations of Venus (Aphrodite) the goddess of love, beauty and fertility. In Botticelli's *The Birth of Venus*, she emerges from the sea on a scallop shell, her principal symbol. Scholars have long speculated about the original form of the sublime Venus de Milo. The black figures on the Greek amphora (*far right*) depict warfare under the auspices of Ares, god of war. Unlike Aphrodite/Venus, Ares was an unpopular and unscrupulous deity, although he assumed more personable attributes as the Roman Mars.

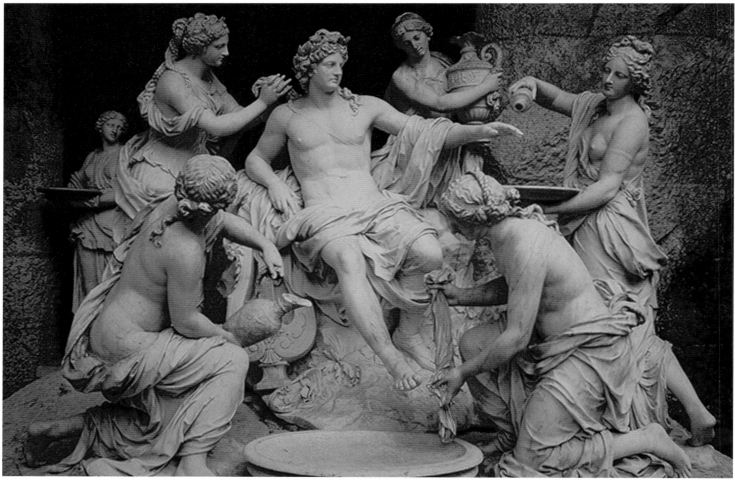

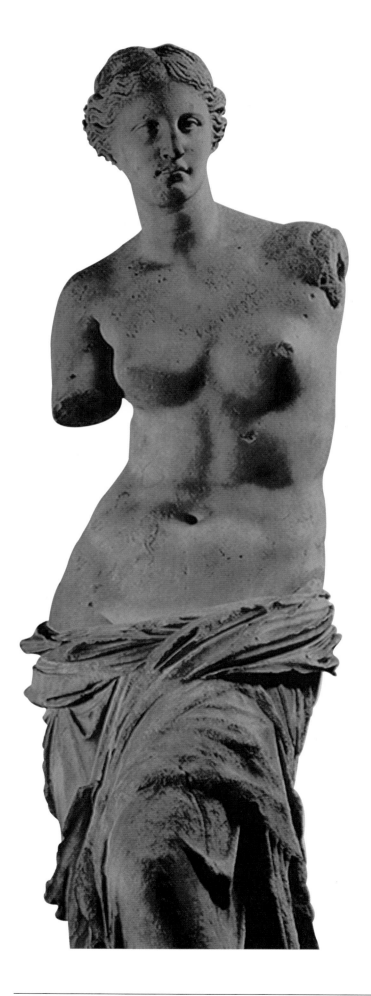

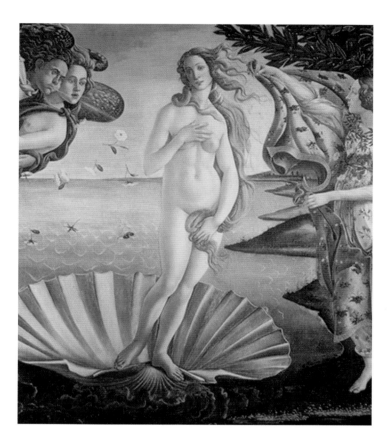

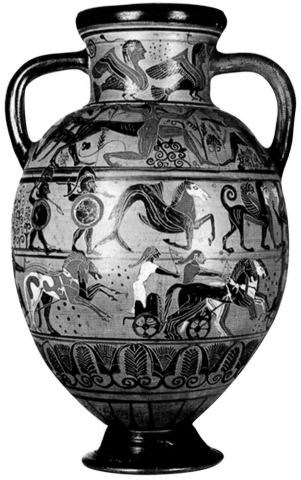

HARBINGERS OF VICTORY

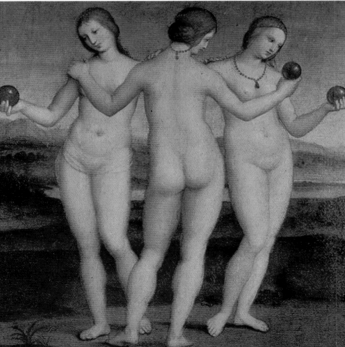

The Three Graces by Raphael (*below*). The daughters of Zeus and Hera, Aglaia, Euphrosyne and Thalia personified grace and beauty and inspired artists and scientists. The apples they hold show their affinity with Aphrodite. *Left:* A headless statue of Nike, goddess of Victory, worshipped by athletes and charioteers. Her image was placed in the shrine at Delphi after the Greek naval victory over the Persians at Salamis in 480 BC.

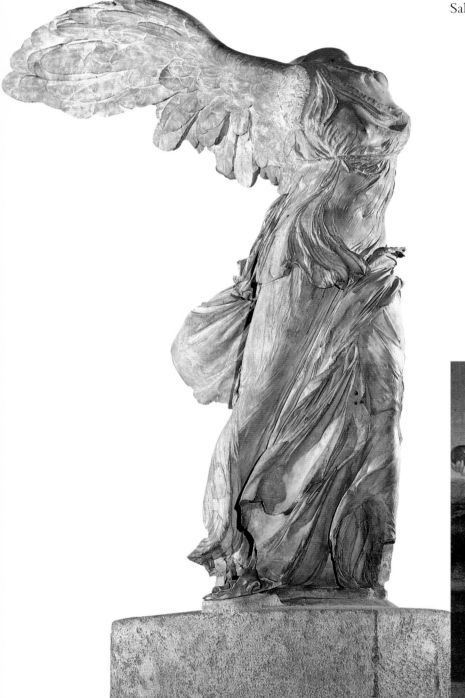

SEDUCTION AMONG THE IMMORTALS

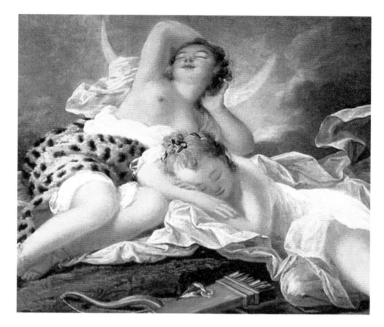

Fragonard's rococo portrait of Diana (*right*), the virginal and capricious Roman goddess of the moon and the hunt. This eighteenth-century painting incorporates several of Diana's symbols drawn from Roman representations—the crescent moon, the quiver of arrows and the wild–animal skin. *Below: The Bath of Mars and Venus* by Giulio Romaro (1499–1546) represents the legendary love affair between Mars, the god of war, and Venus, goddess of love, attended by Cupid, at right, with his quiver of arrows.

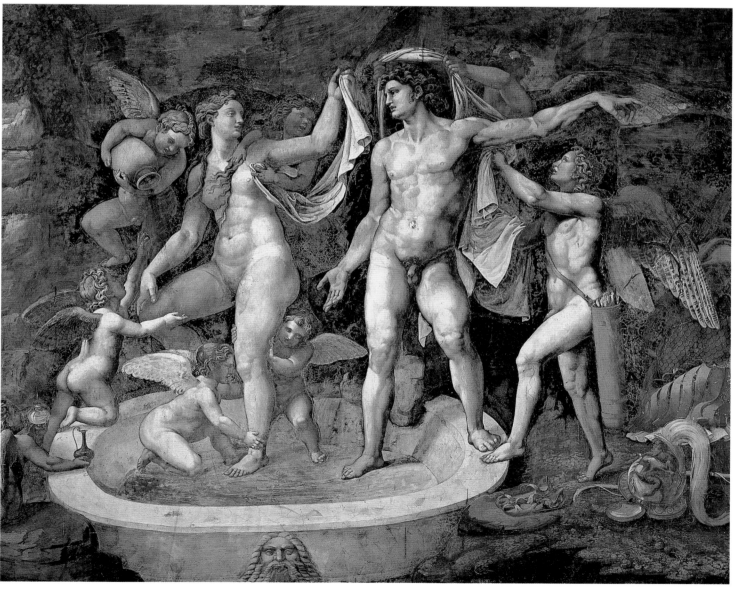

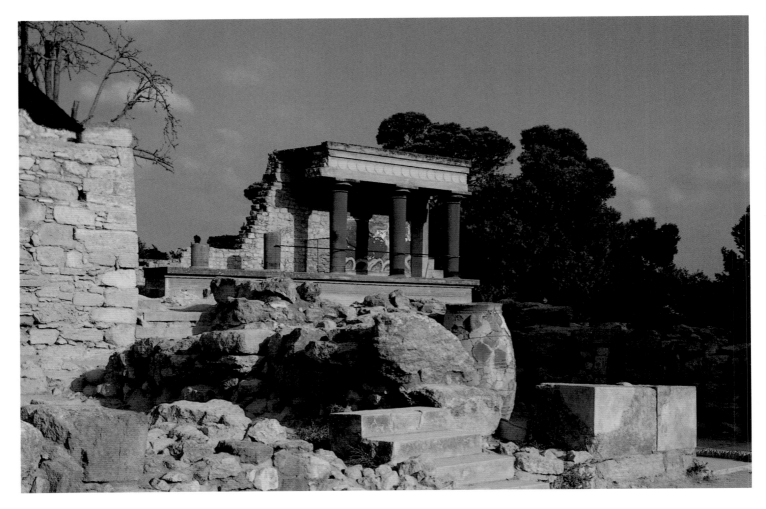

GREEK TEMPLES

Early Greek temples were regarded as the residences of the gods, although important rituals were conducted outside the temple itself, at the altar. These sacred buildings faced the east and were used almost exclusively for worship. Occasionally they served as safe repositories for valuables. The building itself had to be imposing enough to be considered suitable as the abode of a god.

The palace of Minos at Knossos, Crete (*above*), was constructed in about 1700 BC. The Minoans left few written records, but it is clear from the amazing frescoes at Knossos that religion played an important part in daily life at court. Several large chambers were set aside for rituals, and the legendary bull-leaping ceremony was held here. Incised double axes, which were probably used for killing the sacrificial bulls, are among the Cretan religious symbols depicted on the walls.

As the home of King Minos, Knossos was a wellspring of Greek mythology. The fearful Minotaur (half-bull, half-man) was spawned here, Daedalus built the labyrinth to contain it, and Theseus came to kill the creature and fell in love with Ariadne, the king's daughter.

THE TEMPLE OF APOLLO

The ancient Greeks believed that the Temple of Apollo at Delphi (*right*) was the center of the world, hence the *omphalos*, or "navel stone," in the sanctuary, where pilgrims left offerings. The fame of the oracle at Delphi spread throughout the known world, and envoys were sent from all over Europe to consult the oracle and to make offerings on behalf of their rulers. Divination was performed only nine times a year, and the prophecies that resulted were often obscure and equivocal.

THE PARTHENON

The Parthenon (*below*) is a classic Doric temple built between 447 and 432 BC. Its majestic marble halls were dedicated to the powerful virgin goddess Athena, patroness of the city. The ruins of the Parthenon still dominate Athens. It was built by Pericles to house Phidias's 40-foot-high statue of Athena and to glorify her martial qualities, which had helped create the mighty Athenian empire.

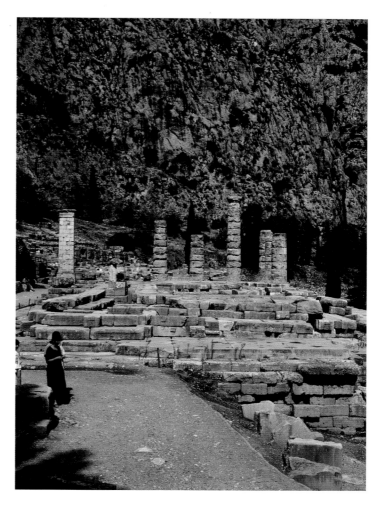

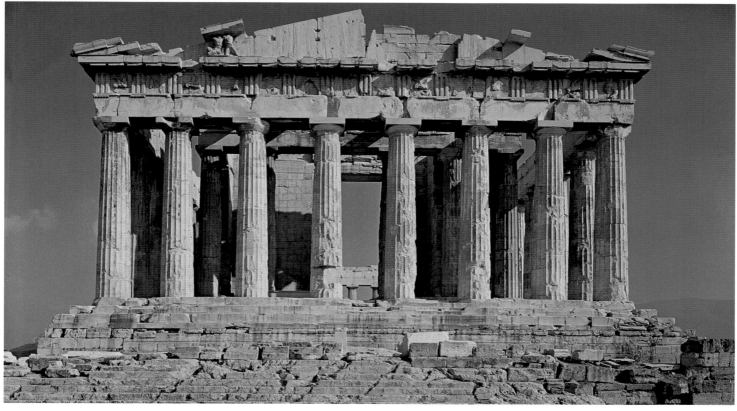

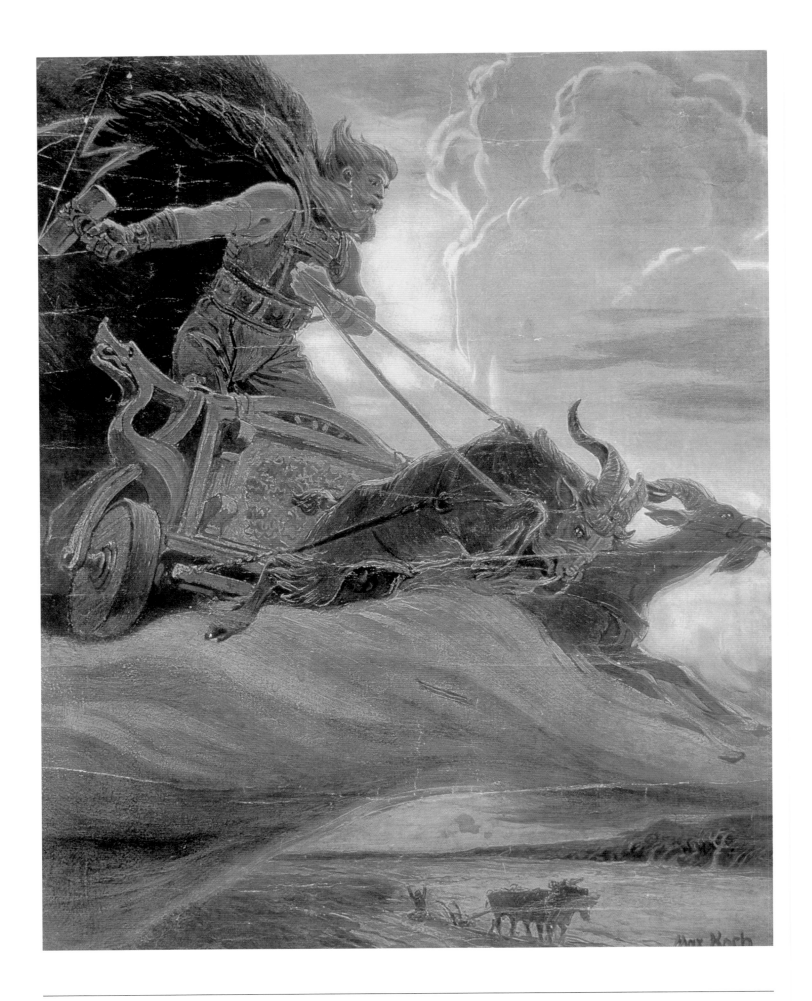

GERMANO-NORSE LEGEND

The Norse gods could be brutal and terrifying, including Thor (*opposite*), the son of Odin and Fjorgyn, who was associated with thunder, the sky, fertility and the law. If plague or famine threatened, sacrifices were made to him. Armed with his hammer and the girdle of his strength, he drove his chariot across the sky behind the fearsome mountain goats Toothgrinder and Toothgnasher.

The Norse Heaven and Earth were united by Yggdrasil, the great evergreen ash tree (*below*), whose roots lay in Asgard, Jotunheim and Niflheim. The tree of life and knowledge, it was watered by a fountain of virtues. All the worlds, mortal and supernatural, were encompassed by it. Midgard, the human realm, is at the bottom; Afgeinm, the land of the fairies, above it; and Asgard, the home of the gods, at the top.

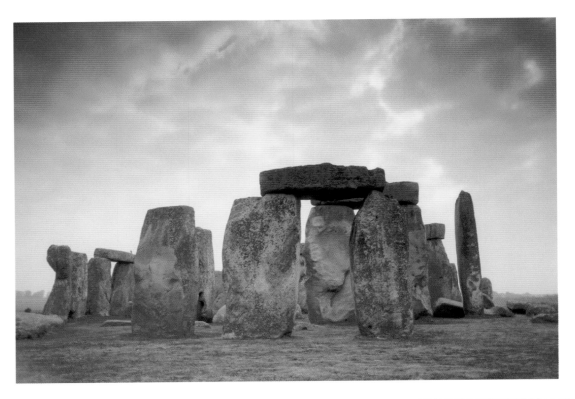

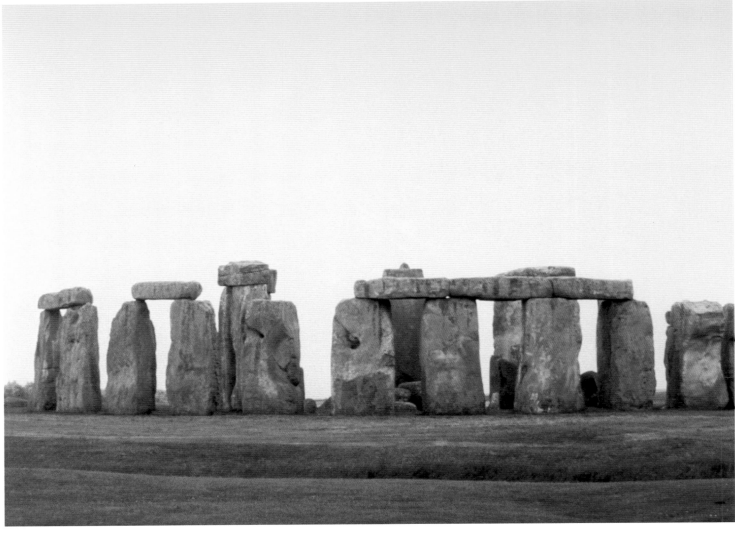

STANDING STONES

The megalithic monuments of Western Europe—of which England's Stonehenge (*opposite*) is the finest example—are evidence that early man worshipped the elements and sought to control aspects of a mysterious world. The standing stones, which were probably transported hundreds of miles to the site on Salisbury Plain, were carefully chosen and positioned. Archaeologists have proved that these stones were carefully aligned using geometric and astronomical principles, as were those a few miles away at Avebury (*right*).

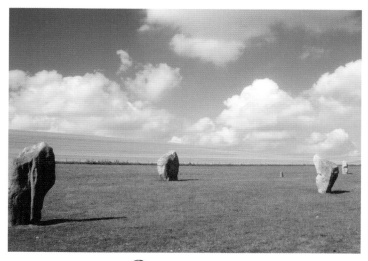

THE CELTS

Pre-Christian Celtic art was full of symbols and elaborate designs incorporating animals and human beings, reflecting the mystical belief that everything in the natural world had a magical meaning. It was the work of a society that valued elaborate display, and the adoption of Christianity only added to the visual library of Celtic symbols. Celtic crosses (*right*) incorporated the circle, an ancient pagan solar symbol, into the Christian cross.

The Christian iconography of illuminated manuscripts like the *Book of Kells* (*overleaf*) retained the interlaced woven patterns typical of earlier Celtic art forms, including jewelry and metalwork. Produced in the monasteries of the British Isles, these incomparable works of sacred art helped keep the light of knowledge burning in the Dark Ages of tribal invasion and warfare. *Page* 40: portrait, presumed to be Christ; *page* 41, *clockwise from top left*: the Four Evangelists, the Virgin Mary and Christ Child, St. Matthew and St. John the Baptist.

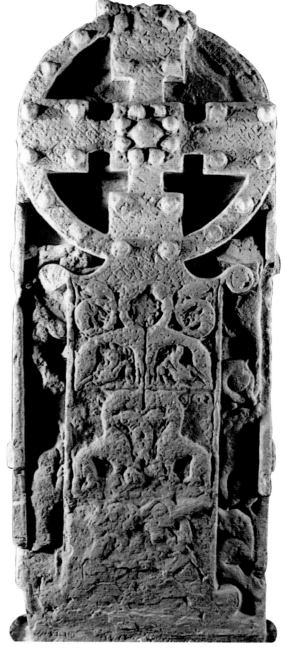

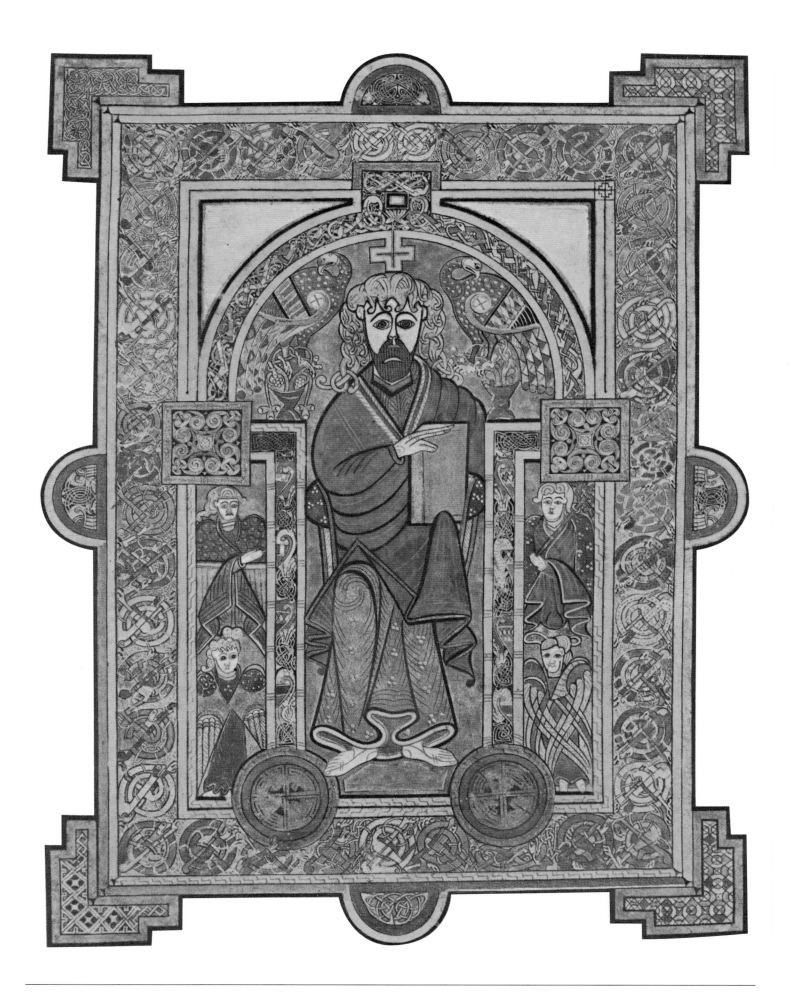

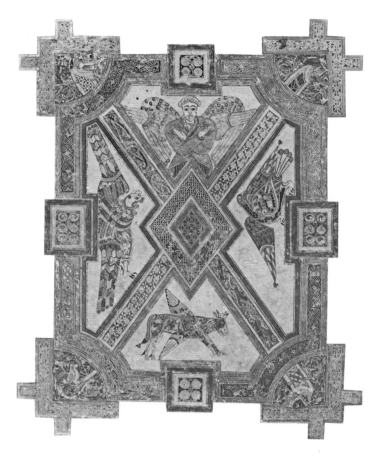

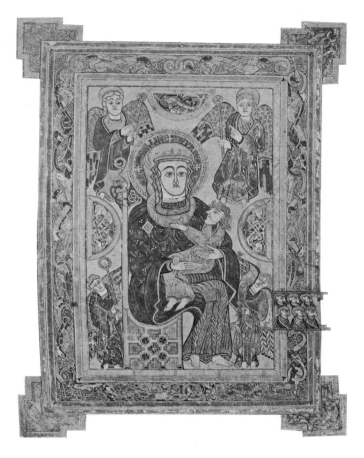

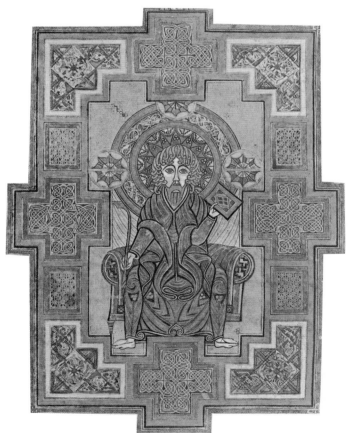

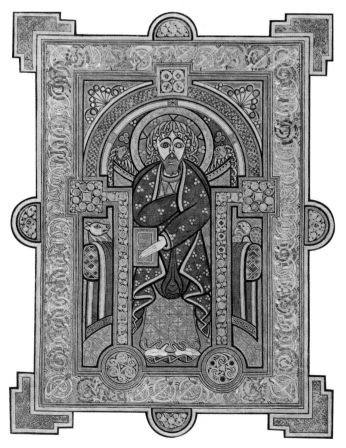

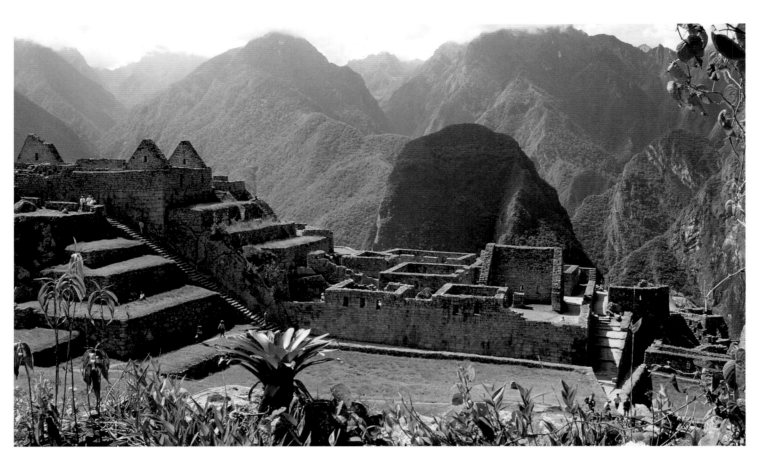

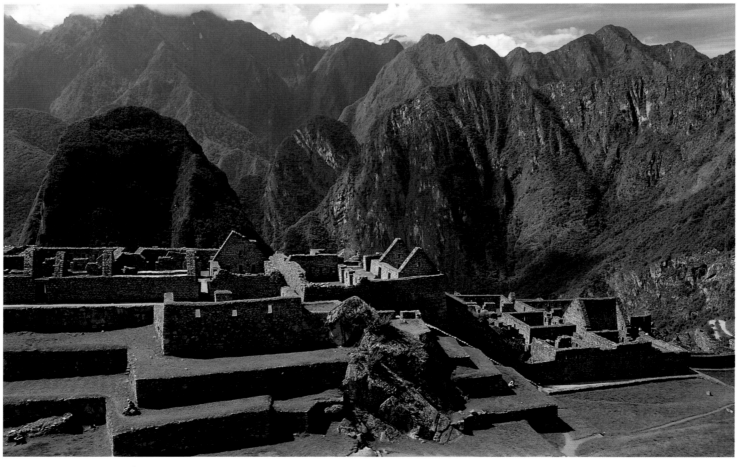

THE INCA AND THEIR PREDECESSORS

Macchu Picchu (*opposite*), the lost city of the Inca, was hidden high in the Peruvian Andes until the early 1900s. It proved to be a royal estate built by the first Incan emperor, Pachacuti, with numerous shrines aligned with celestial formations. The Temple of the Three Windows, seen in both views, is one of 143 granite buildings on the site. *Right and below:* Bolivia's Tiahuanaco, near Lake Titicaca, was built around AD 300 and abandoned seven centuries later. Little is known of its builders, but it is believed that the shrine's great idol, at right, was an early form of the Inca god Viracocha. The Gateway to the Sun (*below*) stands in a huge sunken courtyard that served as an astronomical observatory.

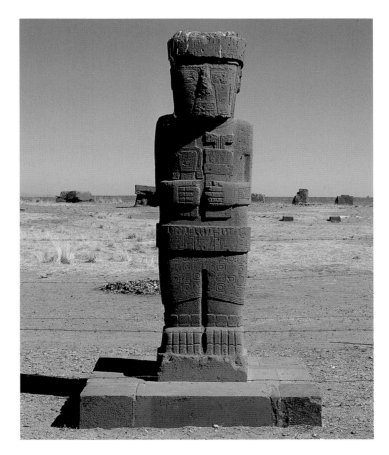

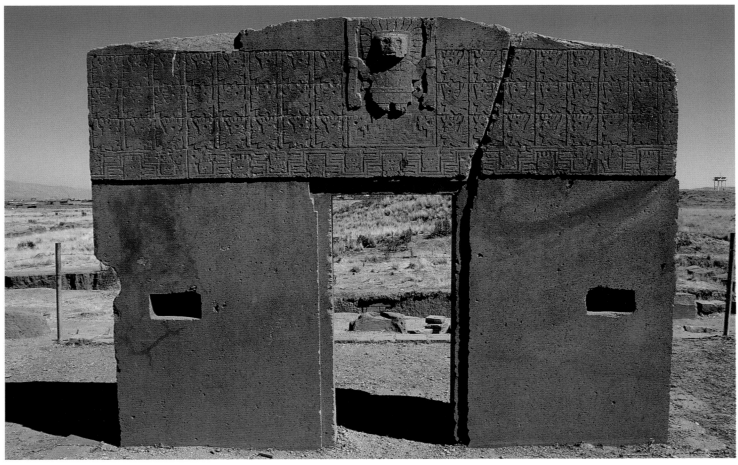

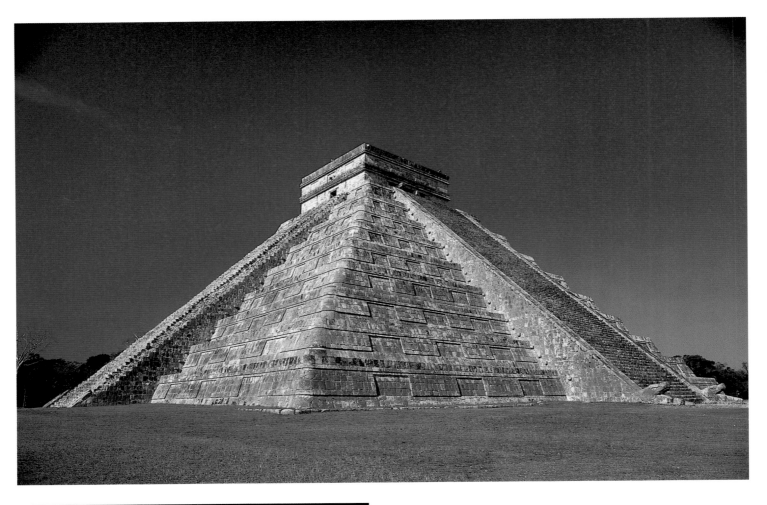

CENTRAL AMERICA

In Yucatan, stepped pyramids like the one above testify to the pervasive quality of ritual human sacrifices throughout the Mesoamerican culture area. At Chichen Itza and Palenque, powerful relief carvings (*left*) depict the fierce hybrid gods of pre-Columbian civilizations. *Opposite:* The Aztec deity Huitzilopochtli, identified with the sun, the Xiuhcoatl fire serpent in his right hand and the shield fringed with hummingbird feathers—symbols of war.

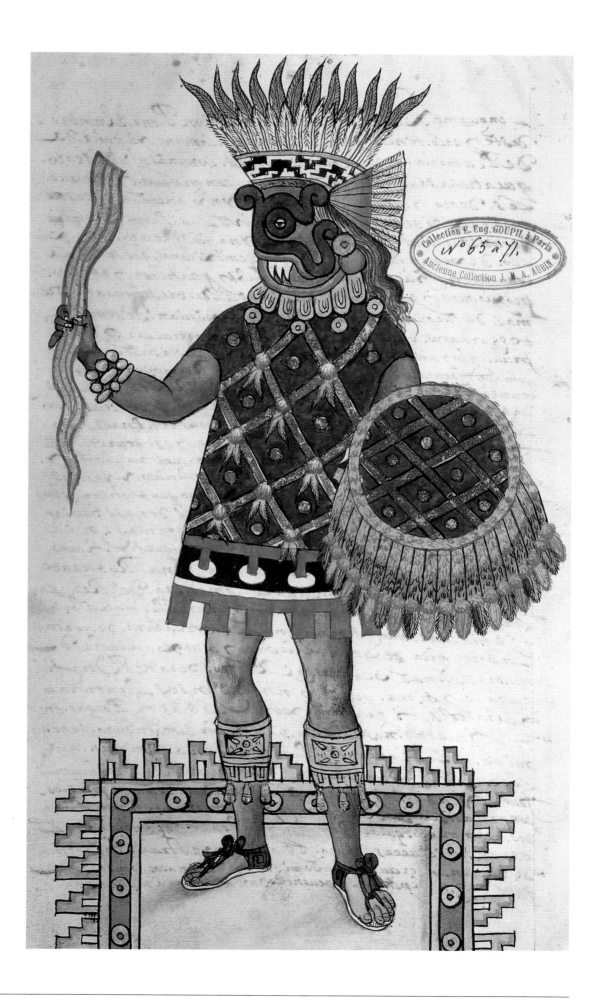

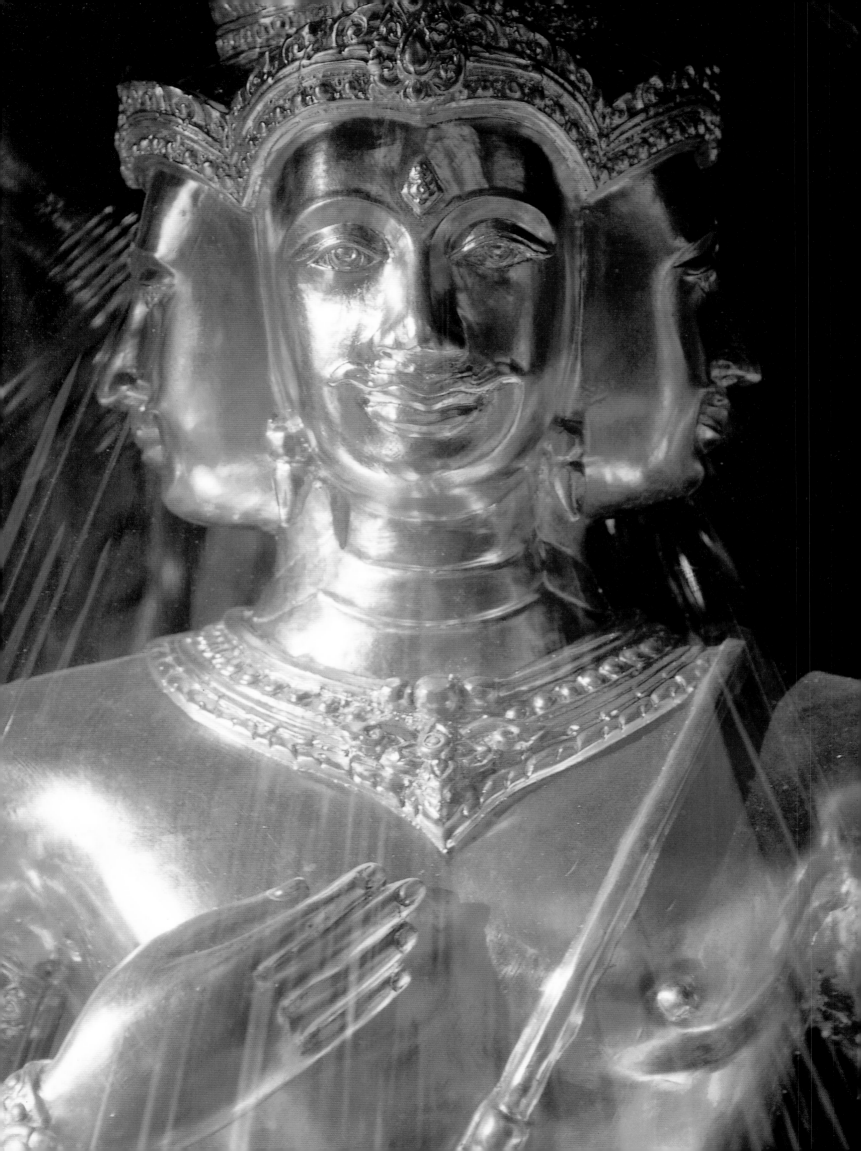

India and the Far East

The oldest faith on the Indian subcontinent is Hinduism, which provided the basis for Buddhism, Sikhism and Jainism. All of these religions share certain root beliefs: in cycles of reincarnation; *karma* (the principle that an individual's actions affect his or her next incarnation); and the struggle to achieve eternal release from rebirth—*moksha* for Hindus and Jains, *nirvana* for Buddhists.

The sacred art of these religions shares a number of regional characteristics and symbols. Icons, for example, often have multiple limbs, heads or eyes, signifying the many aspects of the deity. Stylized hand gestures, or *mudra*, convey special meaning to the faithful. Statues and other sculptures, such as reliefs, have various traditional postures. Buddhas, *bodhisattvas* and important Hindu deities, for example, are often depicted sitting in a relaxed position with one leg (usually the right) hanging down. The Buddha is most often seated on the sacred lotus in the cross-legged meditative position. Voluntary poverty or asceticism may be symbolized by matted hair piled high on the head, a loincloth and a begging bowl. Renunciants, called *sadhus*, leave the material world behind to share their wisdom with others who, in turn, support them. They often bear the image of the Third or Inner Eye on their foreheads.

Far Eastern images, by contrast, are generally more meditative and restrained. Symbolic landscapes and natural features figure prominently in Chinese sacred imagery. The Zen Buddhist art of Japan is austere and minimalist as compared to Indian sculpture and painting. Images of the gods are less common and elaborate than in the Hindu and related faiths of the subcontinent.

HINDUISM

Hindus believe that their faith is the eternal way, following the rules of cosmic order, or *dharma* ("appropriateness"), in which everything is created, flourishes, decays and dies, only to be recreated in an eternal cycle. The supreme deity has three aspects: Brahma, the creator; Vishnu, the preserver; and Shiva, the destroyer. Brahma is not worshipped as a personal god, partly because his task of creation is complete for now. Instead, Hindus worship aspects of the supreme being, with the understanding that he appears in many different guises. However, Vishnu explained the nature of the Hindu trinity (*trimurti*) in this way: "Only the unlearned deem myself [Vishnu] and Shiva to be distinct; he, I and Brahma are one, assuming different names for the creation, preservation and destruction of the universe. We, as the triune Self, pervade all creatures; the wise therefore regard all others as themselves."

The pantheon of Hindu gods is wide-ranging, and consequently religious symbolism is especially rich. The gods of Hinduism are at once human and superhuman: there is a feeling of warmth and even familiarity toward them among followers. Hindu art celebrates life, depicting the human form in every imaginable type of activity. Certain symbols recur, such as the cosmic lotus, from which Brahma emerged. It is associated with creation, fertility and water. Conch shells, often seen in temple carvings, represent the primordial sound, the *Om* of creation, which worshippers intone in meditation. Brahma may be depicted with a swan or a goose, symbols of knowledge, and sometimes holds a string of beads and a bowl of holy water, both fertility symbols.

***Opposite:** This richly gilded triune image of the Buddha reflects the Triple Jewel, consisting of the Buddha himself; the Dharma, or Buddhist law; and the Enlightened Community (Sangha).*

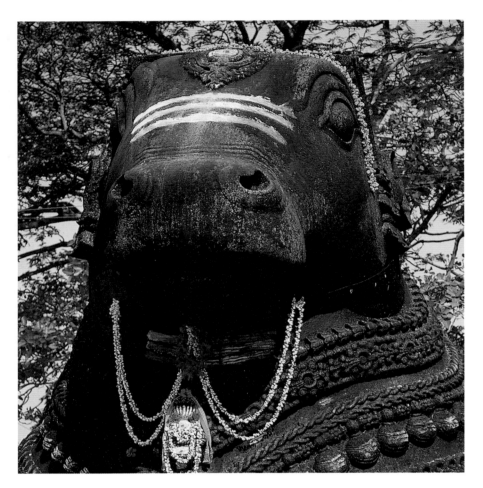

Above: Nandi, the sacred bull, is the vehicle of Shiva and a symbol of his nature as the dualistic god of desire and death.

the phallic *lingam*, a cylinder of dark shiny stone with a curved top set in a circular receptacle, and with the *yoni* (the symbol of female sexuality).

Hindu sacred art concentrates on the human form, both real and imagined. As Lord of the Dance, Shiva is often depicted with four arms, and his wife Durga, an aspect of the great mother goddess, Devi, appears as a figure with eighteen arms riding a tiger. The terrifying Kali, with her lolling tongue that savors blood and her girdle of severed arms, has four arms that symbolize both the shadow of death and immortal life. One holds a bloody sword, another dangles a head by its hair; one right hand confers blessing, and the other exhorts her followers not to be afraid.

JAINISM

Founded in the sixth century BC by Mahavira, (a contemporary of Buddha), Jainism emerged in reaction to the elitism of the Hindu caste system and the practice of ritual animal sacrifice. Jains believe that the cosmos, or *loka*, was not created by a single deity, but is eternal: it always has been, and always will exist. Jain belief shares such Hindu characteristics as the search for *moksha* (the release from rebirth), and its legends include a number of Hindu gods, but they are not regarded as supreme beings. Jains follow the *Jinas* or *tirthankaras*: human teachers called ford-makers who have attained the highest knowledge and spiritual insight, enabling them to lead souls across the fords of the river of rebirth. Salvation lies in conquering material existence by adhering to a strict ascetic discipline, which for lay people embrace vows — *anuvaratas* — imposing vegetarianism and abstention from any kind of work that involves the destruction of life (e.g., hunting or fishing).

Originally a minor solar deity, Vishnu is now the most widely worshipped of Hindu gods. He appears in many incarnations in his eternal effort to ensure the triumph of good over evil, and is represented by a variety of symbols. Often depicted with four arms, Vishnu holds in his hands a wheel or disk (representing the eternal cycle of creation and destruction), the conch shell (associated with the origin of existence) and the club (expressing authority and power); his fourth palm is upraised in reassurance. Vishnu has appeared on earth in nine incarnations or *avatars*: three in animal form (fish, boar, turtle); five in human form; and as a hybrid half-man, half-lion. The tenth *avatar* is expected to present itself when the earth comes to the end of its present cycle.

Shiva, the third member of the *trimurti*, is a part of everything and thus assumes many different forms. His worship is associated with

The cultural influences of the Indian subcontinent are uppermost in Jain art, and lay patrons were encouraged to commission

sacred works. Scenes from the Jain narrative tradition were an important theme in Indian art from the eleventh century. Images of the *tirthankaras* were especially popular, as it is believed that adherents will makes spiritual progress by meditating on their iconic forms. Typically, Jain figures are depicted naked, with broad shoulders and narrow waists, and asceticism is implied by piled-up and matted hair. Parasols may be placed above their heads to represent their royal spiritual status. Human silhouettes, or *siddha*, signify a liberated soul— the ultimate goal of the religion. The Jain emphasis on learning created many important scriptures, as well as a body of popular literature in many different Indian languages. The Jains have also produced beautiful symbolic maps of the cosmos, which is often depicted as a glorified human body, in the age-old belief that the human being is a microcosm of the universe.

SIKHISM

The Sikh religion was founded in the fifteenth century by Guru Nanak. Dismayed by the religious antagonism between Muslims and Hindus, he announced, "There is no Hindu or Muslim, so whose path shall I follow? I shall follow the path of God." He established a faith centered on belief in one God, the ten gurus and the teachings enshrined in the sacred text called Guru Granth Sahib.

Members live according to a discipline marked by adherence to the principles called the five K's: *Kes,* uncut hair, representing God's will; *Kangha,* the comb, symbolizing controlled spirituality; *Kirpan,* the steel dagger, or a determination to defend the truth; *Kara,* the steel bracelet worn to express unity with God and fidelity to one's guru; and *Kachh,* an undergarment representing moral strength.

Below: Hindu temples are located by rivers wherever possible, as the river— especially the sacred Ganges—is auspicious. The slender tower, or shikara, *links heaven and earth.*

Above: *The hand of the Buddha is portrayed in many different positions, each* mudra *having sacred significance. This is the Bhumi sparsha mudra, in which the hand points downward to call the earth to witness to his enlightenment.*

The most important Sikh symbol is the *Khanda*: a double-edged sword in a circle, representing belief in one god and protection from oppression, flanked by the curved blades of spiritual and temporal power. Guru Nanak is often shown with a multi-pointed star on his foot—a symbol of greatness and a mark of his exalted status. The prayer beads clasped in his hand, and the necklace usually worn by *fakirs* or ascetics, signify holiness.

Temples are especially important to Sikhs, as they believe that God manifests himself in them. The "Holy of Holies," the Golden Temple at Amritsar, built by Gurus Ram Das and Arjan, is the spiritual center of Sikhism and the primary site of pilgrimage. The Guru Granth Sahib was installed there in 1604.

BUDDHISM

Like Mahavira, the Buddha, born Prince Siddartha Gautama in northeast India, questioned the limitations of the Hindu faith in the sixth century BC. The story of his life is well known: he cast aside his worldly inheritance and wandered for years as an ascetic, finally achieving enlightenment, or *nirvana*, at Bodh Gaya in Bihar. He went on to teach his followers that suffering, caused by desire, is the nature of human existence, which ends

inevitably in death and decay. Both desire and suffering could be overcome by non-attachment. The code of behavior called the noble eight-fold path would enable his followers to achieve this state of grace.

Perhaps more than any other religion, Buddhism has evolved and developed new concepts during its 2,500-year history, acquiring national characteristics. The Mahayana school is most prevalent in China, Korea and Japan; the Theravada, or Hinayana, predominates in Sri Lanka, Burma and Southeast Asia, and Tibet adopted the Tantric school, fused with its native faith, Bon-Po.

Mahayanas taught that the Buddha (literally, "the awakened one") was not alone in attaining enlightenment; both past and future buddhas would manifest themselves as they passed through the various stages of self-realization. Those who were only a step away from buddhahood were called *bodhisattvas* ("those containing the essence of enlightenment"), and were able to help and encourage other souls along the path to nirvana.

Many images of Buddha would appear throughout Asia, but in the first few centuries after his death, he was represented mainly by such symbols as the wheel of his teaching, the *dharma*. The earliest sacred objects were symbols of his royal status: the flywhisk or parasol, the Bodhi tree, where he reached enlightenment, or his footprints. Figurative representations date from the second century BC in northern India, and today their many styles reflect the diverse cultures in which Buddhism has flourished. The earliest sculptures were influenced by Greek and Roman art, which represented gods as figures of beauty and grace. Later artists focused mainly on the twelve elements of the Buddha's biography, including his previous existence in Tusita heaven; his earthly life, from initial luxury and worldliness to later asceticism; the Bodhi tree and the defeat of Mara's evil forces;

the emblems of enlightenment; his first sermon; and his death. Buddhist art employs a rich but clearly defined symbolic vocabulary. As in other traditions, repetition is the key to emphasizing the spiritual message over time across many different cultures.

As the spiritual center of consciousness, the head is always particularly detailed, and each of the many hand gestures, or *mudra*, has a meaning. Tantric Buddhism established a wide range of gestures, each with a specific magical attribute. Like Hindu gods, some Buddhist images have many limbs, representing aspects of their power and spheres of influence.

Among the common symbols in Buddhist art are the lotus, which has its roots in the earth, but flowers into pure open space, thus symbolizing the state of enlightenment. The triple jewel, or *triratna*, resembling a three-pointed crown, signifies the three jewels of Buddhism — the Buddha, his teaching and the community of monks who preserve and transmit it. Mandalas are sacred representations of the cosmos, regarded as powerful centers of psychic energy. Essentially a circle enclosing a square with four doorlike apertures, the shape may be sculpted, drawn, or used as the ground plan for a sacred building. It is itself an object of meditation in many Eastern traditions. The swastika — a symbol now reviled in the West — was originally an ancient sign of good fortune, and it is often shown on the chest, palms or footsoles of the Buddha.

CHINA

Chinese religion combines several different philosophies and folk traditions, as simplistically expressed by the adage: "Confucian in office, Taoist in retirement and Buddhist as death draws near."

Confucianism emphasizes harmony (balancing the opposite forces of *yin* and *yang*), and respect for family, tradition and society. It is the dominant ethical influence on Chinese and Japanese society, and believers look to *Tien*, or heaven, as the source of cosmic order and the potential for human goodness, rather than to a single revelatory god.

Taoism posits a natural world order that determines the behavior of all things: by studying the world of nature, Taoist thinkers

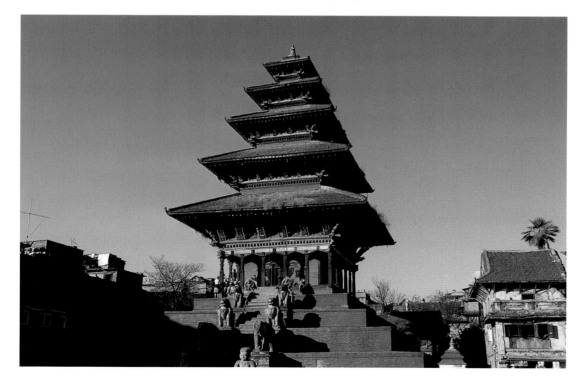

Left: In Southeast Asia, China and Japan, the ancient Indian burial mounds called stupas evolved into multitiered pagodas that symbolize the Buddhist cosmos.

Right: A spirit house in Thailand, a stronghold of Theravada Buddhism, which follows the most ancient form of Indian Buddhism, highly colored by Hindu mythology.

hope to discover essential laws. This attention to the spirit of things—particularly such phenomena as water and wind—led Taoists to make systematic investigations that laid the foundation of science in China. Later, Taoism incorporated aspects of animistic folk religion. The belief that each inanimate object had its own spirit or god gave rise to a system of worship designed to propitiate these powers, which was far removed from early Taoist principles.

Taoism had a strong influence on the development of Chinese landscape painting. Its concerns are reflected in the subject matter of the genre—for example, the scholar gazing out from the shelter of a rustic retreat, conducive to contemplation, at pine-clad mountains shrouded in mist. Pine trees are a symbol of longevity and endurance in Chinese art, and the ageless mountains were associated with immortality and spirituality, encouraging freedom from the fear of death.

As in other traditions, sacred art recalled the great exemplars of virtue from the golden ages of the past. Buddhism had a profound impact upon Chinese art. Here, more than anywhere

else, the Buddha and his followers were depicted with extraordinary realism. Buddhism also ensured that the Chinese adopted a reverential attitude toward art itself. They regarded the creative artist as an inspired craftsman, like the poet, rather than as a glorified decorator.

Religious art in China was used not so much to teach a particular doctrine as to aid in meditation. Devout artists painted beautiful mountains and bodies of water, peaceful scenes that evoked contemplation and deep thought. Their pictures, painted on silk scrolls, were treasured items kept in ornate containers and unrolled only in quiet moments. This form of sacred art is restrained, graceful and governed by convention.

JAPAN

Like the Chinese, the Japanese drew upon several different traditions as the basis for religious practice. The oldest, indigenous to Japan, is Shinto, "the way of the gods." Chinese Buddhism with its Confucian influences arrived from Korea in about the sixth century, and by the fifteenth century the scholar Yoshida Kanemoto had concluded that Shinto

was the original way of truth and that the Buddhas were the fruit of its teachings.

As in many cultures, the sacred imagery of Japanese religion is inspired by nature. The sun is a major symbol in Japanese mythology, still worshipped at the shrine of the sun goddess Amaterasu at Ise. Indeed, in the "land of the rising sun," the solar image is embedded in national consciousness, as seen in the Japanese flag. Followers of Shinto regarded the Japanese emperor as a direct descendant of the Sun Goddess, and for centuries the emperor was revered as a living god. Until 1945, the Shinto religion was entwined with the Japanese political system.

Shinto rites and ceremonies are designed to propitiate the *kami*, the deities who govern the sun, earth, moon, fertility and other natural forces. The religion stresses purity, and ceremonies are held regularly at shrines throughout Japan. The shrines themselves embody serenity, encouraging a mood of calm and meditation among worshippers by achieving a perfect balance between their architecture and the natural surroundings. Every shrine is marked by a *torii*, a gate symbol consisting of two beams supported by two columns. This represents the division between the secular and the sacred. Animal images of stone, either *komainu* ("Korean dogs") or *karajishi* ("Chinese lions"), protect the shrine from evil. Visual representations of the *kami* themselves were uncommon until after the sixth century, when Buddhism began to influence the native religion. Icons are placed within temple sanctuaries, but are objects of veneration rather than worship.

The Japanese school of Zen Buddhism incorporates a mixture of meditative Buddhist philosophy and the nature mysticism associated with Chinese Taoist beliefs. It seeks the personal experience of enlightenment based on a simple life lived in harmony with nature. Zen complements Shinto and has had a profound effect on Japanese cultural life. Art and architecture are regarded as extensions of nature's perfection and are designed to enhance meditation and holistic simplicity.

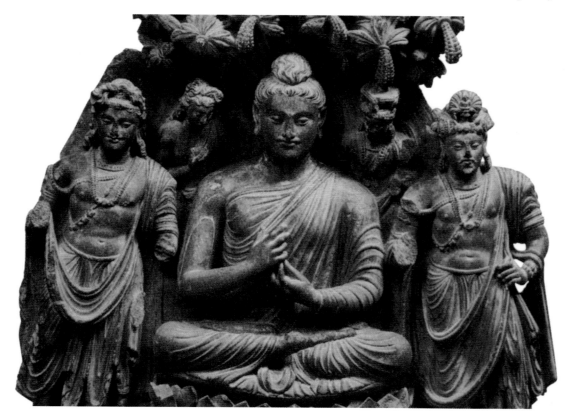

Left: *An early image of the Buddha and his attendants: it shows the influence of Greek and Roman art in such details as the drapery and the royal canopy.*

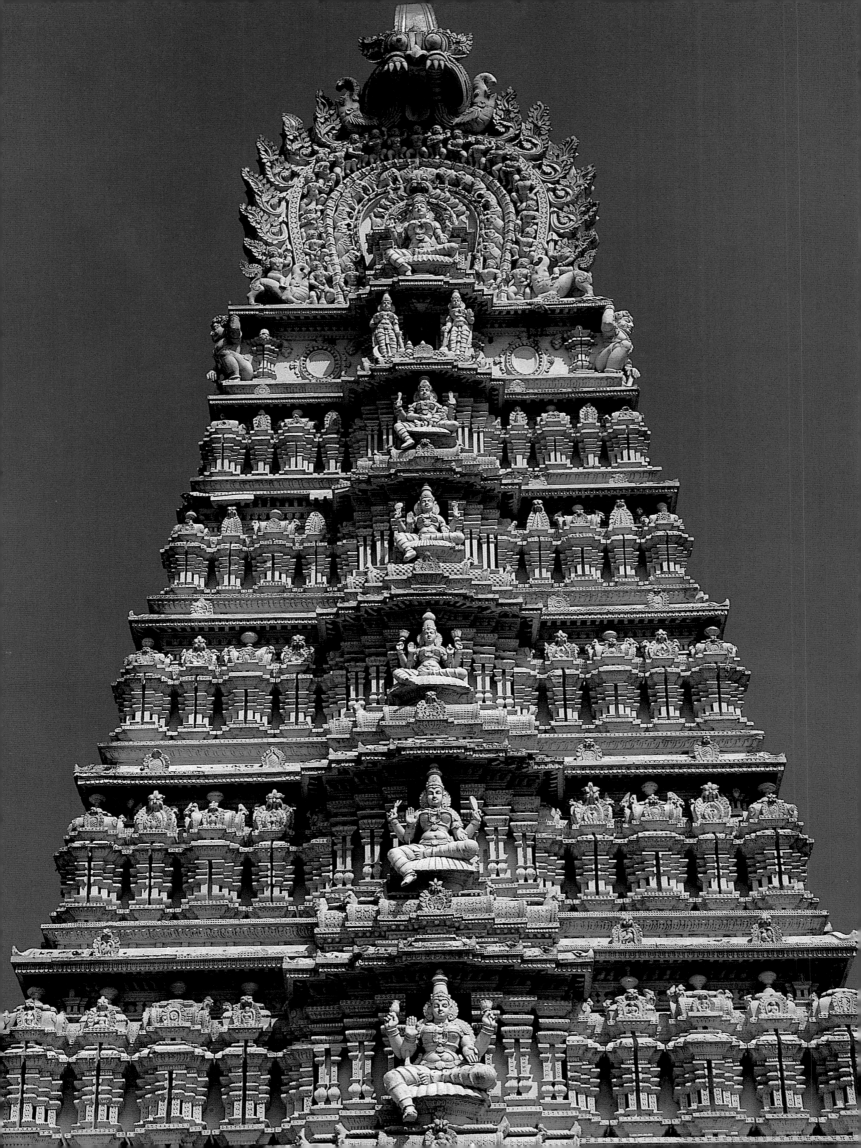

THE HINDU PANTHEON

Hindu temple (*opposite*) in the style of southern India, with tiers of carvings representing divine powers surmounted by a crownlike tower that recalls Mount Meru, the mountain home of the gods. *Right:* Ganesha, the elephant-headed god revered as the remover of obstacles and the lord of beginnings and learning. *Below:* A temple dedicated to Ganesha, symbolized by the elephant carvings and guarded by the traditional lion-dogs. Like all Hindu shrines, it represents the universe and the divine.

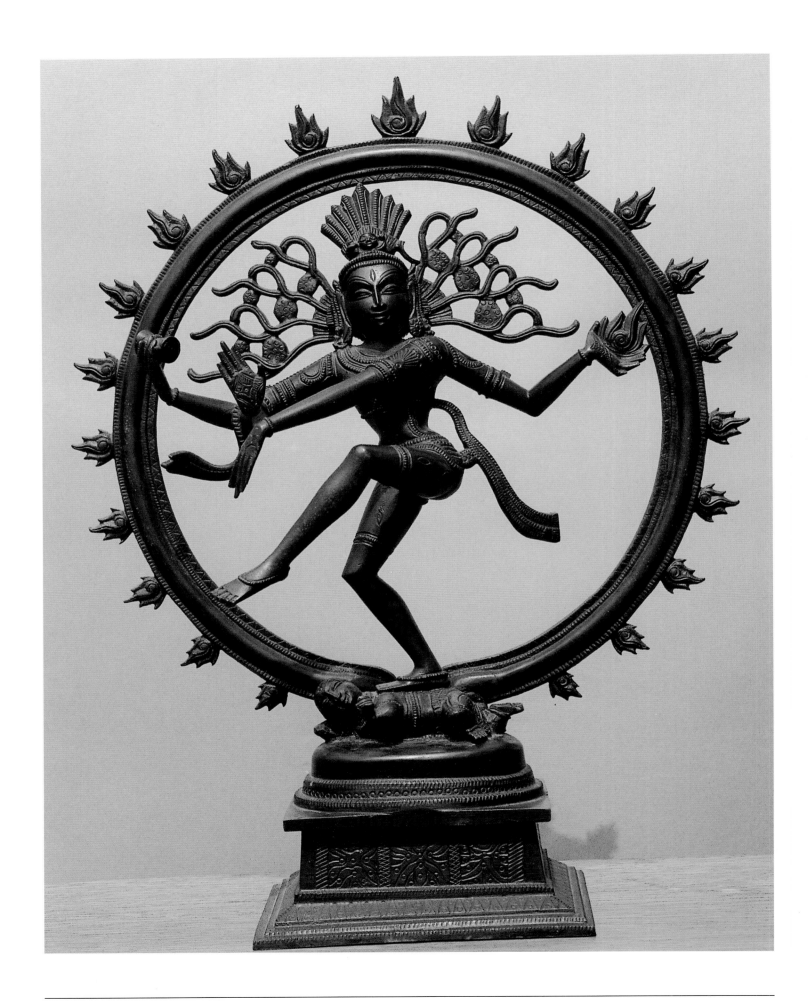

ASPECTS OF SHIVA

Because Shiva is everything, he is known by more than a thousand names and appears in many guises. *Opposite:* Shiva as Nataraja, Lord of the Dance, surrounded by a ring of fire, holds the flame of destruction in his cupped hand (*at right*). All opposites meet and are reconciled in his dance, as signified by the upraised palm facing outward to reassure the devotee. *Above:* Shiva as part of the Hindu trinity, holding the trident and flanked by his mount, the white bull Nandi. *Right:* The cult of Shiva is linked to pre-Aryan beliefs in the Indus Valley, which focused on fertility goddesses who were associated with trees and, by extension, the Tree of Life.

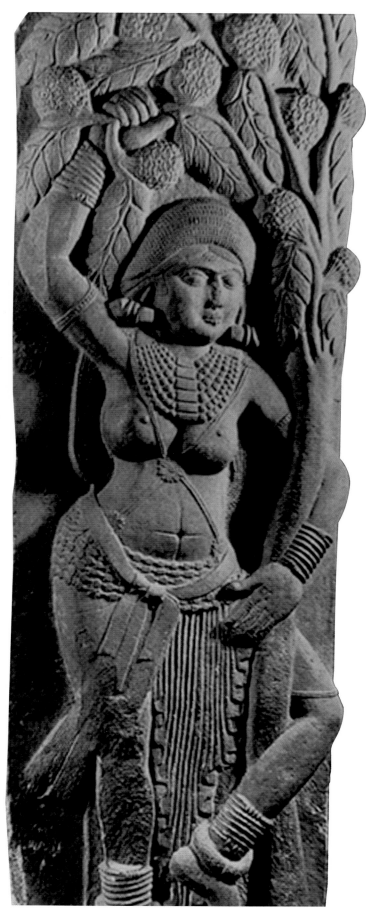

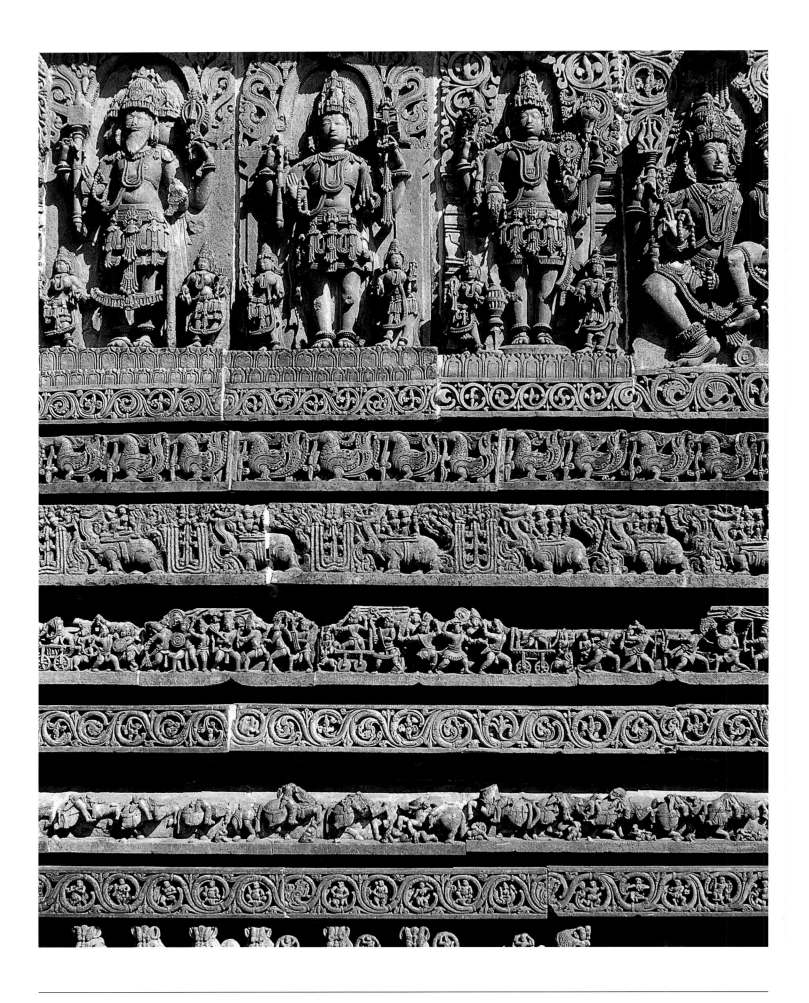

HINDU WORSHIP

The temple façade opposite (*detail below*) reflects the Hindu concept of worship as both *darshan* (viewing the sacred image) and *puja* (ritual), which is conducted here (and in the home as well) to bring the divine presence into communion with the seeker. Each band of symbols directs the eye upward to the apex of the shrine, above all images, which is considered the pivot of the world.

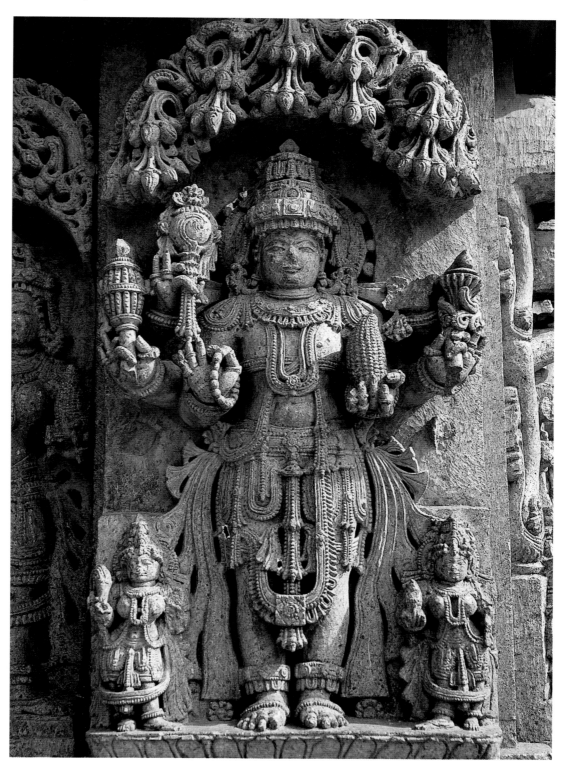

THE SIKH TRADITION AND JAINISM

The Punjabi word *sikh* (learner) is the key to this faith, born of Hinduism, which emphasizes fidelity to the one God (*Sat Guru*) and the ten Gurus who revealed His teachings, beginning with the Guru Nanak (1469–1539). *Below:* A shrine at the Golden Temple of Amritsar, the spiritual center of Sikhism, whose adherents follow a rigorous path that emphasizes meditation, devotion and service rather than ritual. *Opposite:* A monumental image of Lord Bahubali, whom Jainists of the Digambara sect consider an exemplar of forgiveness. Devotees have anointed the feet of this icon daily since 981, when it was erected at Shravana Belgola, India. Their faith is based on six "great vows" or *mahavaratas*, of which the most important is *ahimsa*—not harming any fellow creature.

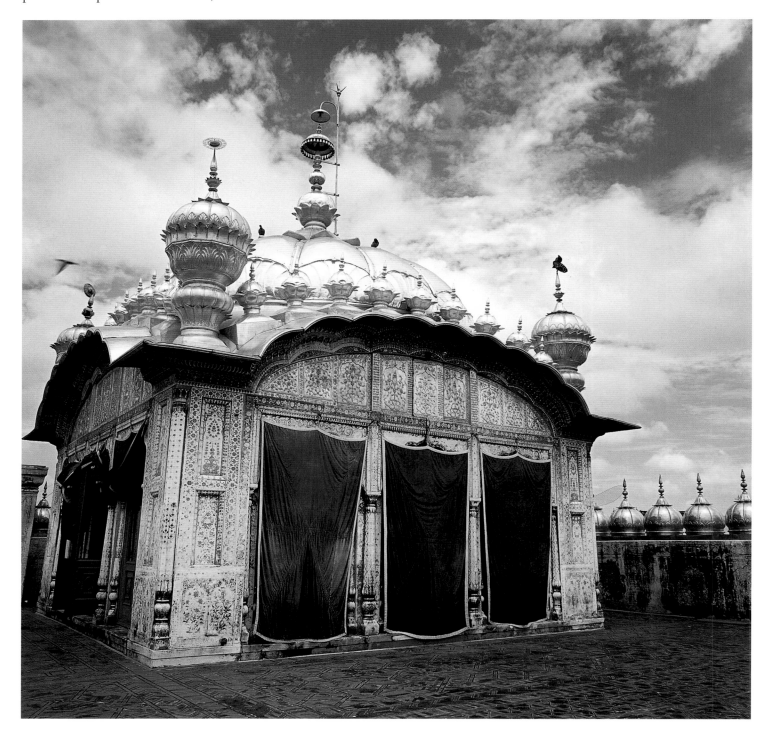

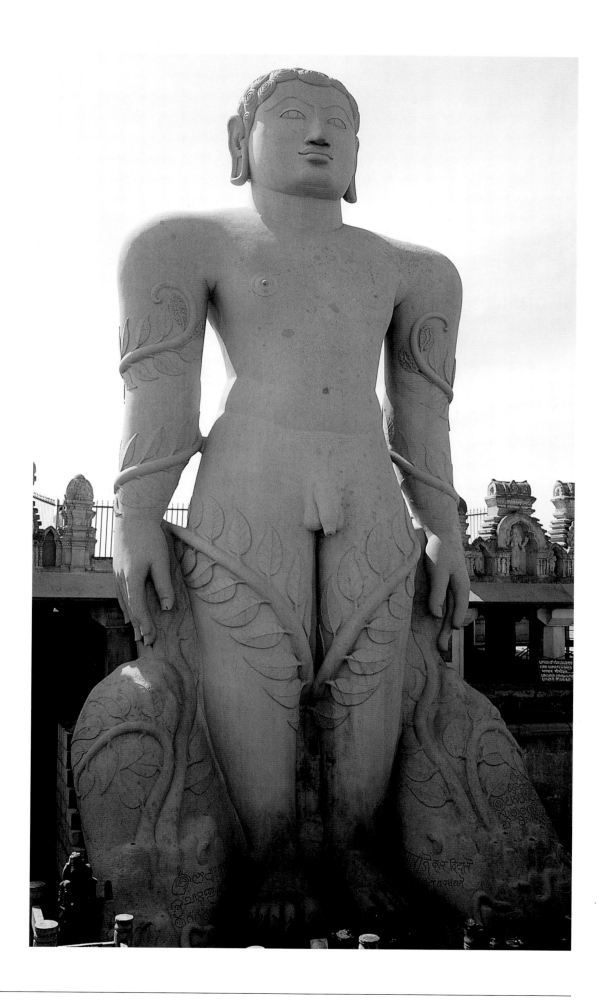

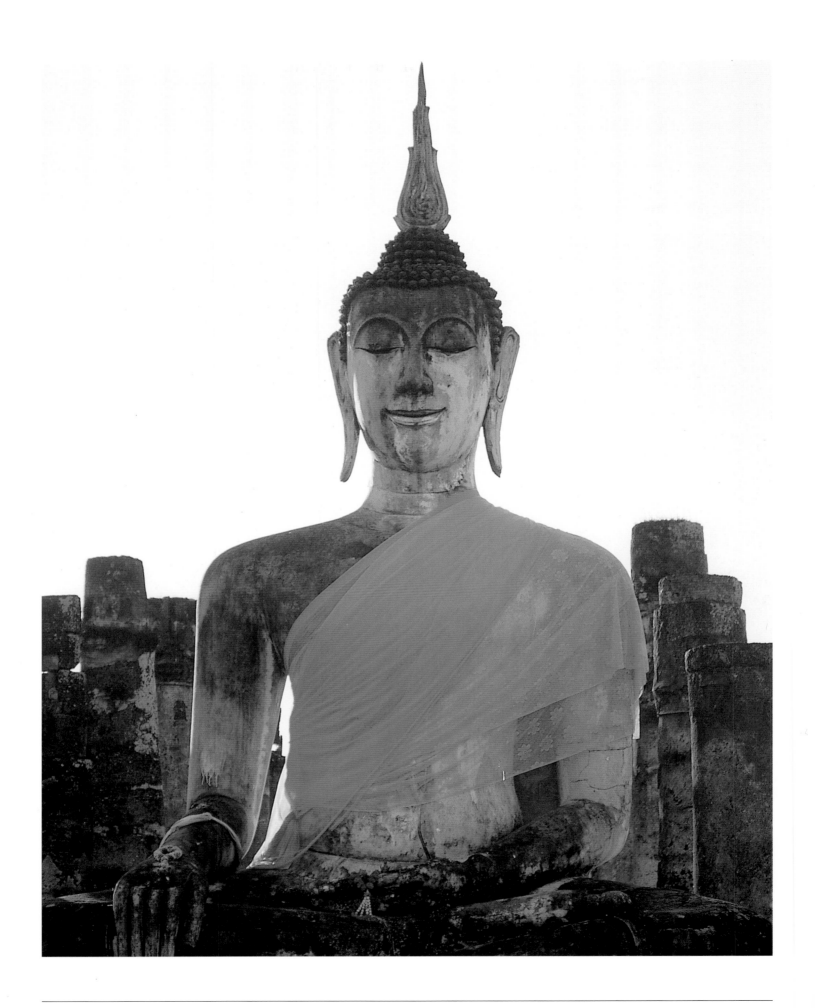

THE BUDDHA AND HIS TEACHINGS

The influence of Buddhism permeated all of Asia, as seen in the many forms of sacred imagery derived from the *dharma*, which originated in India. *Opposite:* This figure of the contemplative Buddha from Lei, India, has serene, inward-looking features; elongated earlobes (symbolizing enlightenment); and a characteristic gesture of the right hand, indicating the defeat of Mara's evil forces. The symbolic "wisdom bump" on the head is crowned by a spire resembling that of the pagoda. *Below:* This Tibetan image of the golden Buddha is in the Tantric tradition, which emphasizes the use of powerful sacred sounds (*mantras*) in meditation leading to attainment of the Buddha-nature.

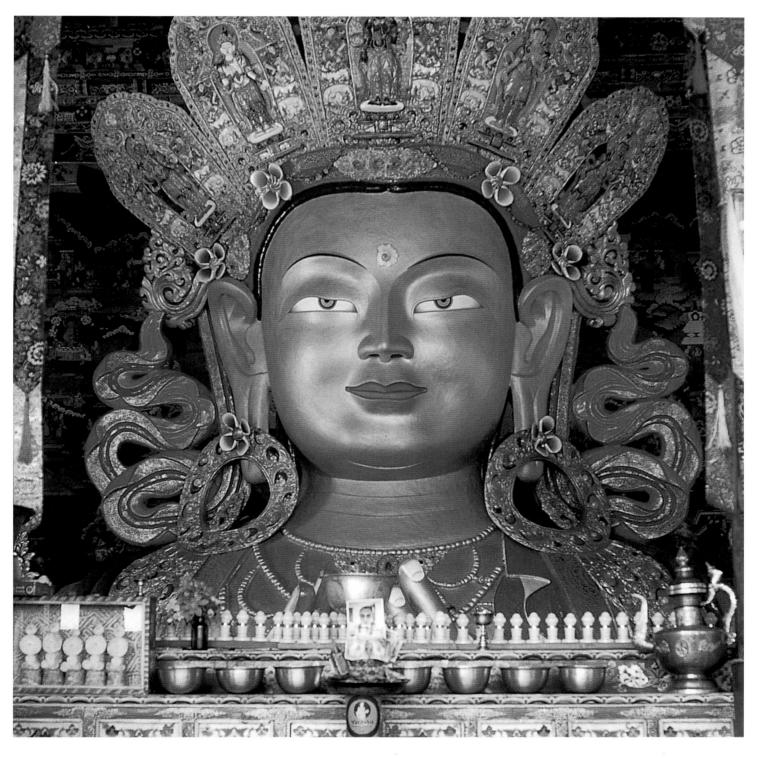

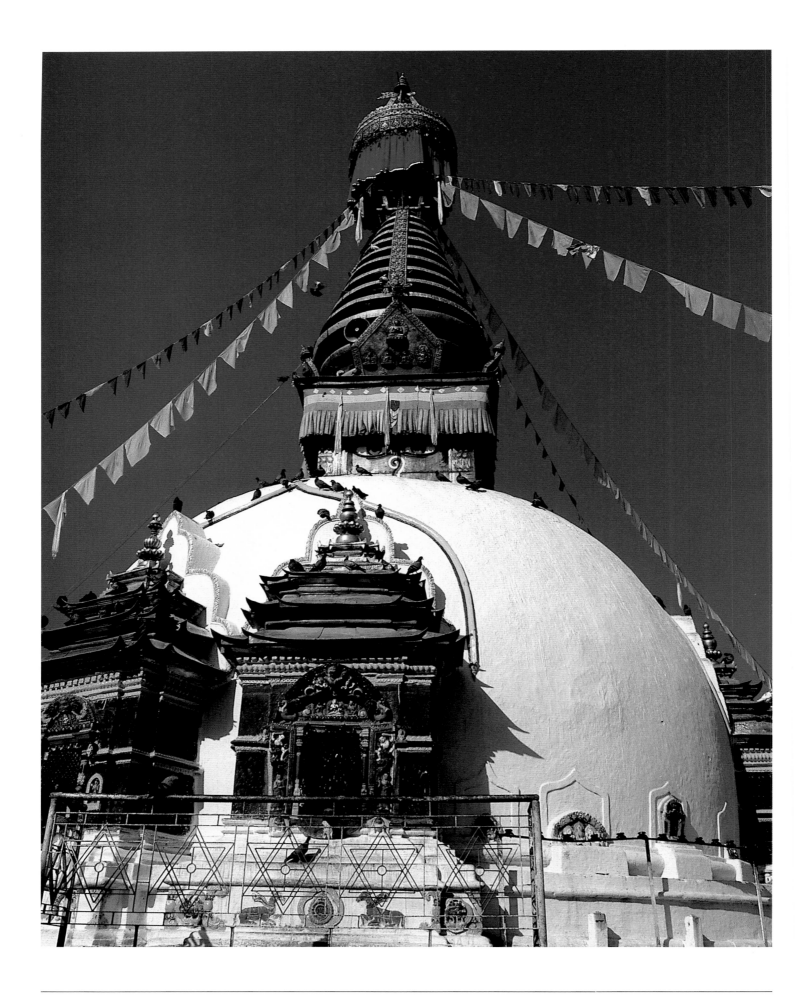

BUDDHIST SHRINES

Buddhism spread rapidly under the patronage of the Indian ruler Ashoka (268–239 BC), and the ancient burial mounds called stupas assumed new forms as reliquaries of the Buddha. In Tibet (*opposite*) they became the *chörten*, with the dome resting on a base with five tiers, symbolizing the five elements of the world. The spire is crowned by an image of the sun above the crescent moon—wisdom and compassion—and the prayer flags carry believers' prayers toward heaven. In Thailand (*below*), the stupa is bell-shaped, and the elegant spire tapers to a point. Jeweled and gilded images of celestial beings surround the central shrine.

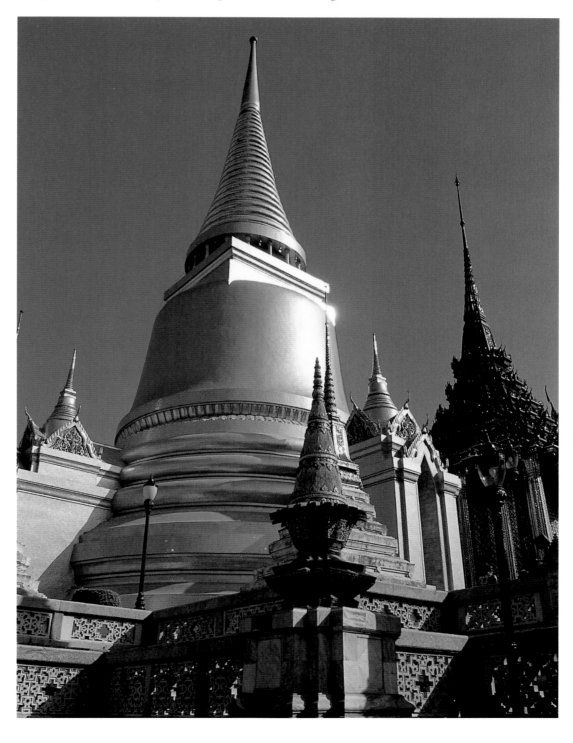

BODHISATTVAS: BUDDHAS-TO-BE

These enlightened beings, who choose not to pass into nirvana so that they can help those still suffering through the cycles of rebirth, are deeply revered. In Tantric Buddhism, Manjusri, the bodhisattva of wisdom (*below*), takes on a frightening form to wield the sword of wisdom against ignorance. *Opposite:* Typical of Mahayana (Great Vehicle) Buddhism is this serene Tibetan figurine of a crowned bodhisattva in the meditational posture; he is depicted with hands clasped in prayer and upraised in the *mudra* of the Buddha's teaching.

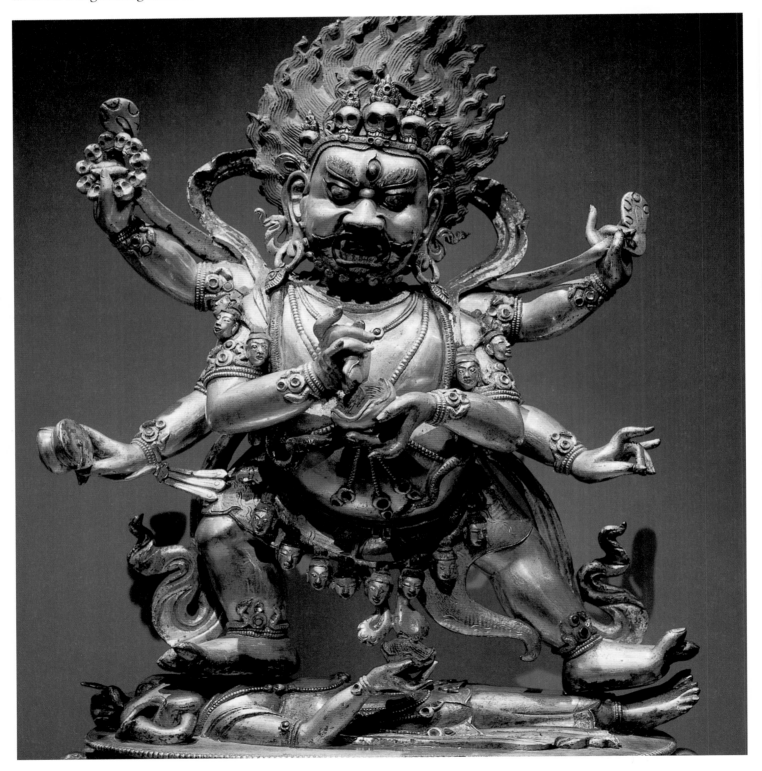

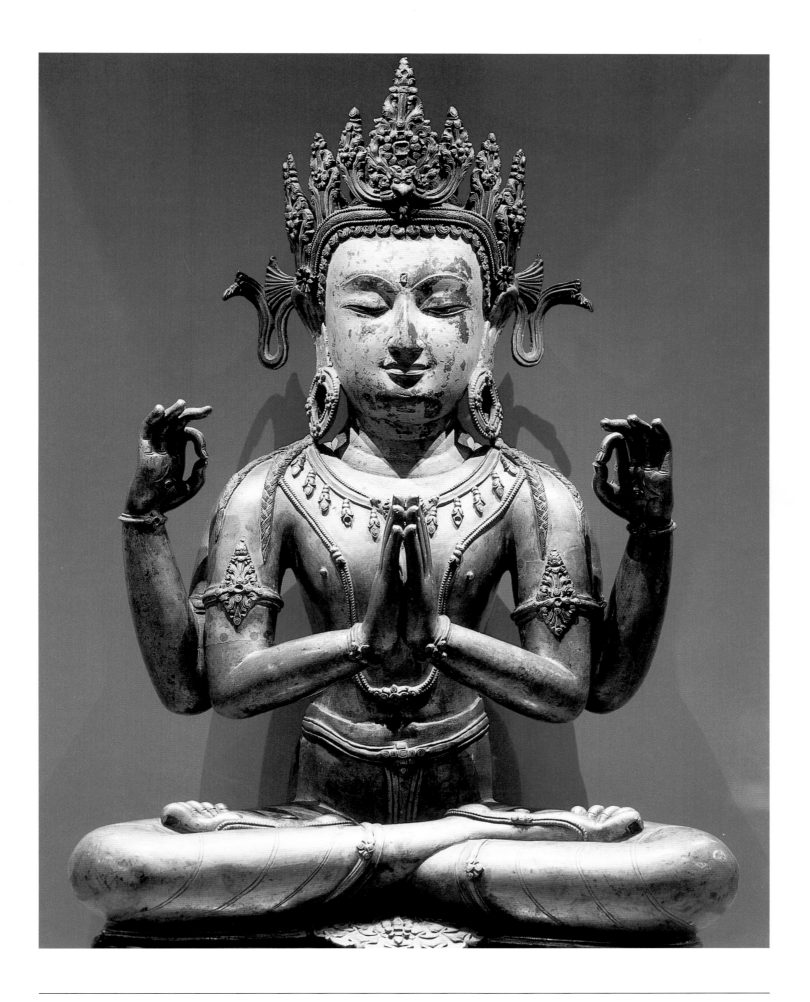

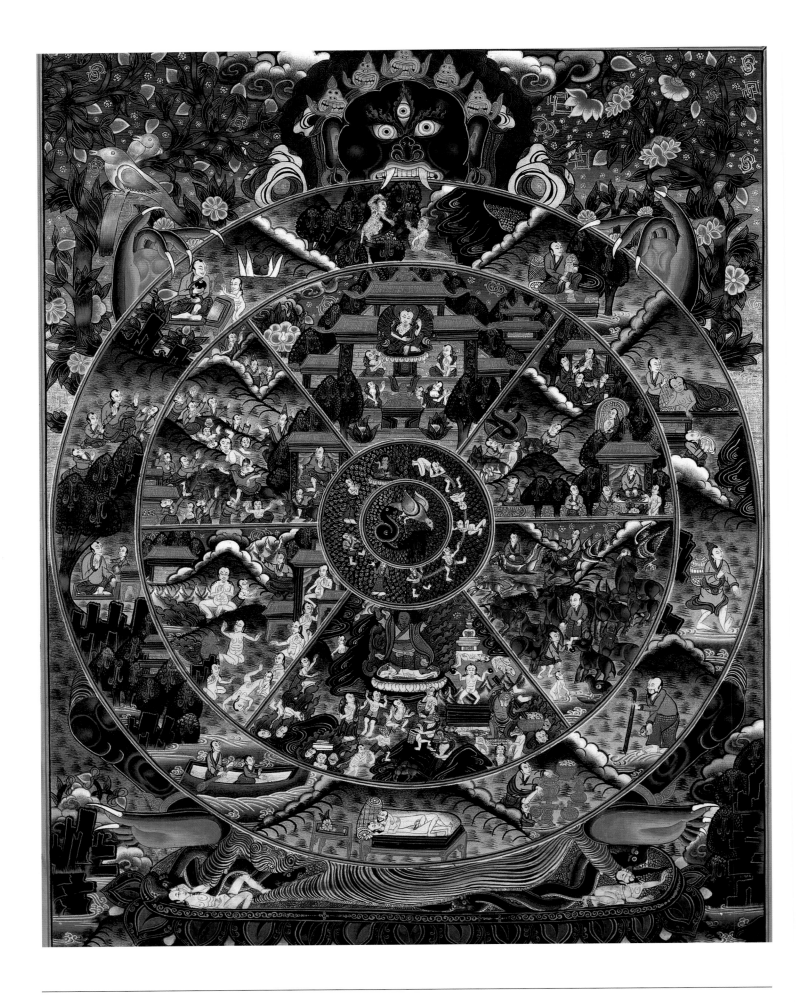

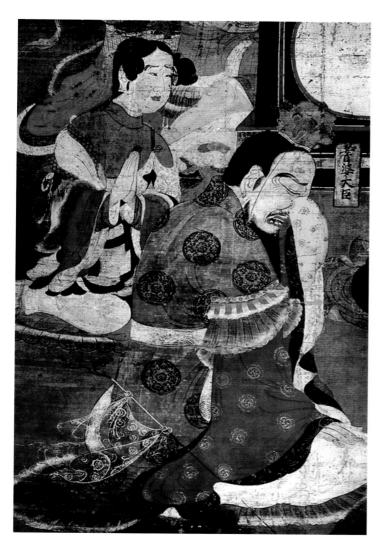

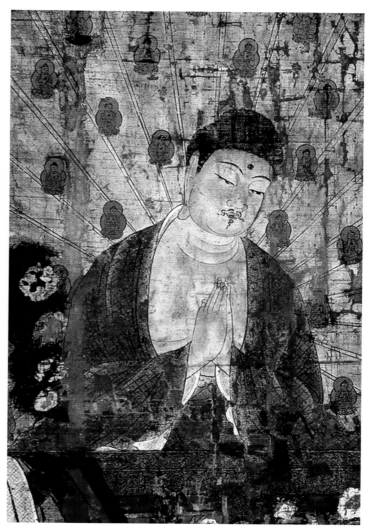

THE BUDDHIST COSMOS

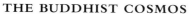

This Buddhist mandala (*opposite*) symbolizes the Wheel of Life, grasped by the frightful Yama, lord of death. At its center are the three creatures that symbolize the great sins of greed, hatred and delusion. The six spheres of existence into which beings can be reborn form a patterned wheel that encircles the center on this *thang-ka*—a temple hanging used in meditation. *Right:* Prayer wheels are spun to release petitions and praise to the heavens. *Above:* Mourning disciples attend the Buddha at his death, followed by his ascension to the Tavatimsa heaven, where all suffering is at an end.

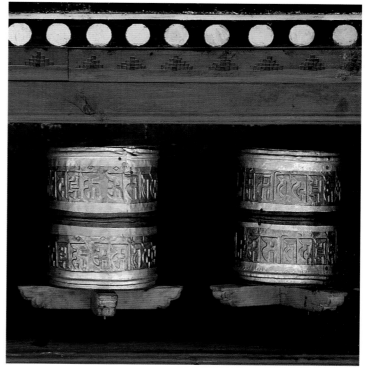

A BUDDHIST STRONGHOLD

The world's largest Buddhist shrine is the magnificent Borobudur, in Java, Indonesia (*opposite and below*). More than a thousand years old, it combines major sacred symbols including the *stupa*, the temple mountain and the mandala of the Wheel of Life. Pilgrims are conducted from the base, which is an emblem of the lower worlds and hells, through the circles of earthly life to the celestial realm at the apex of the monument.

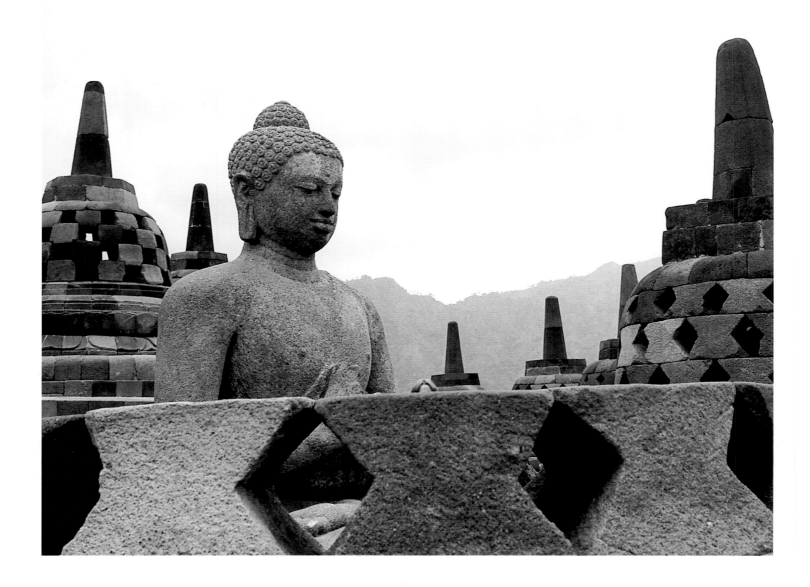

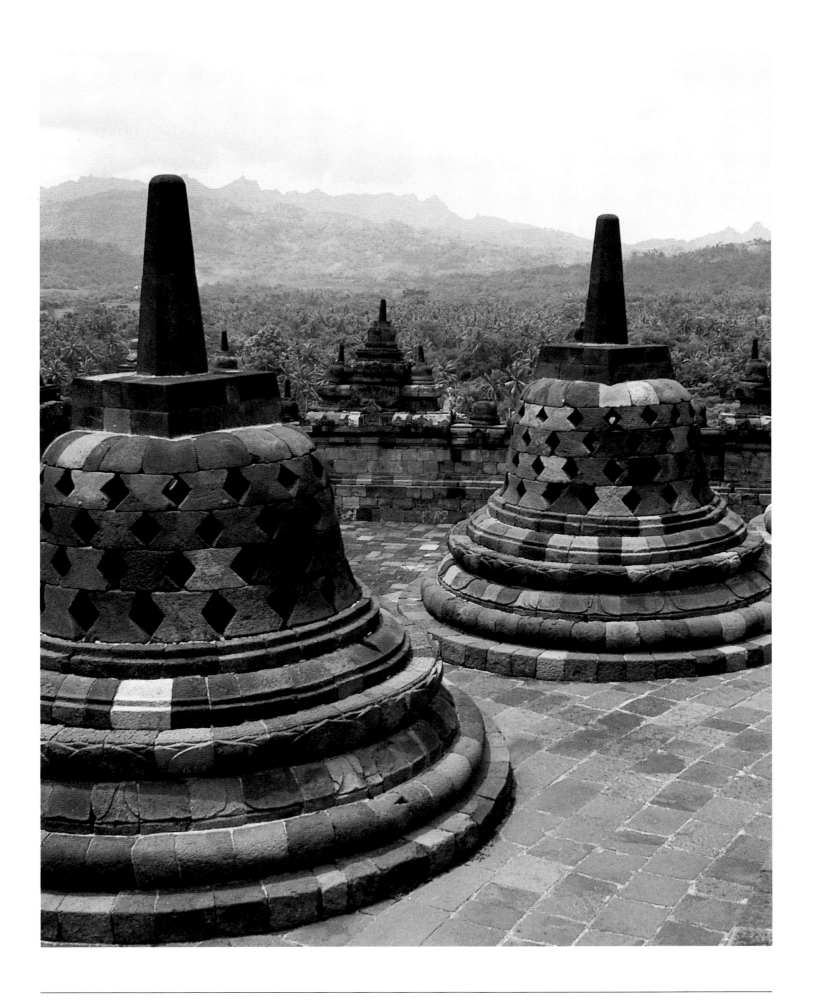

RELIGIOUS SYNCRETISM IN THE FAR EAST

The benevolent Chinese folk goddess Kuan Yin (*opposite*)—known to Japanese Shintoism as Kannon—was transformed over time into a royal bodhisattva of compassion whose symbols include the jewel of sovereignty, indicated by her left hand; the cosmic mountain; and a flowering branch. *Below:* The pre-eminent Japanese goddess Amaterasu, deity of the sun and ancestress of emperors according to Shinto belief. Her shrine at Ise has been the nation's most important since the first century AD.

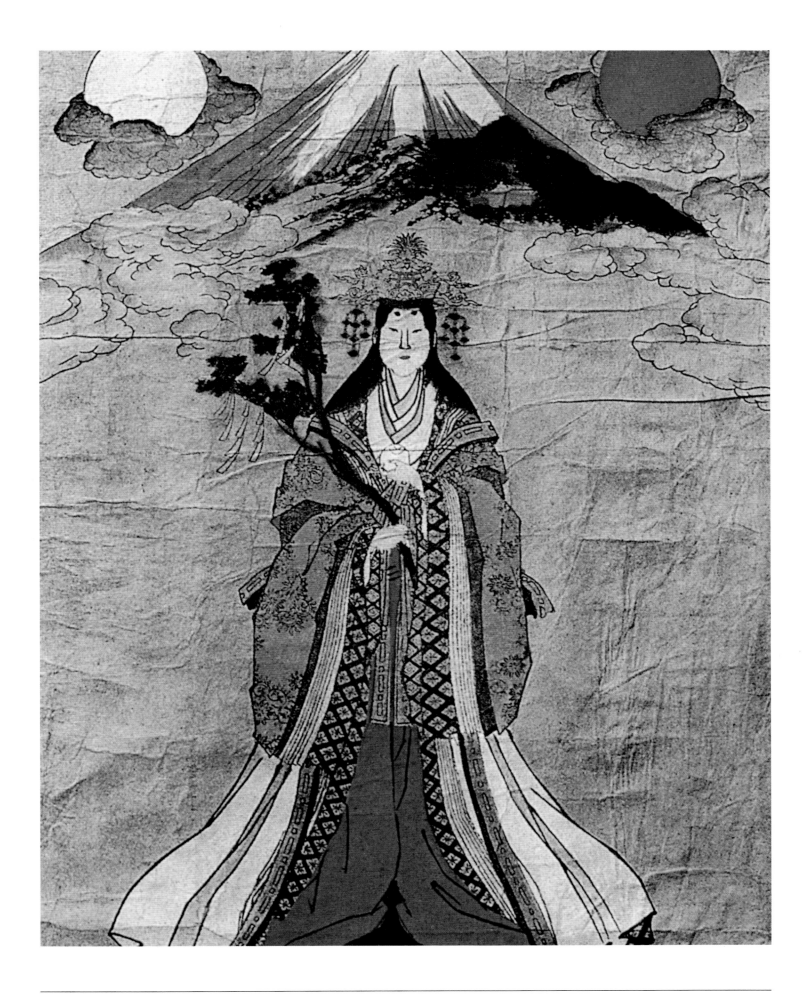

ZEN AND SHINTO SANCTUARIES

Indigenous Shintoism and imported Buddhism joined hands in the Japanese islands, where spiritual seekers may find themselves equally at home in a Zen Buddhist meditation garden (*below*) or a Shinto shrine (*opposite*) with the traditional torii gateway: twin columns crossed by two beams, symbolizing the division of sacred from secular concerns.

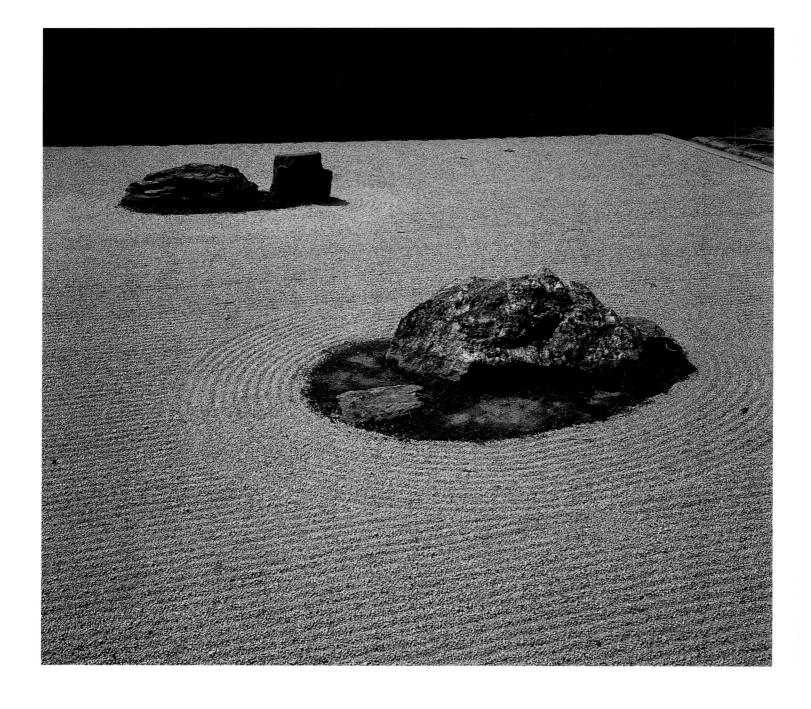

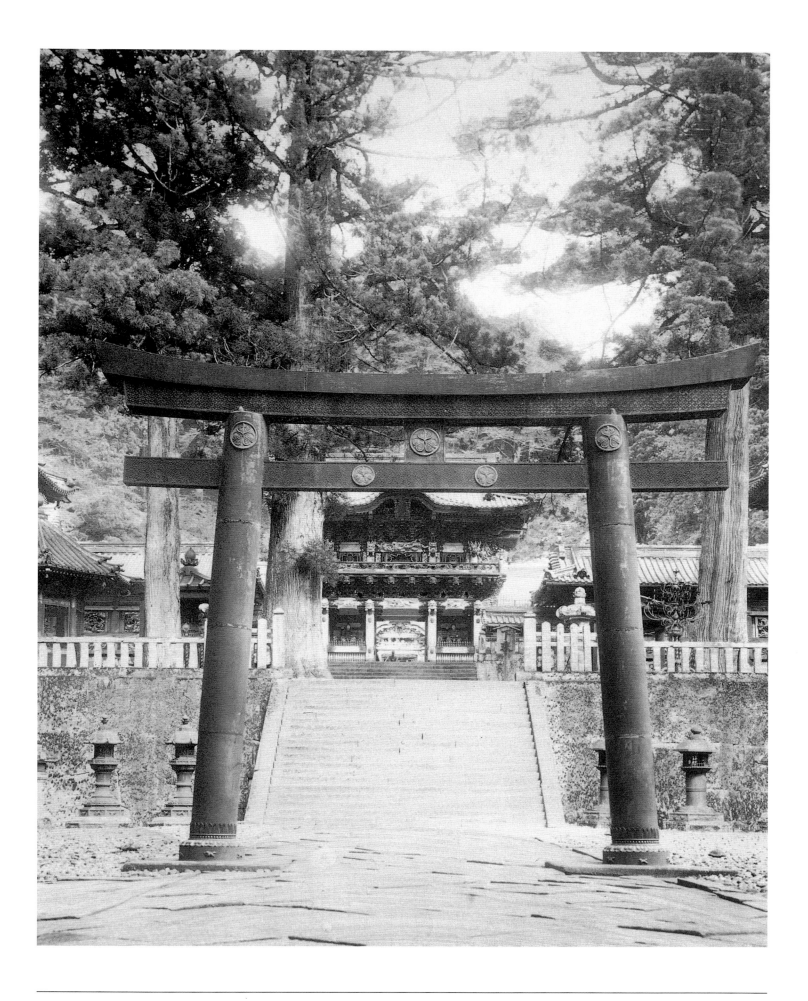

Judaism, Christianity and Islam

The three great monotheistic religions of the world, Christianity, Judaism and Islam, share many theological characteristics: they have their origins in the Middle East and express belief in one God, whose commandments encompass almost every facet of life. Christianity has its roots in Judaism, and both traditions believe that the books of the Old Testament are sacred. Early Christians, most of whom were Jewish by birth, added the New Testament to the scriptures.

The word *Islam* can be translated as "submission to God," called Allah. The Creator is an omniscient divine being, who shows both justice and mercy to those who seek him. The primary credo of Islam is: "There is no God but Allah, and Muhammad is his prophet."

The sacred imagery of each faith is connected to three main strands of religion: the word of God as revealed in holy scriptures; the life and works of the great prophets of each religion; and the sacred rituals and ceremonies of worship. Muslims, Christians and Jews all regard the history of their faiths as essential, and without some knowledge of the scriptures and tales from the Qur'an, the Bible and the Torah, their sacred imagery is less meaningful. Such ceremonies as the Jewish Passover, the Muslim Haj and the Christian Eucharist re-enact historical events crucial to their respective faiths.

JUDAISM

The Judeo-Christian tradition has inspired some of the greatest artists in history, and the iconography of these ancient beliefs is among the world's most widely disseminated.

Observant Jews believe that they are descended from the Patriarch Abraham (or Abram), with whom God made a covenant. He and his offspring were promised possession of "a land flowing with milk and honey"—the Promised Land—to set them apart from those who worshipped many gods. In time, God would send a Messiah to redeem the people and judge the nations. The Jewish religion is based on God's revelations in the *Torah*—the first five books of the Bible, which were interpreted to contain 613 commandments central to Jewish life. Moses received the original Ten Commandments from God on Mount Sinai and inscribed them on stone tablets that were placed in the Ark of the Covenant. Consequently, Moses, who led the Israelites out of slavery in Egypt and took them to Palestine (later Israel), is regarded as the pre-eminent Jewish prophet. Jews believe that the commandments are intrinsic to their covenant with God, and that by adhering to their laws of morality, ritual and everyday life, they are fulfilling their role as God's chosen people.

Exile from the Promised Land, or *galut*, has been a recurring feature of Jewish history: the people have never enjoyed undisputed possession of the land for long. Their Diaspora through Europe and the Mediterranean region ensured that Judaism, along with the Greco-Roman tradition, would become an important influence on the development of Western religion and culture. However, the various styles of Jewish sacred art and architecture usually reflect the influence of the larger community. Synagogues, for example, although they conform to certain religious laws of design and orientation, may be built in any architectural style.

Opposite: A seventeenth-century Turkish miniature showing Muhammad and his father-in-law, Abu Bakr, one of the four caliphs who succeeded him as spiritual leaders after his death. Consistent with Islamic tradition, Muhammad's face is not shown.

Right and below: *Primary symbols of Judaism include the six-pointed Star of David, the seven-branched candelabrum called the menorah and the richly ornamented Torah mantle that covers the sacred scrolls of the Law.*

The great sacred symbols of Judaism are unchanging and serve to recall a 4,000-year-old heritage. "Graven images," especially three-dimensional depictions of Yahweh (God) or human beings, were forbidden under Jewish religious law for fear of idolatry. Thus the creation of ritual objects for use in worship became the most important outlet for artistic creativity: candlesticks, jewelry, spice boxes, the Ark housing the Torah scrolls and illuminated manuscripts. All of these items are relatively portable—the products of a culture prone to migration and expulsion. Because of the proscription against "graven images," the overwhelming majority of painting, sculpture and illustrated manuscripts depicting the history of the Jewish peoples before the rise of Christianity has been created by Christian artists, whose images thus reflect a single Judeo-Christian tradition.

One of the best-known Jewish sacred images is the *menorah*, the seven-branched candlestick whose specifications were given to Moses by God on Mount Sinai. The original, which was kept in the Temple of Jerusalem, was made of a single piece of gold: its seven holders and three joints represent the unified and unchanging world of the ten *sefirot*, or God's attributes. The central trunk is the Pillar of Equilibrium; on the right is the Pillar of Mercy, on the left, the Pillar of Severity.

The Wailing Wall in Jerusalem is now one of Judaism's holiest sites. It is all that remains of the magnificent Temple built originally by King Solomon to house the Ark of the Covenant. Destroyed and rebuilt twice, the western wall is all that stands of the building constructed by Herod the Great and destroyed by the Romans in AD 70. A major pilgrimage site, the faithful travel there to lament the loss of the Temple and the lives of those who fell to persecution. They believe that when the Messiah comes, the Temple will be rebuilt and project the glory of God to the world.

Synagogues still reflect many of the original Temple rituals. The buildings are oriented toward Jerusalem, and the cupboard in the east wall containing the scrolls of the Law is known as the Ark, for the Ark of the Covenant. Before it hangs the eternal light, a lamp or candle that represents God's eternal presence and recalls the *Ner Tamid*, the candlestick that burned perpetually in the Temple at Jerusalem. Incense was used in the Temple as a sign of divine presence: its fragrant smoke also represents prayers rising to heaven.

The ancient *magen David,* the six-pointed star of David, is still a powerful symbol. Traditionally, David carried a hexagram-shaped shield when he fought the giant Goliath before he was anointed king. A sign of Jewish identity, the star is used on the pall

at funerals and on other ritual artefacts. The Jews of Germany and Eastern Europe were forced by the Nazis to wear the yellow star as a badge of persecution, and it is now displayed with pride upon the flag of the state of Israel.

CHRISTIANITY

The sacred imagery of Christianity draws upon both the Old and New Testaments, other sources on the life and teachings of Christ, the lives of saints and martyrs, and the rituals and traditions of the faith.

Christians focus on the life, death and resurrection of Jesus Christ, whom they believe to be the Messiah—the Savior of the world. His life and works are recounted in the Bible's New Testament. He told His followers that God had sent Him to earth to save mankind from sin and death, the consequence of sin. This could be achieved by accepting God's love and obeying His commandment to love one's neighbor. Christ emphasized His divinity, yet also called Himself the "son of man," a phrase Jews understood to mean "One who is born to die, but who will be saved beyond death." His reward for preaching this deceptively simple doctrine was defamation and execution, but the great miracle of His resurrection three days after His crucifixion is seen by Christians as the ultimate proof of God's love for humanity.

The life of Christ provides the four basic doctrines of Christianity: the Incarnation (that God became human in the person of Christ); Christology (that Jesus was the perfect exemplar of virtue); the Trinity (that God is revealed through Christ as Father, Son and Holy Spirit) and the Atonement (that humankind is destined for eternal life through Christ's self-sacrifice on the cross).

Today, the most common and visible symbol of Christianity is the cross, the emblem of Christ's saving death. It was adopted as a

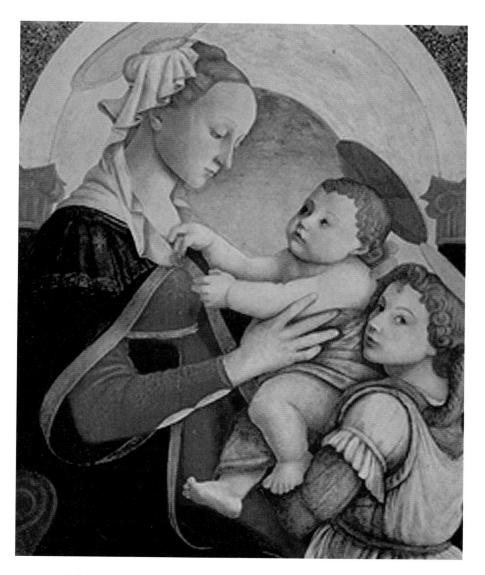

sign of faith by the Roman emperor Constantine in the fourth century and gained ascendance as the early persecution of Christians gave way to acceptance. The triumph of western European culture ensured that the Christian images that dominated Western art until the seventeenth century were widely known. Ironically, however, Christian art was almost non-existent during the first three centuries, partly because of the inherited Jewish prohibition on images of God, and partly because the early church fathers feared that pictorial representations of the Creator might become objects of worship, as in paganism. Even when pictorial art had become more accepted, some theologians still warned against the dangers of idol-

Above: In Botticelli's Virgin *(1465), a devout and modest Virgin Mary clasps the Christ Child, who was often painted with an expression serious beyond His years to signify his destiny as redeemer of the world.*

This debate reached its peak in Byzantium with the iconoclastic controversy of the seventh and eighth centuries. The iconoclasts had denounced the use of images as inadequate representations of an object of worship. Eventually, it was agreed that as God had revealed Himself to humanity in the form of his only Son, then surely He should be willing to receive veneration inspired by images. It was clear that the images themselves were not the objects of worship. This decision had profound effects upon the use of art in churches, especially in the Eastern Orthodox communities of the Byzantine Empire. No longer were paintings regarded as mere illustrations for the illiterate, but as reflections of the supernatural world.

Religious art in Byzantium developed around a number of traditions and restrictions that resulted in a highly stylized form of iconography. For example, all icons have golden backgrounds, because this color represents heaven; they are usually two-dimensional, because they are regarded as "windows on eternity," enabling the faithful to see the numinous from an earthly perspective. The

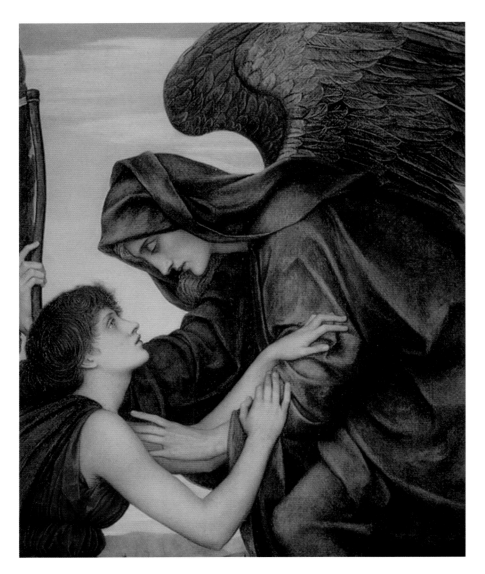

Above: A Pre-Raphaelite angel by English painter Dante Gabriel Rossetti, a cofounder of the nineteenth-century Brotherhood that drew inspiration from the medieval classic The Divine Comedy. *The angel is depicted as guardian and guide.*

Right: The triumphant risen Christ sees His enemies in disarray in this illumination from a medieval Book of Hours.

atry, as seen in the clash over iconoclasm— the breaking of images. As Asterius, Bishop of Amaseia, warned in the early fifth century: "Do not picture Christ on your garments. It is enough that he once suffered the humiliation of dwelling in a human body which of his own accord he assumed for our sakes. So, not upon your robes, but upon your soul, carry his image."

At the end of the sixth century, Pope Gregory the Great reminded his scholarly advisors that most Christians were illiterate and that sacred art could teach and reinforce the faith: "Painting can do for the illiterate what writing does for those who can read." His opinion had an immense effect on the history of art.

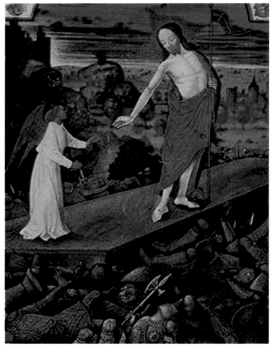

traditional image of Christ as a long-haired bearded figure derives from the apocryphal Letter of Lentulus, a Roman consul who was in Palestine at the time of the Crucifixion. In his letter to the emperor, he reportedly included a description of Jesus, which Byzantine artists later used as their model.

The Western Church did not agonize long over such knotty theological problems, and its development of sacred art continued without the stylistic strictures imposed on Byzantine art. Early Christian representations of the Savior, for example, were influenced by the ancient Greek tradition of depicting perfect human bodies: Christ often appears as a youthful, heroic figure, surrounded by older apostles who bear an uncanny resemblance to Greek philosophers. The more familiar bearded, careworn figure is a later stylistic development.

During the first Christian millennium, art was used in a variety of ways in both churches and manuscripts: to depict scenes and tales from the Bible, as in missals, psalteries and monastic manuscripts; as an aid to devotion, with images of holy persons offered for veneration (icons); or to present the central doctrines of the church (large-scale murals or wall decorations). It was not until the emergence of more stable governments throughout western Europe from the tenth century onward that patronage by royalty and wealthy nobles encouraged the production of the great paintings familiar to students of Western art.

Christian art soon developed a visual shorthand to assist the faithful in interpreting the great friezes and frescoes that adorned churches around Christendom. The images were inspired by the Trinity and the saints, and ideally, the Christian at prayer would be surrounded by pictorial representations of his faith. Fish, for example, were important symbols as an emblem of Christ and the apostles; the Virgin Mary often wore blue robes, as the

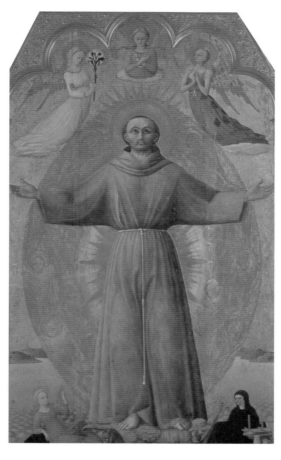

Left: One of Christendom's best-loved saints, Francis of Assisi, depicted in ecstasy by the Renaissance painter Sassetta in 1437. The oval-shaped aureole that surrounds him is a sign of heroic sanctity.

color blue symbolized purity, the sky and, by extension, heaven; St. Peter's name often included visual puns with stones, because his Latin name, *Petrus*, meant "rock"; St. John the Baptist, who referred to Christ as *Agnus Dei*, or the "Lamb of God," is often shown with a lamb, or against the desert background where he prepared for his role as the herald of Christ's coming.

It was during the late Middle Ages and, notably, the Italian Renaissance that Christian art really broadened its scope, and symbolism became more complex and far more widely understood. Growing prosperity led to widespread artistic patronage throughout Europe, and patrons themselves were generally better educated than their forefathers. The great bankers and merchants of Italy, the territorial princes of France and Germany and the nobility of England upheld the ideals of a courtly lifestyle, surrounding themselves with beautiful possessions. It was an age of

"conspicuous consumption," but they also tried to ensure their places in the hereafter by commissioning sumptuous religious paintings, buildings and artefacts.

Sacred imagery became more lavish and was no longer confined to churches. Books of Hours—small prayer books, beautifully illuminated with devotional images—became popular among the nobility, and patrons commissioned pictures for their homes. Artists produced works that assumed some knowledge of a particular Biblical text or story, and used conventions that would be understood by their audience. Mary Magdalene, for example, is often shown carrying a jar of herbs, as she prepared Christ's body for burial after the Crucifixion; St. Francis of Assisi is easily identifiable by his brown robes, the small animals surrounding him and his stigmata; the girdle of the Virgin Mary represents purity, and is also an attribute of the doubting apostle Thomas, to whom legend says she threw it as evidence of her assumption into heaven.

A far more public display of religious patronage during the medieval era was the endowment of a church, cathedral or abbey. The very shape and orientation of Christian churches is full of symbolism The ground plan is usually in the shape of a cross, and entrance is through the west door, which affords a perfect view of the altar and sanctuary at the far end of the building in the east, the direction of the Resurrection. The altar, where the Eucharist, the re-enactment of the Last Supper, is celebrated, is usually slightly raised and may have a richly decorated altarpiece behind it, with images of Christ in glory.

Below: Saints and martyrs robed in the symbolic fleurs de lis*, an emblem of the Trinity, are strengthened by the Father, Son and Holy Spirit in this painting by Bellechose (1416).*

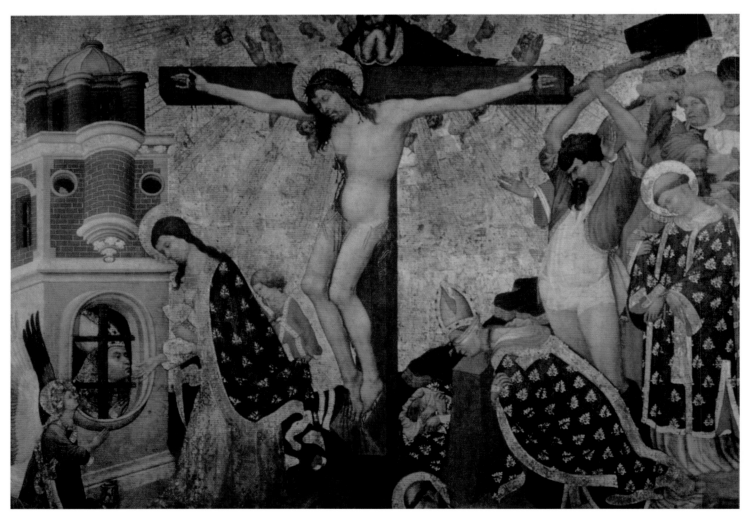

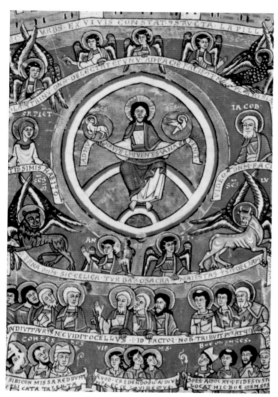

Medieval churches and cathedrals incorporate soaring vaults that draw the eyes and minds of the faithful toward heaven. "By the grace of God I can be transported from that inferior to that higher world," wrote the twelfth-century Abbot Suger, initiator of the first Gothic church, the Abbey of St. Denis, near Paris. They are decorated with carvings, murals and sculpture illustrating Biblical tales and the lives of Christ and the saints that helped the laity to understand the mysteries of their religion. Medieval churches that may seem almost colorless today were once far more richly decorated: traces of wall paintings and frescoes long since faded are still visible, but they merely hint at former glories. They were illuminated by candles and by stained glass windows that threw shafts of colored light into the nave and onto the choir and altar. The effect of rays of light filtering through the stained glass into the body of the church seemed like the light of heaven itself, and the power of the stories and images depicted on the leaded windows was reinforced and clarified.

ISLAM

Islam, the third of the three great monotheistic faiths, has produced a very different sort of sacred art. At the heart of Islam is an experience of awe in the one, all-powerful, mysterious creator Allah, and the religion's dominant theme has been surrender to God's will. Not only a religion, but also a way of life and civilization, it proclaims a ritualistic faith and prescribes a code of social, ethical and legal behavior encompassing everything from family life to criminal law, social etiquette and hygiene.

The sacred images of Islam are drawn more from its historical tradition than from the credo itself. Islamic art, like Judaic imagery, has been constrained by the ban on depicting both the divine and (at certain times) the human form, prohibitions that forced artists to create more abstract forms. This is seen in the intricate tiled patterns of mosques, the labyrinthine weaves of pictorial carpets, and the elegant, highly detailed calligraphy of religious texts. Persian, Turkish and Mogul miniatures—diminutive detailed pictures—are deliberately flat and two-dimensional, lacking any real perspective. This style was adopted to ensure that believers were not seduced into confusing imagery with reality.

Muslims believe that they are descended from Abraham via his son Ishmael, the child of Abraham's servant Hagar. Ishmael and his mother were cast out into the wilderness once Abraham's wife Sarah conceived Isaac in old age, but God ensured that Ishmael survived to found a great people.

Islam was founded in the seventh century by the Prophet Muhammad, an Arab merchant (570–632). Born in Mecca, a polytheistic religious and commercial center, he received visions and revelations from God which he began to disseminate among the city's pagan inhabitants. He preached belief in one God (Allah), which brought persecu-

Left: From a medieval Book of Hours: Christ enthroned at the end of time, flanked by the emblems of the Paschal Lamb and the Holy Spirit.

Right: A Turkish miniature showing Eve as seductive temptress, the antithesis of Islamic traditions governing female modesty. All three of the patriarchal "religions of the book" emphasized Eve's role in bringing sin and suffering into the world.

regarded as the explicit word of God. Muslims believe that Muhammad was the last in a line of prophets stretching back by way of Jesus Christ (known as "Isa" to Muslims) and Moses to Abraham. The Qur'an states: "He has revealed to you [Muhammad] the Scripture with truth, confirming what was before it, just as he revealed the Torah and the Gospel." Muslim scripture teaches that all of the earlier prophets (including Christ) were simply human, and Muhammad himself stressed his own humanity. After his death, however, his followers elevated him into the archetypal Perfect Man, basing their own lives on his words and actions, as recorded in the Sunna. He is still revered so highly that no Muslim will hear any criticism of him, and when his name is mentioned, it is always followed by the invocation "peace be upon him." Islam prohibits pictorial representations of the Prophet: if he does appear, his face is usually covered by a veil or mask.

The ban on the representation of living things seems to have originated in the eighth century. Its justification was that God alone can create living creatures: humans who do so compete with God. According to the Prophet (but not the Qur'an), artists who have made the image of a living being will have to spend eternity trying to animate it. Their failure to do so will ensure that they are cast into hell. More tolerant believers, including the sixteenth-century Persians and Moguls, allowed figurative art, but avoided naturalism. Images of animals and human figures were traditionally combined with ornamental designs. As a result, Islamic sacred art is used mainly to transform the worship space and to inspire contemplation among the faithful. By excluding living beings from the design of mosque interiors, believers are forced to focus upon God, aided by the abstract forms and unbroken rhythms of the ornamentation.

tion by his fellow citizens, who feared that Muhammad's new faith would drive away the lucrative pilgrim traffic to their ancient shrine, the Ka'ba. Muhammad continued to receive his divine revelations over a period of some twenty years, from 610 until 632, but in 622 he was forced to flee Mecca for the comparative safety of Yathrib (now known as Medina). This journey, which came to be known as the *hejira*, marks the beginning of the Muslim era. During the next ten years, Muhammad organized his followers, transforming them from a small religious group into a powerful political force that ruled virtually all of western and central Arabia by the time of the Prophet's death. Perhaps most importantly, he had conquered Mecca, the site of the sacred Ka'ba, which was rededicated to the worship of Allah and became the spiritual center of the new faith.

Muhammad's revelations are expounded in the Qur'an, Islam's sacred text, which is

The Arabic language is highly important to Islam, which began in a nomadic society whose only cultural treasure was its language. The verses of the Qur'an dominate Muslim life in the form of invocations, praises and litanies, which is one reason why calligraphy became an important art form. Sacred art draws heavily upon the Qur'an, whose verses decorate innumerable artefacts from swords to ceramics. The *Shahada*, the Muslim declaration of faith, which proclaims "There is no God but God and Muhammad is his prophet," is often inscribed on the tiles of mosques and in manuscripts, or woven into carpets. The opening words of every chapter in the Qur'an, "In the name of Allah, the compassionate, the merciful," are another recurring theme.

Complex and beautiful carpets have been produced for centuries by Muslim artisans. Their decoration is usually floral, and based on the image of the scriptural paradise, "a garden traversed by rivers." The perfect carpet is believed to represent the cosmos, with its various forms woven into a harmonious whole.

Architecture is another important aspect of Islamic sacred imagery. The dome of a mosque represents the cosmos or heaven, while the minaret is symbolic of Allah's supremacy. The focal point of every mosque is the *mihrab*, a small arch or niche on carved columns that indicates the direction of Mecca, which Muslims must face when they pray. The *mihrab*, often intricately decorated, is inscribed with the *Shahada*. Many of the oldest have shell-shaped canopies, recalling the Prophet's statement that the world was created from a white pearl, and the shell enclosing the pearl is like an ear poised to receive the word of God. Thus the pearl is an enduring symbol of the Divine Word.

Left: An Islamic miniature showing ritual ablutions before prayer against a background of floral and geometric designs typical of mosque ornamentation.

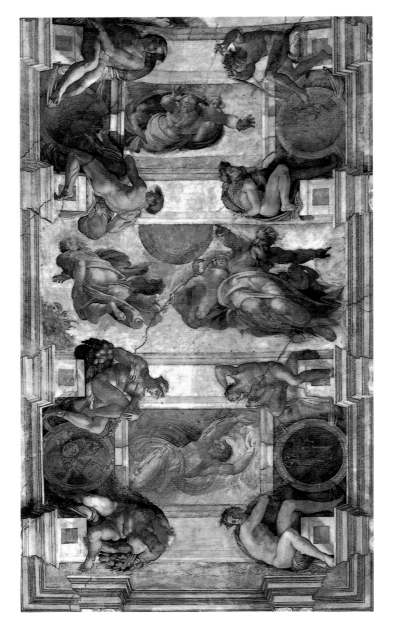

IN THE BEGINNING

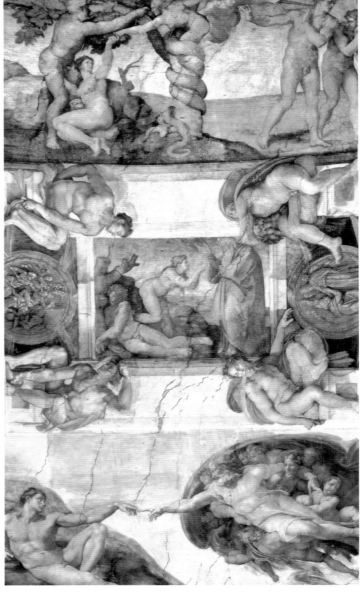

THE FALL FROM GRACE

These famous scenes from Michelangelo's Sistine Chapel frescoes capture the Judeo-Christian creation story, as recounted in Genesis. Above is *The Creation of the Sun, Moon and Planets*. The second panel (last scene) shows *The Creation of Adam*. Both images illustrate the symbolic power of "the right hand of God," often referred to in the Bible, which is extended to endow his creations with life. God the Father, a majestic, awe-inspiring figure, calls forth the lights of heaven and forms Adam in His own image and likeness.

In Michelangelo's *Temptation and Expulsion* (*above*), the serpent has the head of a woman, and a cherubim drives Adam and Eve from the Garden of Eden into the harsh, unknown world beyond it, now tainted by sin. Raphael's depiction of the Fall (*opposite*) shows Adam accepting the forbidden fruit from Eve, who has been duped by the serpent. The tree, often misidentified as the "Tree of Knowledge," was originally described as bearing the fruit of "the knowledge of good and evil," because to know, in Hebrew, means to experience evil in defiance of God's command.

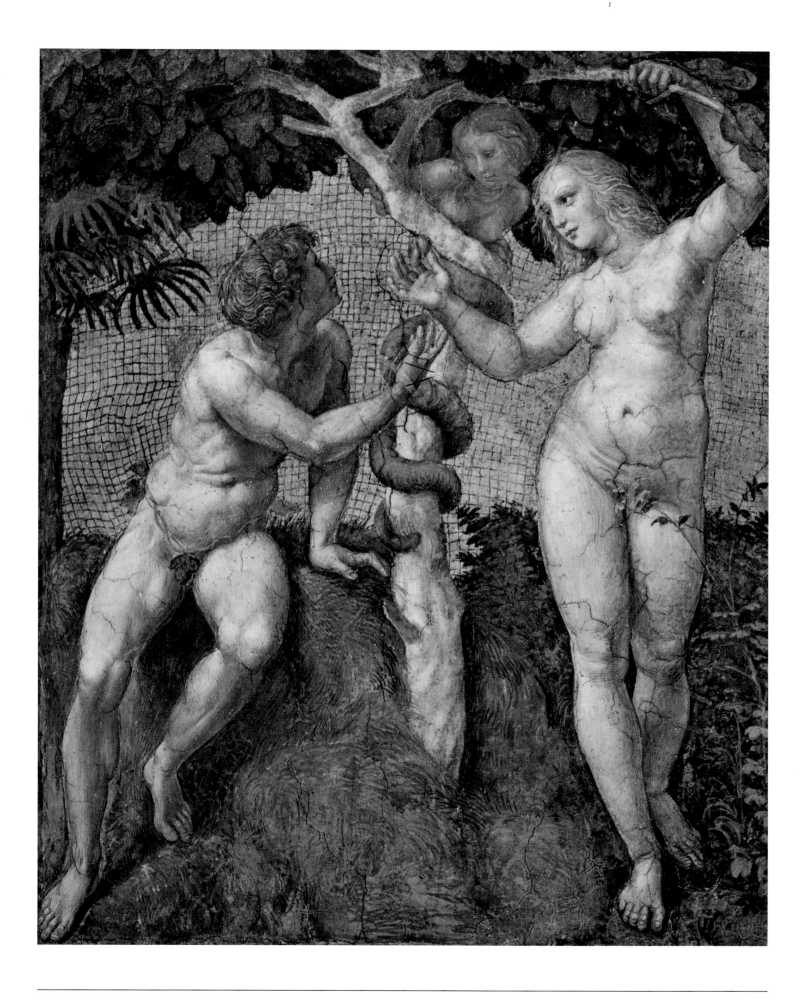

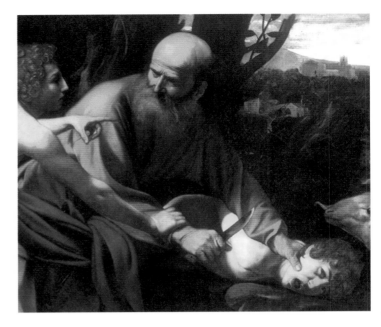

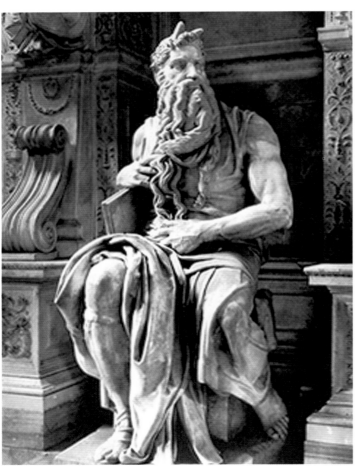

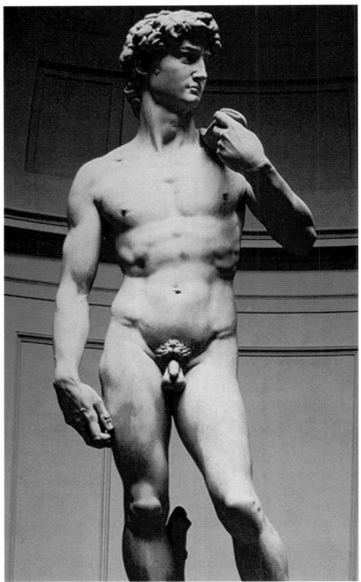

OLD TESTAMENT TALES

The stories of the Old Testament have provided artists with richly symbolic themes as seen in these Renaissance works. Veronese's *The Finding of Moses* (*opposite, top left*) shows the recovery of the infant Moses from the Nile by the pharaoh's daughter. Moses was commanded by God to lead the Children of Israel out of slavery, and Michelangelo's sculpture (*opposite, below left*) shows him grasping the stone tablets of the Ten Commandments in his right hand, emphasizing his role as transmitter of the Law. The artistic tradition of depicting Moses with horns stems from ancient translations of the Bible that described horns of shining light radiating from his head.

Caravaggio's powerful *Sacrifice of Isaac* (*opposite, top right*) recalls how the faithful Abraham was prevented from sacrificing his son Isaac at the last moment by the intervention of the archangel Michael, sent by God.

Titian's *David and Goliath* (*below, right*) shows David raising his hands in thanksgiving after slaying the brutal giant Goliath. Michelangelo's *David* (*opposite, below right*) depicts the shepherd king in classical Greek style, as the ideal of human youth and beauty.

The hero of the Flood, Noah (*below, left*) was also the first vintner. This carving from 1470, with its symbolic grapevines, shows his shame after the episode described in Genesis: "He drank some of the wine and became drunk, and he lay uncovered in his tent." His son Ham told the story to his brothers, who covered Noah with a cloak, walking backwards so as not to see their father naked.

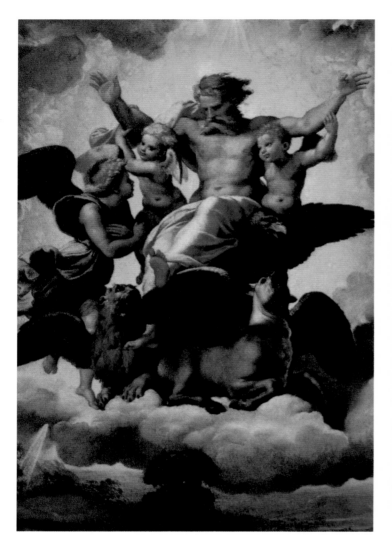

MESSENGERS OF GOD

The Old Testament prophets were impelled by their God-given foresight to warn the Jews against idolatry and other sins that betrayed the Covenant. Courageous visionaries, their predictions of events to come combined warning and exhortation to repentance.

Raphael's masterpiece *The Vision of Ezekiel* (*above*), painted in 1518, depicts the prophet's ecstatic vision foretelling the coming of Christ, with the four Evangelists in their symbolic forms of winged animals and a man (St. Matthew).

In the Sistine Chapel Michelangelo painted the prophets of the Old Testament as mighty men engrossed in thought, perhaps attending to the voice of God. These enormous frescoes are positioned in the vaulting between the window embrasures. Jeremiah's pensive demeanor (*opposite*) is reflected in the gravity of his genii, in the background. Pessimistic by nature, and tortured by his contemporaries, who failed to heed his message, Jeremiah's name would become a byword for gloom and dire predictions.

Isaiah (*above*) foresaw the fall of the Assyrian Empire that ruled Judah, and predicted that God would make a new beginning for the world, a kingdom ruled by one from the line of David. He is credited with foretelling Christ's coming, although his Messiah takes the form of the suffering servant, not the worldly king anticipated by the Jews.

OLD TESTAMENT FIGURES

Jews and Christians share a belief in the sanctity of the Old Testament, which is a font of Judeo-Christian imagery. Art helped to educate the (mostly illiterate) laity by illustrating timeless stories like these.

Opposite, top left: After Moses murdered an Egyptian, he fled from Pharaoh's wrath to Midian. Resting by a well, he met the seven daughters of Jethro, a Midianite priest, who were watering their sheep. When some shepherds tried to drive them away, Moses came to their defense, the scene dramatically evoked by Fiorentino in *Moses Defending the Daughters of Jethro.* As a reward, Jethro allowed Moses to marry Zipporah, one of his daughters.

Opposite, top right: The Book of Job is one of the most challenging in its exploration of the mystery of suffering. Job was a blameless patriarch who endured great misfortunes when Satan received divine permission to test the strength of his faith. Having lost everything but his life, he refused to "curse God and die," and his afflictions were removed. Laurent de la Hire's *The Offering to Job* depicts Job's restoration to prosperity in the classical style.

Piero della Francesca's frescoes of the Legend of the Holy Cross, in the Church of San Francesco, Arezzo (c. 1455–65), depict the dying Adam (*opposite*) as a repentant patriarch.

King Solomon, the son of David and Bathsheba, was renowned for his widsom and justice. Early in his reign, God had asked him to name a gift: Solomon asked only for wisdom, and God rewarded him with long life and wealth as well. Raphael's *Judgement of Solomon* (*top right*) illustrates the famous story in which two women bore children, only one of whom survived, and both claimed it as their own. Solomon ordered that the baby be cut in half, and instantly recognized the true mother as the one who abandoned her claim.

The story of Judith (*right*), the heroic Jewess who decapitated Holofernes, one of Nebuchadnezzar's generals, was a popular subject with Renaissance artists. A wealthy widow of Bethulia, in Judah, Judith learned that her city could not hold out against Nebuchadnezzar's army for more than five days. She entered the enemy camp by a ruse and beheaded the drunken Holofernes. Botticelli's *Return of Judith* shows the heroine, accompanied by her maid (with the head) returning to Bethulia. Judith carries a sword, representing justice, and an olive branch, symbolizing peace.

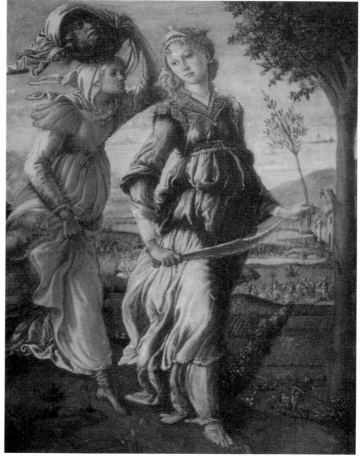

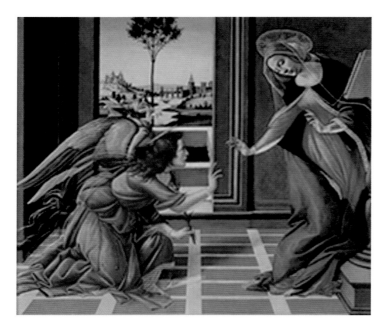

THE ANNUNCIATION

The New Testament Gospel of Luke tells the story of the Angel Gabriel's visit to the Virgin Mary to announce that she will conceive and bear the son of God—one of the most frequently depicted scenes in Christian art. Fra Angelico's interpretation (*below, left*) shows Gabriel kneeling and holding a lily, which represents purity and became a symbol of the Virgin herself. In this picture, and in Botticelli's *Annunciation* (*left*), Gabriel's head is haloed by light, the conventional sign of sanctity. The Virgin Mary figure in the carved medieval bas-relief (*below*) draws back modestly and with great awe from the angel, reflecting the fact that "she was much perplexed by his words" (Luke 1:29).

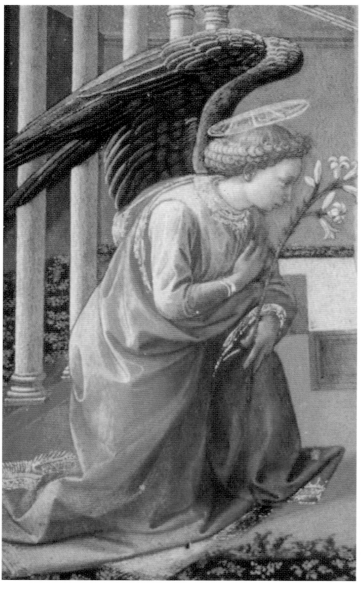

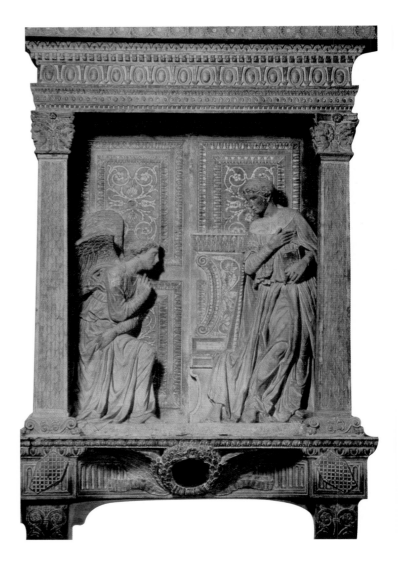

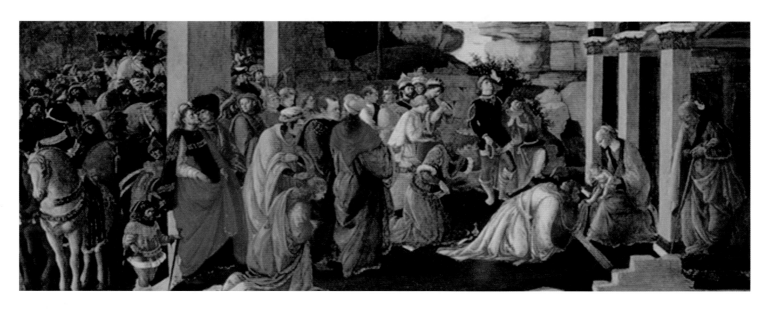

THE ADORATION OF THE CHRIST CHILD

The Gospels recount that after His birth, Christ was visited by shepherds, representing the Jewish people, and by the Magi, the Three Wise Men from the east, who symbolize the Gentiles. Botticelli's *Adoration* (*above*) is a detailed rendition dominated by the crowds who have come to venerate the Christ Child, held by his mother on the right.

The illustration from a medieval Book of Hours (*left*) shows the Child receiving the Magi's gifts with a blessing. In the carving below, Mary wears a crown, symbolizing her position as queen of heaven; her robe, like those of the Magi, is covered in *fleurs de lis*, a sign of royal authority, purity and life.

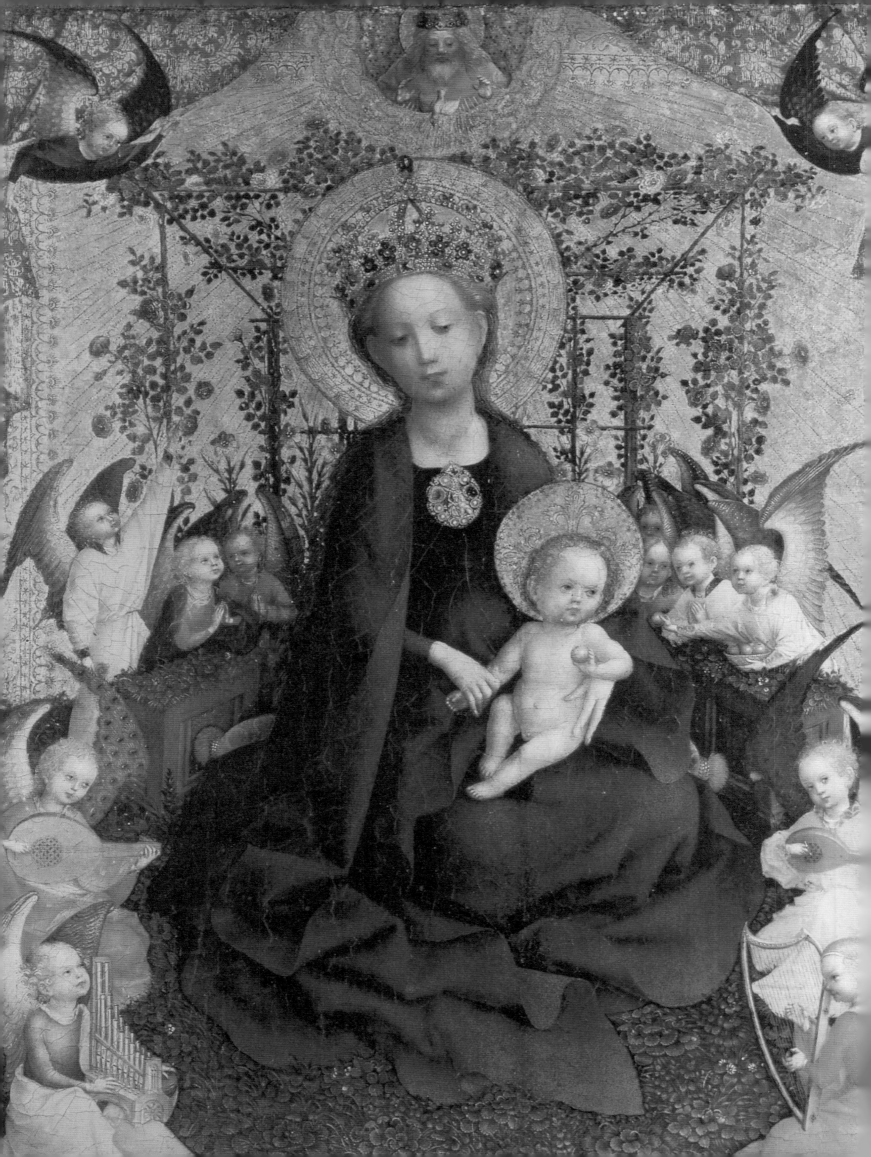

THE VIRGIN AND CHILD

The image of the Virgin and Child is one of the most important in the lexicon of Christian sacred imagery. The virginity of Christ's mother is central to the Christian doctrine of divine Incarnation, so images of Mary emphasize her innocence and piety.

The Virgin of the Rose Garden by Lochner (*opposite*) shows Mary as queen of heaven, surrounded by angels. The rose trellis refers to the Marian titles "mystical rose" and "a rose without thorns," that is, sinless. The Holy Spirit, symbolized by the dove, overshadows them. Like Lochner's Christ, the holy infant in Botticelli's *Madonna of the Pomegranate* (*right*) holds the many-seeded fruit that symbolizes resurrection, immortality and chastity. Raphael's *The Ansideri Madonna* (*below, left*), an altarpiece, depicts Mary enthroned with St. John the Baptist gazing at a crystal cross to her right, and St. Nicholas of Bari to her left. The medieval carving (*right*) is a study in serenity and devotion.

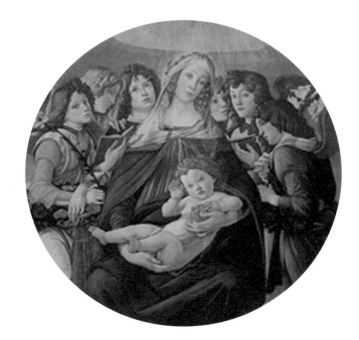

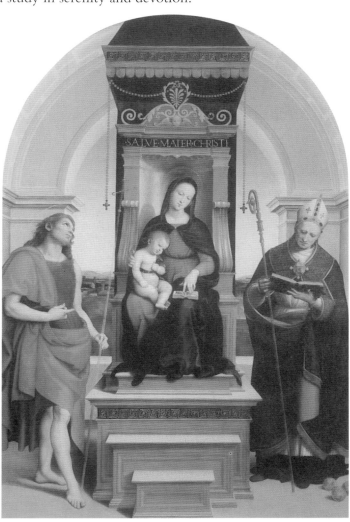

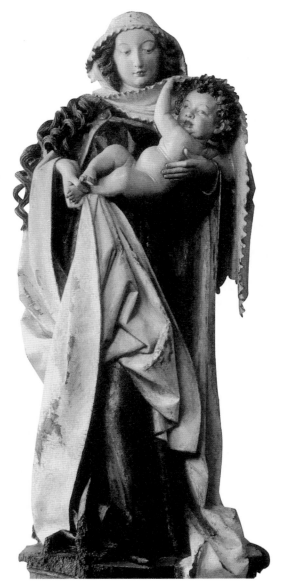

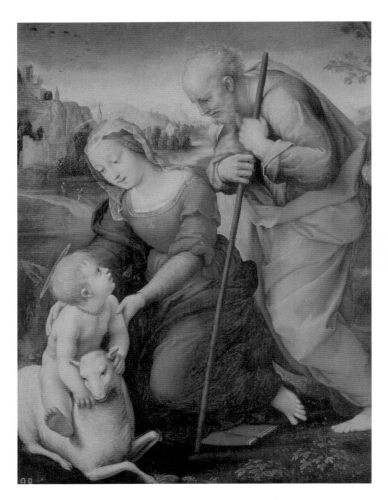

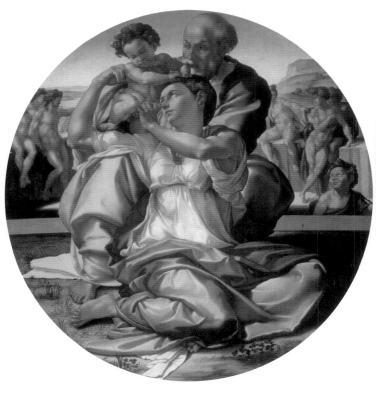

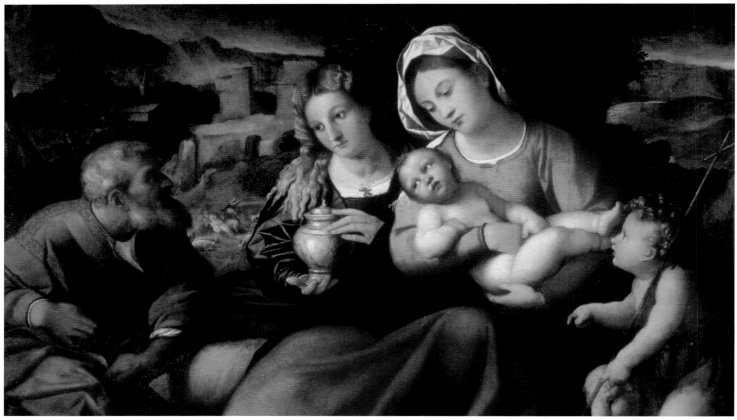

THE HOLY FAMILY

During the Renaissance, pictures of the Holy Family—Mary, Joseph and Jesus—emerged. Michelangelo's *Doni Tondo* of 1503 (*opposite, near left*) is an early example: like Raphael's *Holy Family of the Lamb* (*far left*), it shows them engaged in playful, everyday activities. Such images underline the humanity of the Holy Family, even as the traditional haloes, Mary's blue robe and the presence of the lamb (the symbol of Christ's innocence and sacrifice), recall their sanctity.

In Palma Vecchio's *Holy Family with the Young St John and Mary Magdalen* (*opposite, below*), two symbols anticipate Christ's destiny: Mary Magdalen holds a jar of myrrh, with which He would be anointed for burial, and the infant John the Baptist sits astride a lamb, symbolic of Christ's sacrifice and of St. John himself, who gave his life for Christ.

Raphael's *Madonna of the Linen Window* (*right*) shows the Virgin and Child facing St. Elizabeth (foreground) and St. Catherine. On the right is the young John the Baptist, who was Elizabeth's son and Christ's cousin. In the background is the arched window covered with linen that gives this famous painting its name.

Leonardo da Vinci's *Madonna of the Rocks* (*right*) shows the Virgin Mary in her traditional cloak with her arm around the infant John the Baptist. Christ, who is depicted blessing St John, is held protectively by an angel.

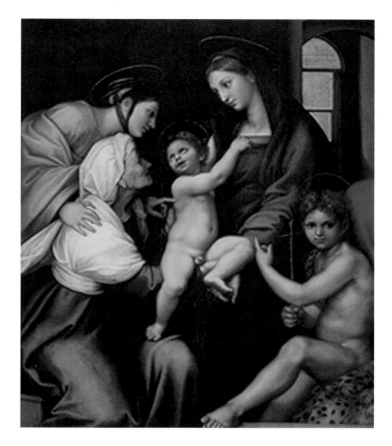

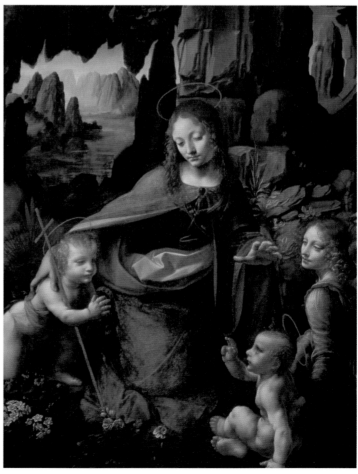

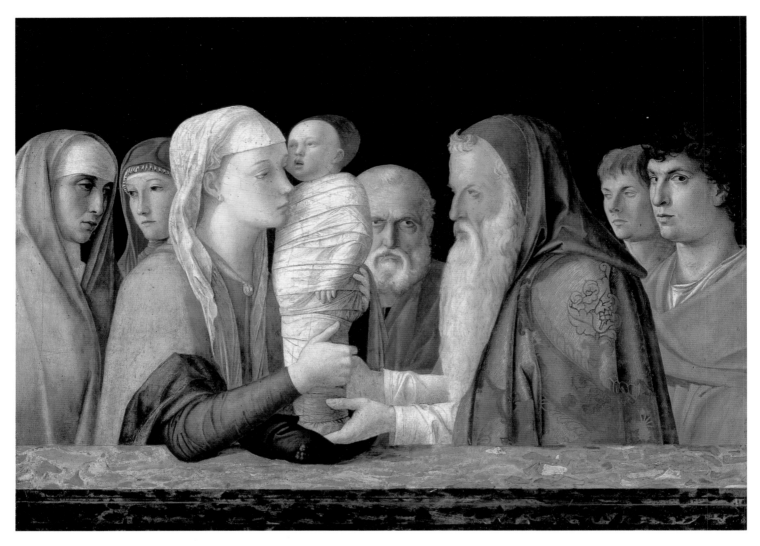

THE REDEEMER RECOGNIZED

Eight days after his birth, Christ was taken to the Temple, according to Jewish custom, for presentation to God and ritual circumcision. In Bellini's *Presentation in the Temple* (*above*) Mary gives the infant Jesus to Simeon, a devout old man who had been told by God that he would not die until he had seen the Messiah. Simeon blessed Mary and Joseph and predicted that "This child is destined for the falling and the rising of many in Israel, and to be a sign that will be opposed so that the inner thoughts of many will be revealed—and a sword will pierce your own soul too" (Luke 2: 34–5).

Opposite: A thirteenth-century Greek icon of Christ the Redeemer. The Orthodox Church regards icons as manifestations of a heavenly archetype, and for this reason they are usually highly stylized. The golden background evokes the heavenly nature of the image, and its flat planes are consistent with Byzantine conventions.

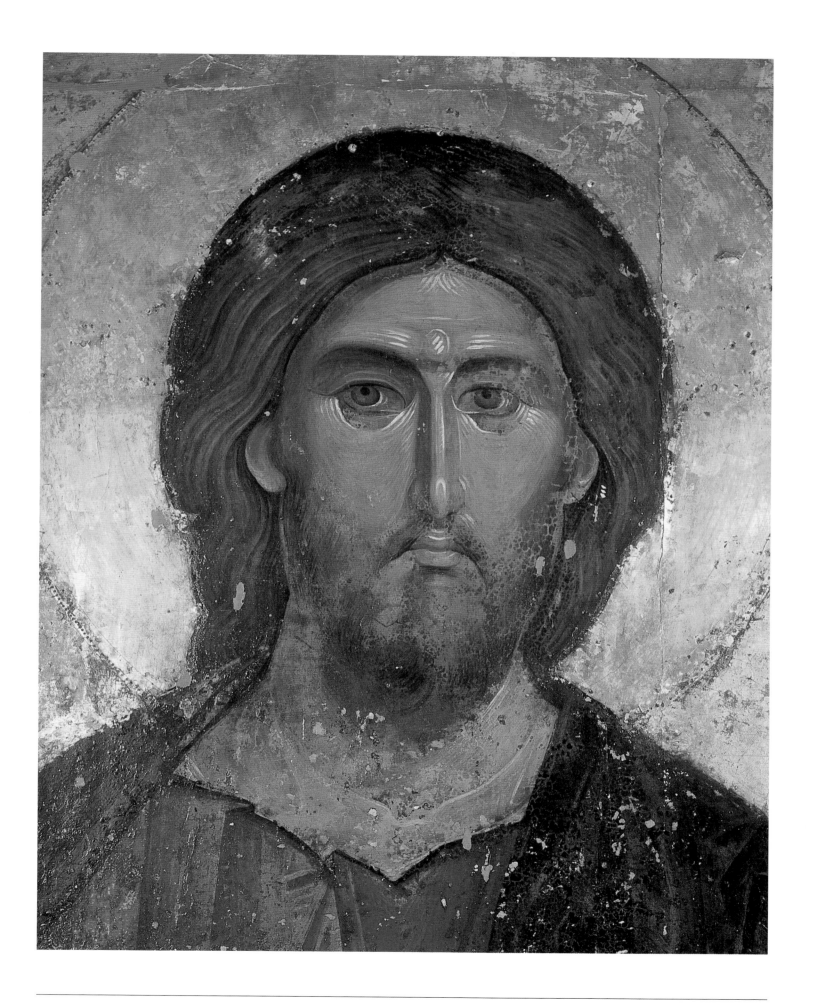

IMAGES OF CHRIST

Representations of the adult Christ are remarkably consistent in showing a long-haired, bearded figure of powerful presence. The altarpiece from Orcagna (*below*) shows Christ in majesty, while Verrocchio's stark *Baptism of Christ* (*bottom*) depicts the beginning of His public ministry. The contemporary sculpture of the risen Christ derives from nineteenth-century apparitions of the Sacred Heart to St. Catherine Labouré.

Juan de Juane's *The Last Supper* (*opposite, above*) shows Christ, surrounded by prayerful disciples, blessing the bread at their final Passover meal. There he announced that one of them would betray him and instituted the sacrament of holy communion in bread and wine, which came to represent His flesh and blood, sacrificed to save humankind. Giotto's *Lamentation Over the Body of Christ* (*opposite, below,* 1305–08) shows the human suffering of His mother after the Crucifixion.

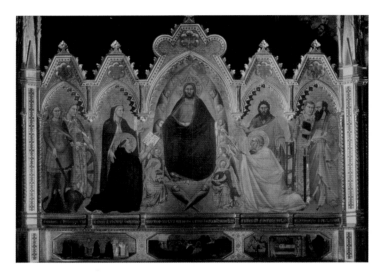

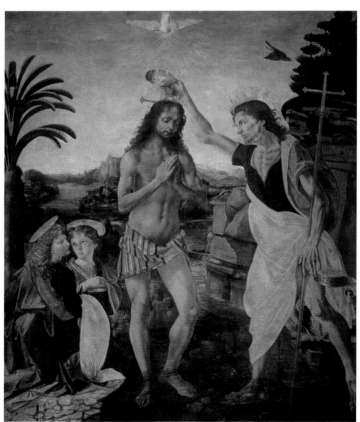

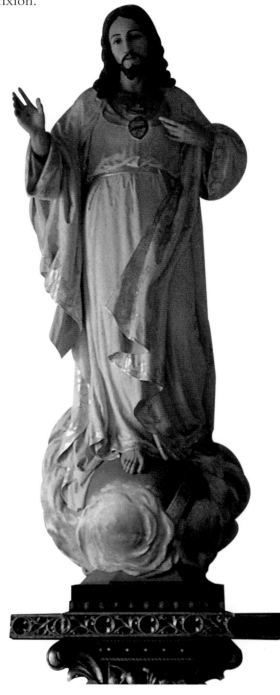

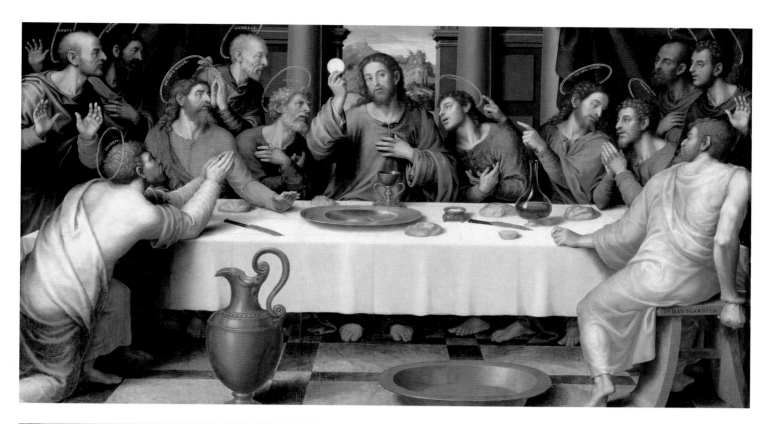

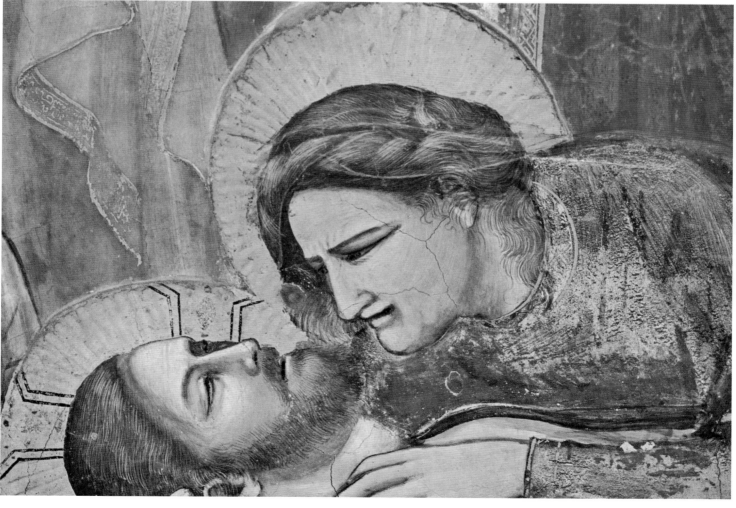

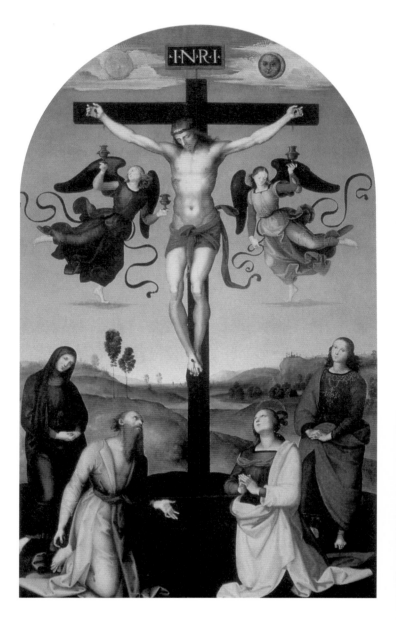

THE CRUCIFIXION AND RESURRECTION

The image of Christ crucified underlines the central tenet of the Christian faith—that Jesus suffered and died to redeem humanity. It became the most important sacred image of the religion once Christians achieved freedom of worship within the Roman Empire during the fourth century.

Raphael's *The Crucified Christ* (*left*) shows Christ supported by two angels. Mary Magdalen, the Virgin Mary, St. John and Mary, the mother of James and John, keep a vigil at the cross. Velázquez' rendition (*below*) is simpler, but in many senses more powerful. *Chiaroscuro* is used to emphasize the wounds and suffering of Christ's Passion, and the artist translates the satirical inscription *INRI* above Christ's head into Hebrew, Greek and Latin: "Jesus of Nazareth, King of the Jews."

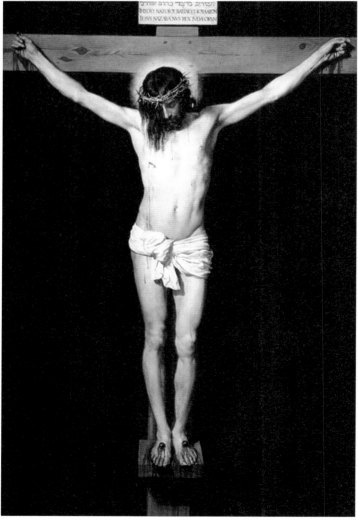

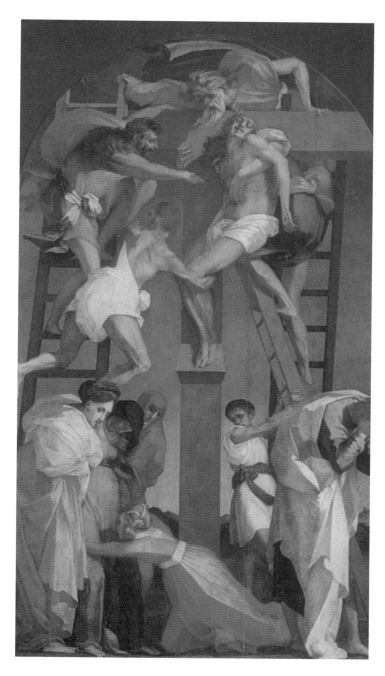

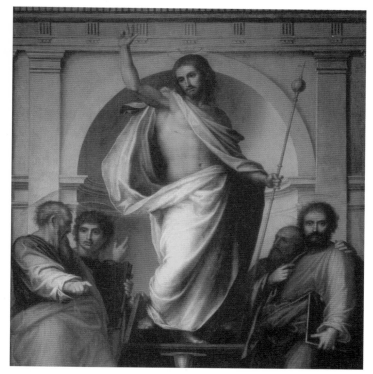

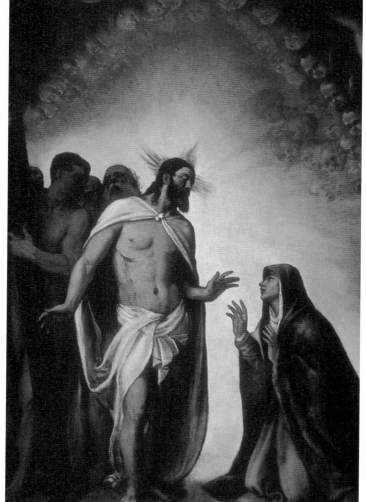

In *The Descent from the Cross* by Fiorentino (*above*) Joseph of Arimathea and the pharisee Nicodemus take Christ's body from the cross for burial.

The Resurrection of Christ, the miracle central to the Christian faith, occurred three days after His death and is joyfully celebrated by Christians on Easter Day, when Mary Magdalen visited the tomb to find that the stone at its entrance had been rolled away. Fra Bartolomeo's *Resurrected Christ* (*top right*) shows Jesus appearing to the disciples; Titian depicted Him (*right*) with Mary Magdalen, asking her to tell the disciples that He was risen.

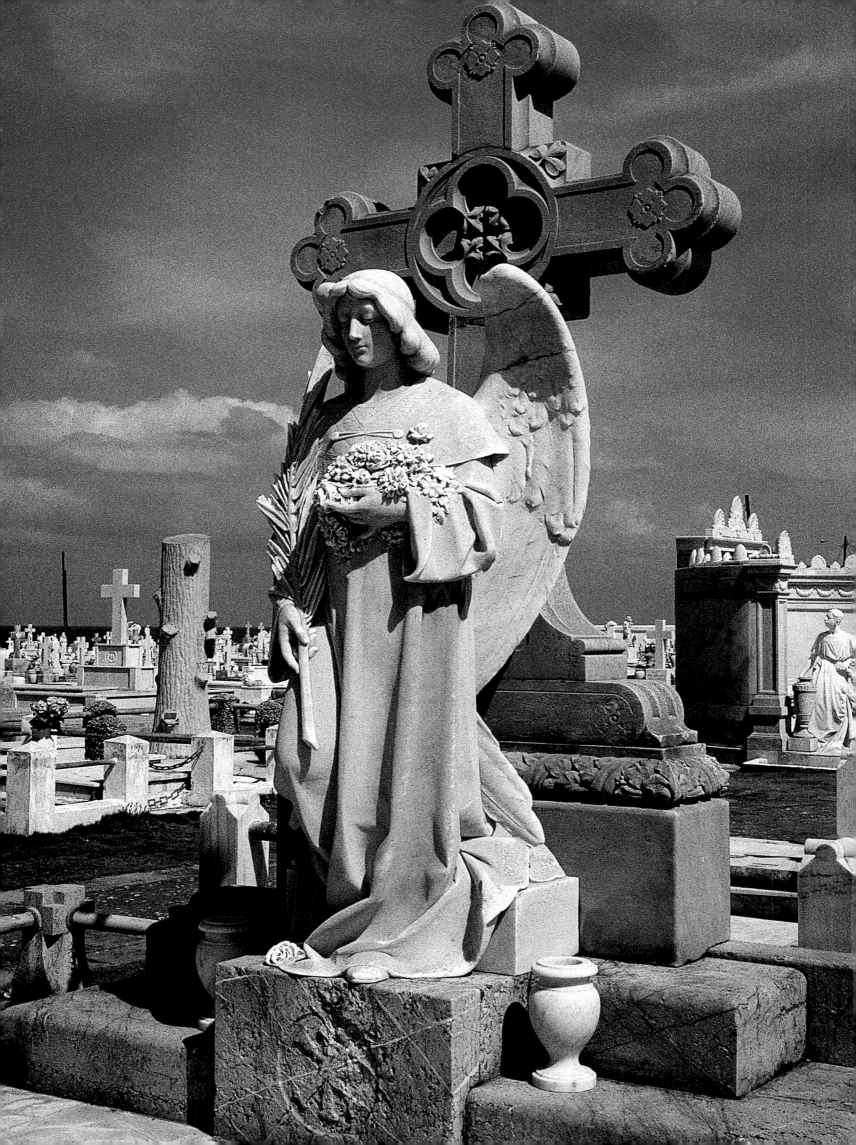

CHOIRS OF ANGELS

Angels are spiritual messengers from God who appear in the Bible to announce or enforce divine will or to provide comfort. An angel with a flaming sword evicts Adam and Eve from Paradise; another warns Joseph to flee to Egypt with the Child Jesus and Mary to escape Herod's wrath; two angels guard Christ's empty tomb, and their images often appear on grave monuments (*opposite*).

Traditionally, nine choirs of angels surround the throne of God, but only the two lowest orders, the archangels and angels, assume physical form to communicate with human beings. The nine choirs represent heaven in both Byzantine and Western art, and angels are often depicted playing musical instruments (*right*) as a sign of divine harmony. They are usually rendered as beautiful young men or women with haloes and wings.

CHURCH AND CATHEDRAL

Symbolism is inherent in the design of Christian churches. Many are built in the form of a cross, with deep entrances leading to lofty sacred spaces. The largest may incorporate soaring vaults and decorations including carvings, murals, lamps and statues of Christ and the saints. Others are as simple as the adobe chapel (*opposite*) surmounted by a cross.

Medieval churches were illuminated by candles and by stained glass windows like those illustrated here. Many cathedrals, including France's Bayeux Cathedral (*opposite, below right*) have a great cross or rose window above the west door, which casts shafts of colored light into the nave.

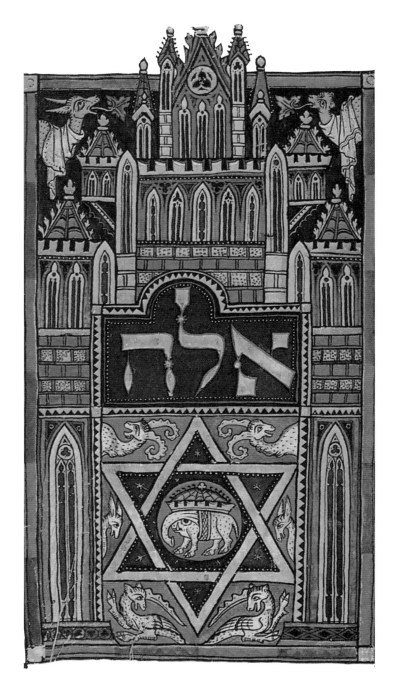

JEWISH SYMBOLISM

Calligraphy and sacred symbols form the basis for Jewish illustrative art. The design from southern Germany (*above*) features the Star of David and the Hebrew word *eleh* ("these"), which is the first word of the Book of Deuteronomy. Mystical symbols including the Star of David and menorah adorn this page (*right*) of a Kabbalistic manuscript.

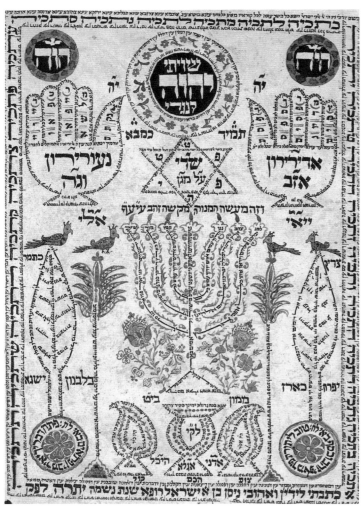

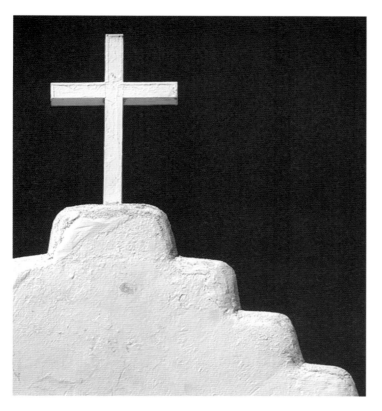

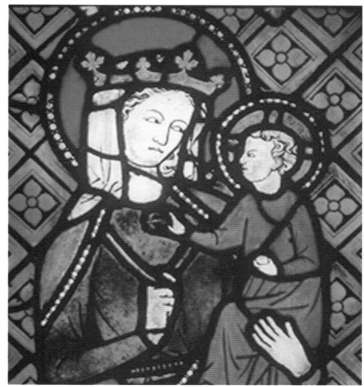

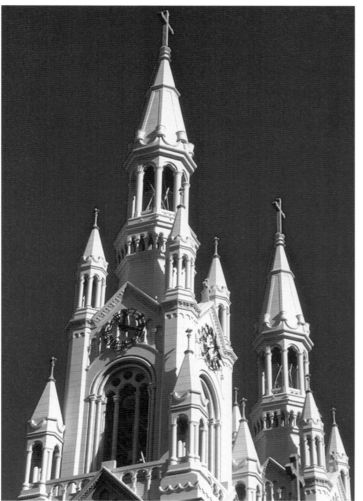

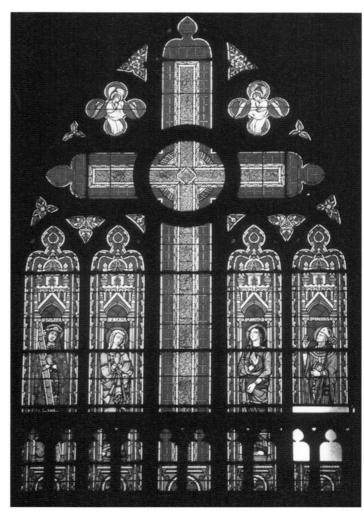

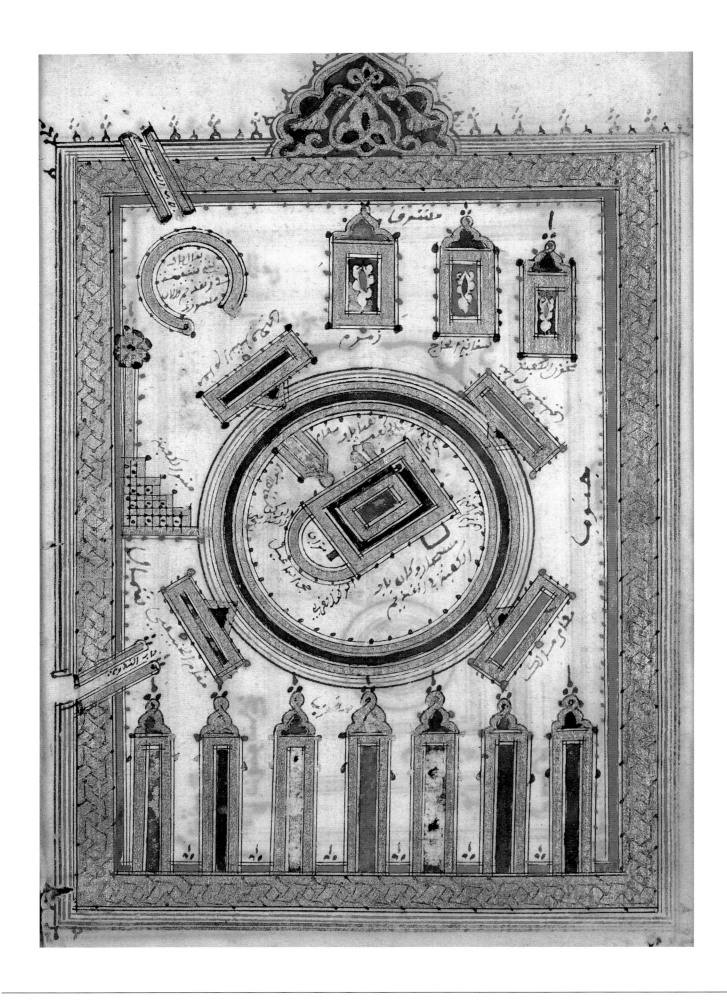

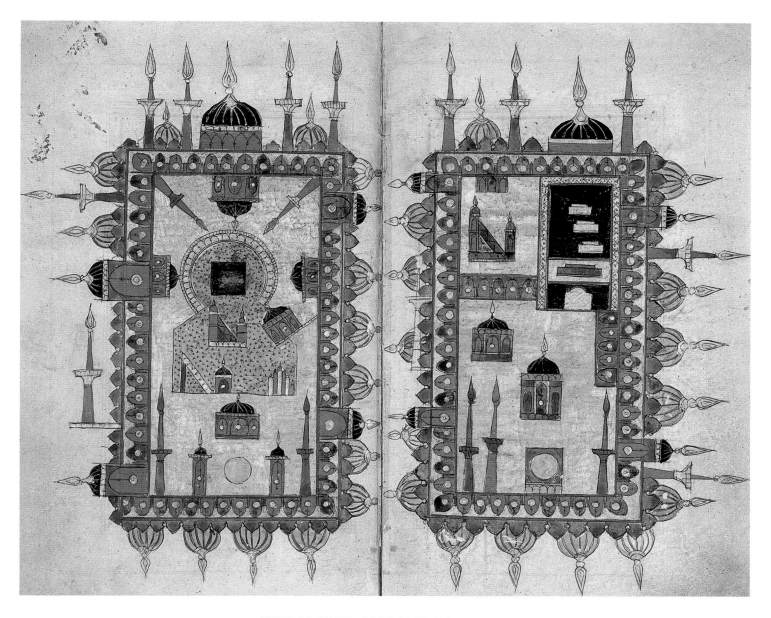

THE SACRED MOSQUE AT MECCA

Islamic art began its first flowering about a century after the Prophet Muhammad's death in 632, and displayed a homogeneity unlike that of any other religion. These plans of the Masjid al-Haram, the sacred mosque at Mecca, are typically detailed and intricate works of Muslim religious art, but they also had a practical purpose. Pilgrims used them to prepare for their visit to the holy city.

The Mosque of Mecca (*opposite*) is a detail from the *Dehail oul Khairat*, an eighteenth-century miniature, showing the sacred *Ka'ba* at the center. *Above:* The shrine was depicted on decorative tiles, prayer mats and manuscript pages with images familiar to Muslims everywhere. They include the semicircular pavement around the *Ka'ba* called the *Mataf* (*at left*), and the tall towers (minarets) from which the call to prayer is made.

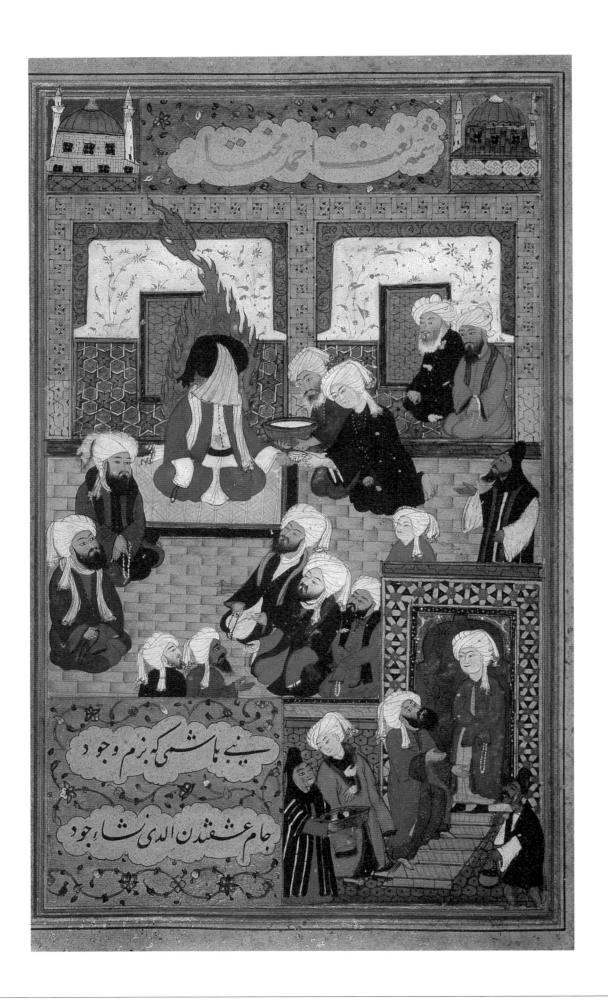

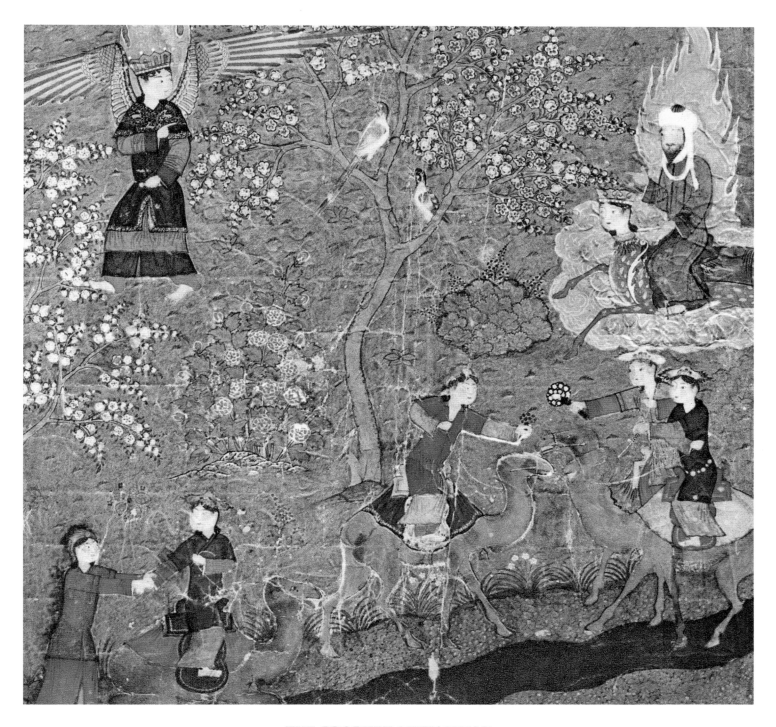

THE PROPHET MUHAMMAD

The exquisite miniature of Muhammad and his faithful companions (*opposite*) shows the solidarity that made the nascent religion of Islam so successful in polytheistic Arabia. *The Ascension of the Prophet Muhammad* (*above*) depicts the Prophet's momentous Night Journey, when the Angel Gabriel (shown at left) brought him from Mecca to Jerusalem. There he led other prophets including Abraham, Moses and Jesus in prayer before ascending to God's presence in heaven (the *Mi'raj*). The veiled prophet is shown wearing the green robe of honor and riding the mythical *buraq*, a hybrid horselike creature with a woman's head whose name means "lightning."

SACRED SCRIPTURE

The Qur'an (*previous pages*) is the holy text of Islam, containing God's revelations to Muhammad and considered the explicit and faultless Word of God. It cannot be translated into any other language, which explains why Arabic calligraphy is so important in Islam. Each of the Qur'an's verses is marked by a gilded rosette at the end, and its invocations, prayers and litanies dominate Muslim life. Artists devoted their lives to "making beautiful the word of God," embellishing its pages with intricate floral and geometric designs. Many of its 114 *suras*, or chapters, are enshrined in Islamic architecture.

MOSQUE AND MINARET

Sacred art and decoration serves to inspire contemplation in worshippers, and religious symbolism shapes the mosque. Its dome represents the cosmos, and the minaret, from which the *muezzin* issues the call to prayer five times a day, is a symbol of Allah's unity and supremacy.

The beautiful Blue Mosque in Isfahan, Iran (*below*), incorporates complex architectural features and intricately decorated blue tiles. The *muqornas*—the honeycomb pattern of niches within the dome—reflect the cosmic link between heaven and earth. The focal point of every mosque is the *mihrab*, a small arch or niche on carved columns that indicates the direction of Mecca, which Muslims must face when they pray. The pulpit or *minbar,* as seen in the illumination *Abu Zayd Preaching in the Mosque of Samarkand (opposite)* is to the right of the *mihrab* and is used by the *imam* to deliver his sermon on Friday, the Muslim holy day.

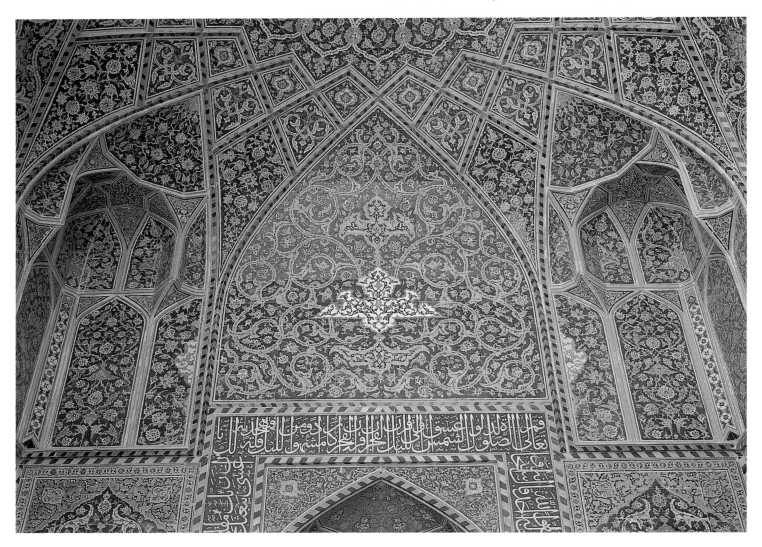

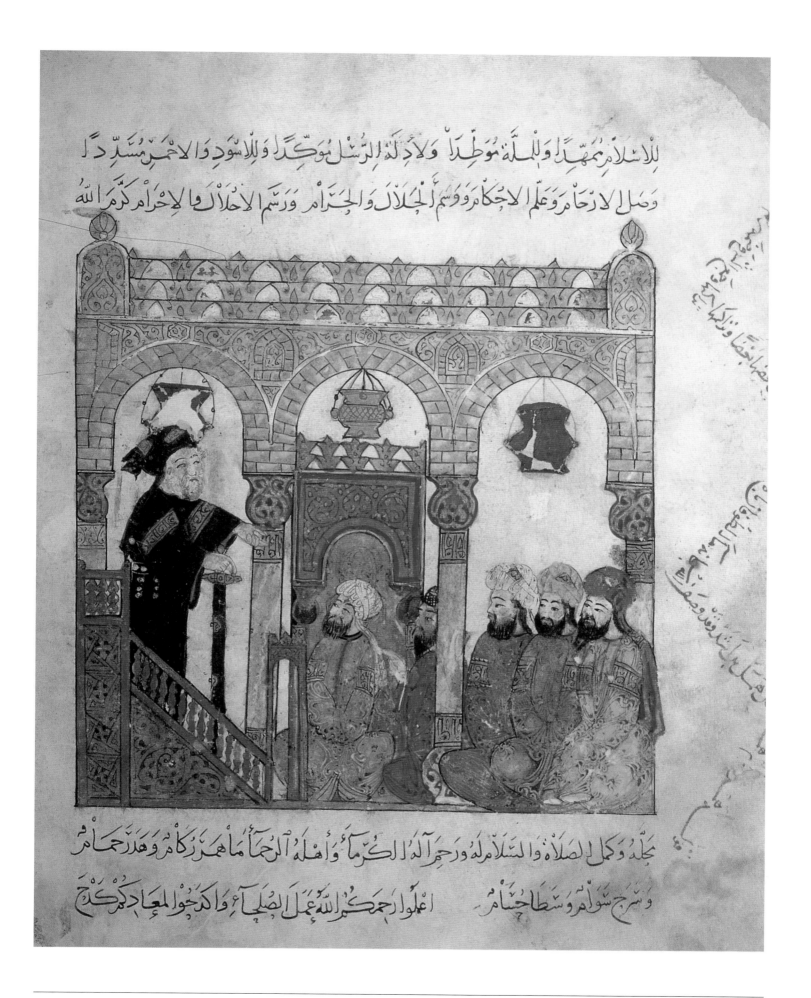

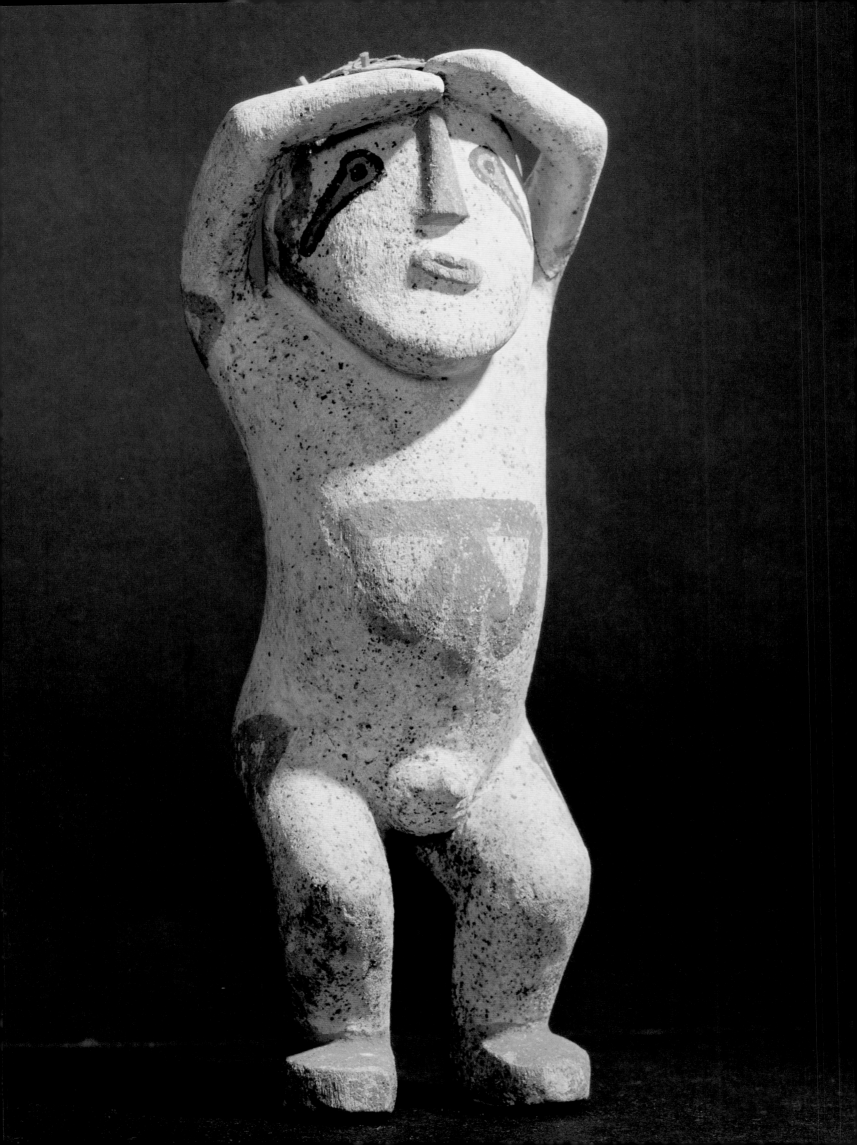

Tribal
Societies

Most tribal societies share a similar world view in which the unseen, or supernatural, and the natural world are totally interrelated. For this reason, their languages rarely contain the words "religion" or "art." Ritual acts of devotion, intercession, healing and invocation are woven into the fabric of daily life. Everyday objects are imbued with symbolic significance, from weaving and pottery to shelter and ornaments. This holds true across a wide spectrum of tribal societies, from the African Congo to the Pacific islands and the northernmost reaches of North America. In fact, there are surprising similarities in the sacred imagery produced by such societies, allowing for regional variations.

The natural world and the many creation stories that have been told to explain it are pre-eminent features of what was once called "primitive" art. Human beings, animals, plant life, rivers and oceans, celestial bodies, rain and drought are widespread themes. Hybrid creatures recur: manlike animals, animal-like gods and demons, gigantic birds and serpents that gave birth to the world. Rites of passage link human sexuality and generativity to the fertility of the earth. Reverence for elders and the ties of kinship that link the generations appear in legends and in effigies of wise men and women who preserve and transmit the lifeways.

Ritual objects include masks, fetishes, medicine bundles, drums and rattles, ceremonial headdresses and carvings believed to house the spirits to be venerated or placated. Among the Iroquois of North America, for example, the basswood masks of the False Face Society, which warded off evil spirits, received offerings of food and tobacco. When a shaman or medicine man dons a ritual mask, he takes on the power of the spiritual being it represents. Other ceremonial clothing, like that used for ritual dances, partakes of the same power, and rigid rules and *tabus* govern its use and safekeeping.

The sacred imagery described and illustrated here is representative of several diverse culture areas, including native Africa; the Pacific—Australia, Melanesia, Polynesia and Micronesia—and native North America, from the remnants of the original Southeastern tribes to the more westerly nations that survived the clash of cultures initiated by the European age of exploration and conquest. They include the Pueblo peoples and Navajo herdsmen of the Southwest, the scattered enclaves of the Great Plains tribes, the seafaring clans of the Northwest coast of the United States and Canada and the Inuit of Alaska and the far north. Each of these societies has survived in the face of adversity, not only from the vicissitudes of nature, but from the exploitation and hostility of alien cultures and the diseases brought by settlers from distant lands. They have much to tell us about the strength and serenity that can be achieved through living in harmony with the natural world and honoring the ineffable spirits that suffuse it.

AFRICA

Many ethnic groups of central and southern Africa share common roots in the Bantu linguistic family and similar elements in their myths. They include the Zulu, Tswana, Swagi, Rundi, Swahili and Ganda. Another coherent linguistic group is

*Opposite: A nineteenth-century Hopi Kachina doll from Arizona painted with phallic symbols—
a ritual artefact used for teaching and initiation rites.*

Right: This Tassilli rock painting from eastern Africa reflects the importance of cattle to the Masai and other indigenous groups, whose creation stories focus on the gift of livestock, equated with wealth.

Below: A Congolese carving from central Africa shows the primordial link between mother and child—a theme common to many cultures centered on kinship groups.

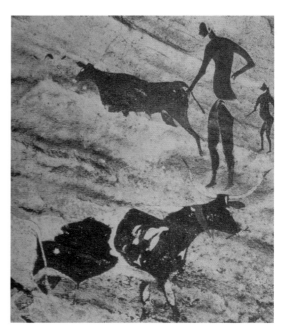

formed by the Nilotic languages, including those native to Zaire, Kenya and parts of Uganda and the Sudan. In general, these peoples worshipped a plurality of gods, including the Earth, Sun, Moon, Ocean and, in Zaire, the Forest. As historian Jan Knappert points out in *Mythology: An Illustrated Encyclopedia* (Orbis, 1980): "The dividing line between gods and spirits is hard to draw but, generally, gods are more human than spirits, have more personality and manifest themselves on a grander scale. Numerous local spirits…live in woods and wells, and are venerated by the local population." This observation applies widely to animistic societies, in which the community and the religious congregation are usually one and the same, closely tied to their "spirits of place." Huge animals with awe-inspiring powers—spider, frog, python—and evil hybrids like the crocodile-man have a central role in the mythology of tropical Africa. So do witchcraft and sorcery, as seen in the wooden fetishes created by magicians to house evil spirits and terrorize their enemies. Nails were driven into these images to make the spirits angrier and more dangerous. In the New World, such effigies had their counterpart in the "voodoo dolls" created by practitioners of Vodun, which was imported from the Ivory Coast with African slaves.

In eastern Africa, from the Sudan to Madagascar, there is a pervasive belief pattern with several major themes familiar to Western believers but arrived at independently: a supreme God; a perfect creation that has fallen into disunity and imperfection; and a corresponding contrast between success and failure, peace and enmity. These themes are expressed in the Chaga story of the Two Brothers, in which the younger prevails over the older by showing humility and kindness rather than pride and spitefulness. Indigenous animals play important roles, including the hare, jackal and dikdik (a small antelope), which are identified with the archetypal malicious Trickster. In spite of life's hazards and duplicity, there is an implicit belief in divine order arising from the power of God and the benign spirits and ancestors.

Western African societies became the most complex and sophisticated on the continent long before Europeans arrived. Rich pantheons and cults of worship developed among the Yoruba of Nigeria, the Ashanti of Ghana and the Dahomeans of what is now Benin, who worshipped more than 600 gods. Many of them were double-sexed, representing unity in duality. Twins and pairs figure prominently in western African mythology, as do creation stories involving both the snake and the primordial egg. Temples and shrines still abound, housing statuettes, masks and ritual regalia. Totem

Left: Australia's Ayers Rock, a monolith sacred to Aboriginal peoples as the home of the Wandjina, the creative spirits of the Dreamtime.

animals include the lion, the elephant, the Monitor lizard and Anlubu, the soldier bird—a kind of diviner.

THE PACIFIC

The Pacific cultures show vast diversity in their sacred systems, consistent with the great distances between them. The islands of Polynesia and Micronesia span some 5,000 miles, encompassing Easter Island, the Marquesas, Hawaii, Samoa, Guam, the Marianas and many others. The primary Polynesian gods, originating with the Maori of New Zealand, are Rangi (Sky) and Papa (Earth). Their offspring include Tangaroa, the deity of oceans and fish, and Tu-matauenga, governor of humankind and war. Other members of the Polynesian pantheon are associated with the elements, wild and cultivated foods, animals, plants and insects. Maui is the Trickster-Hero who fished up islands from the ocean. Sea creatures, canoes and native animals are prominent in the symbolism of these island cultures. The Micronesian gods include the brothers Luti and Olofat, respectively good and evil. *Mana* is equated with power in both culture groups, and *Eapu* (taboo) with contacts that diminish power.

Melanesia extends from Irian Jaya, part of the Indonesian Republic, to Fiji, the New Hebrides and New Caledonia, taking in Papua New Guinea and the Solomon Islands. The sacred imagery of these societies includes ancestor masks of enameled wood, dance masks of carved and painted wood with fiber hair and wooden carvings of sea-spirits and canoe voyages guided by the deities. Cult houses contain drums and carved figures symbolizing fertility, masculine power and kinship groups.

In Australia, the indigenous Aborigines comprised perhaps 400 tribes speaking many different languages when the first Europeans arrived in the late 1700s. They were seminomadic within specific territories, but their trade routes spanned the continent. Sacred belief systems encompassed many gods, including, most importantly, the All-Father, or Sky Hero; the life-giving Djanggau Sisters; the Fertility Mother; the Lightning Snake; and the Wandjina—wandering spirits of the primordial Dreamtime who formed the landscape and generated humans and other animals.

The Wandjina are depicted in both rock and bark paintings, along with sacred trees, springs and the Great Snake in its many manifestations. Totemic ancestors like the

Right: Natural features endowed with sacred significance include the formation called Spider Rock by the Navajo of Canyon de Chelly, Arizona. Here the revered Spider Woman spun the thread of life for humanity.

goosemen govern initiation rites in which young men receive the sacred stories and ceremonies. Carved wooden figures of the Wawalog Sisters recall their part in setting the boundaries of male-female relationship. They gave birth to children who were swallowed by the Rainbow Snake, a gigantic python. After devouring the Sisters as well, he vomited up the children, but kept the women's sacred songs and animals, symbolically granting ritual authority to men. Aboriginal myths and images are enshrined at Ayers Rock, or Uluru, in central Australia, which has become a focal point for pan-Aboriginal identity, much as other sacred places did in North America in the face of invasion by alien cultures.

NORTH AMERICA

By the nineteenth century, most of North America's native peoples had been displaced, forcibly relocated, or confined to reservations. Those who survived clung tenaciously to their ancestral faiths and symbols, which took many regional forms.

Southeastern tribes including the Cherokee, Choctaw, Creek, Chickasaw and Seminole produced masks, baskets and woven artefacts with their traditional scroll and geometric designs, representing the four elements, the cardinal directions in the form of a cross, lightning, rain, sun and other sacred components of the natural world. Like the powerful tribes of the upper Eastern Woodlands, including the Iroquois Confederacy, they believed in a supreme being who was the author of life, a Great Spirit. Popular worship focused on nature-related gods including the Sun, the Four Winds, Mother Earth and the Thunderbirds—giant birds often depicted with human faces and common to other culture areas across the continent.

In the Pueblo culture area of the Southwest, where agricultural societies developed around cliff dwellings, the arts of weaving and pottery emerged. The Hopi decorated their clay vessels and images with human and animal figures, while the Zuñi favored geometric layouts incised or painted with rosettes, deer and other nature symbols. Special underground cham-

bers called kivas were (and are) dedicated to sacred rites governing every aspect of community life, including invocation of the spirit-ancestors called the kachina and veneration of the nature gods known generically as Father Sun, Mother Earth and the Corn Maidens.

The Navajo became shepherds who learned weaving from the Pueblo peoples and became famous for their handsome rugs and blankets with traditional geometric designs, while the nomadic Apache made jar-shaped baskets and ritual headdresses with antelope horns and human hair.

On the Great Plains, agriculture was devoted to maize (corn), beans and squash, and to hunting the bison (which became even more important after the Spanish reintroduced the horse to the region). These animals, along with pronghorn antelope, rabbits, birds and deer, figure prominently in the sacred imagery of the Plains tribes. Mandan villages along the Missouri River, and circular tipi encampments, reflected the plan of the world, which was perceived as a flat surface on a rounded base, overhung by the tent of the sky. The theme of circles, or "hoops of

the world," recurs in sacred stories and rites, including dances. In the Ghost Dance cult of the late nineteenth century, it was believed that rituals introduced by the Paiute of the Great Basin area would restore the way of life that was being destroyed by westward immigration.

Northwest Coast tribes shared many sacred symbols with the Inuit—another seafaring people who practiced no agriculture. The sacred imagery of this culture area is rich in depictions of fish, sea mammals and such legendary figures as the Raven, who is both creator and malicious Trickster. Rattles, masks, totem poles and other ritual objects combine images of the Raven with those of the whale, salmon, bear and other animals associated with clan spirits. The bold, vivid imagery of the Northwest coast shows affinities with that of China and Japan and has become recognized as one of the world's great native artistic traditions.

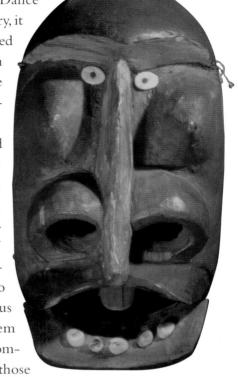

Above: This Inuit shaman's mask of carved and painted wood is studded with marine ivory to create a ferocious expression that will terrify the shaman's adversaries from the spirit world.

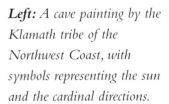

Left: A cave painting by the Klamath tribe of the Northwest Coast, with symbols representing the sun and the cardinal directions.

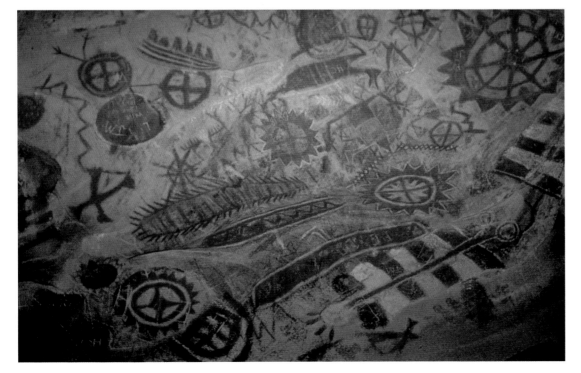

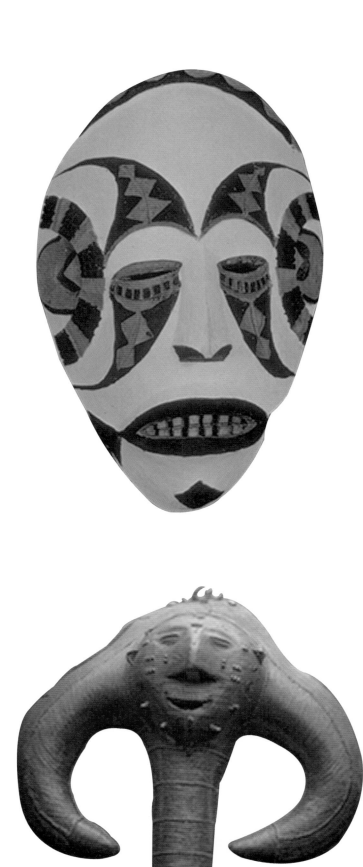

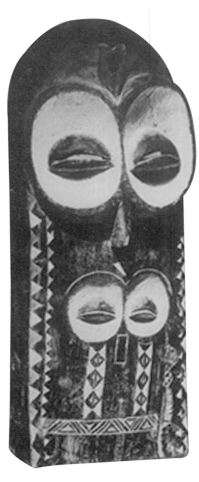

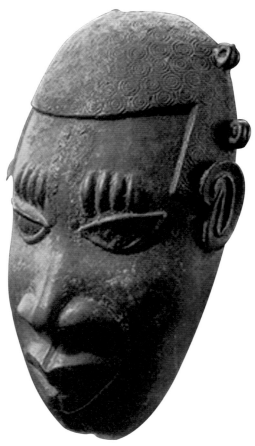

THE MANY MASKS OF AFRICA

Ritual masks are used in many tribal soc-
ieties to effect a transformation in the
person donning the mask, who thereby takes
on the power of the spirit symbolized or ele-
vates him- or herself to communicate with
and placate ancestral spirits. *Opposite, clockwise
from top left:* Carved and painted Igbo maiden
spirit mask, symbolizing beauty and peace,
from Nigeria; representation of a local spirit
of place from the Congo Basin; traditional
Yoruba warrior mask in a style that origi-
nated as early as the twelfth century; image
of a horned animal-like god used in Ivory
Coast rituals. *Right:* A mask representing a
white goddess worshipped by the Bapuna
people of Zaire in secret night rituals.
White is the color of spirits from the
"otherworld," including the dead.

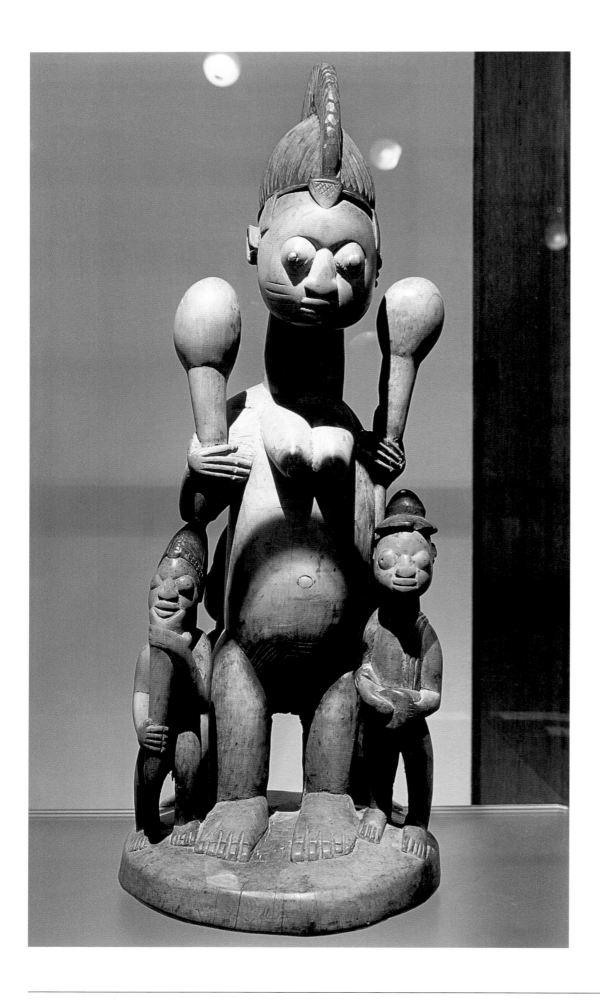

CREATION STORY IMAGES

A Nigerian carving of a fertility goddess with twin off-spring (*opposite*), derived from the Dahomean pantheon of western Africa, in which twins and androgynous beings play a major role. *Right:* An Igbo figurine derived from the androgynous deity Mawu-Lisa, who gave birth to all beings. *Below:* A beautifully embellished mother-and-child carving from Gabon, central Africa.

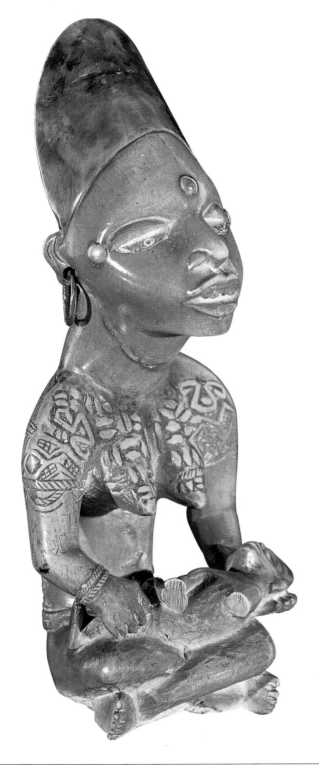

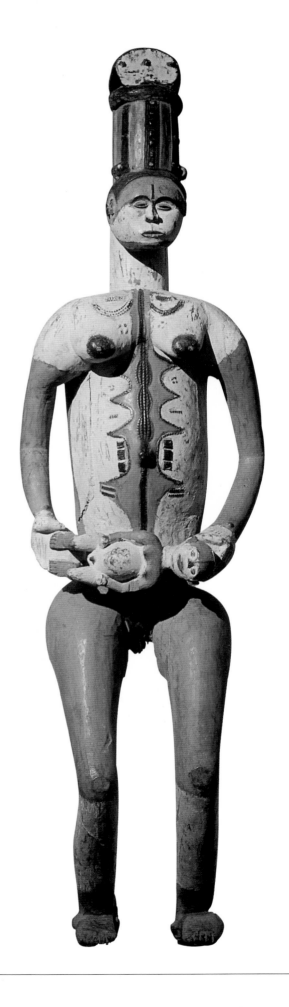

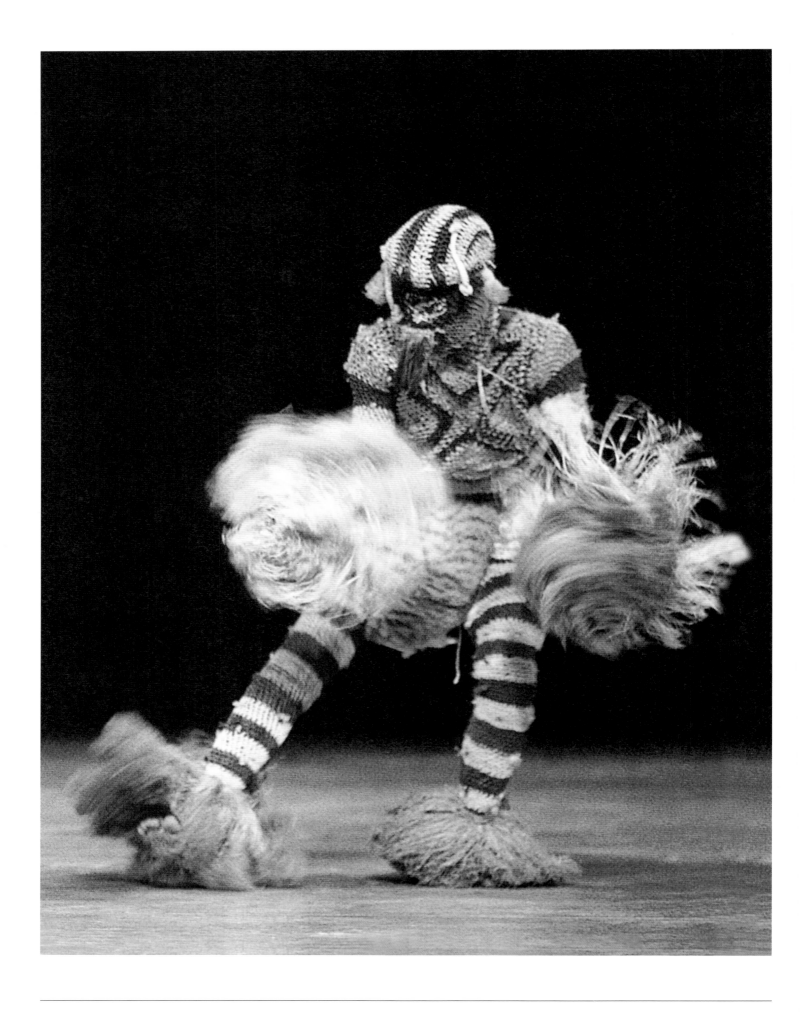

INVOKING THE SPIRITS

A Pende ritual dance of the northwestern Congo (*opposite*), in which the elaborate costume and traditional forms of movement combine to enable the dancer to invoke and communicate with the spirits. Pende masks—as well as the carved wooden and ivory amulets in the same realistic style and similarly adorned with raffia bundles—are considered among the most powerful works of African art.

ANIMAL POWERS

Magical and transformative powers are ascribed to animals in tribal African societies, and animal likenesses are commonly used in ceremony and ritual, usually in the form of carvings, masks and fetishes. A solid-gold pendant in the shape of a ram's head (*below*) is a recurring motif in the ceremonial artworks of Senegal. *Right:* This hybrid cult object from the Sudan has the head, beak and crest of a bird.

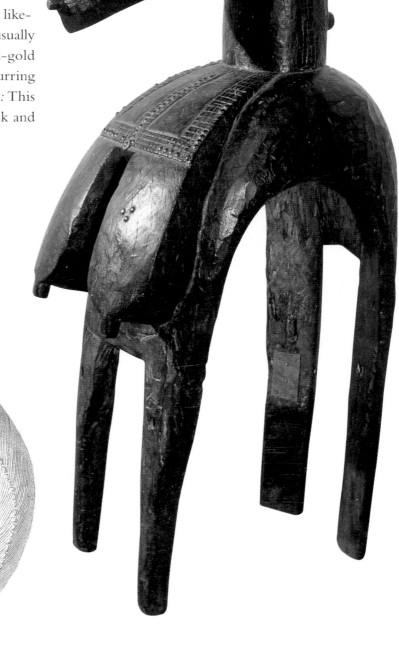

ABORIGINAL ROCK ART

T he kangaroo (*left*), venerated as a totemic ancestor, often appears in Australian Aboriginal sacred imagery. *Opposite:* These ghostlike Wandjina figures bear a close resemblance to the Kultana of Arnhem Land, who is associated with the north wind and rain. She is a guardian of the spirits of the dead. *Below:* This image from Kakadu represents Kunapipi, (lower left) the mother of all things or creator goddess, giving birth. Her many names include "All Mother" and "Old Woman."

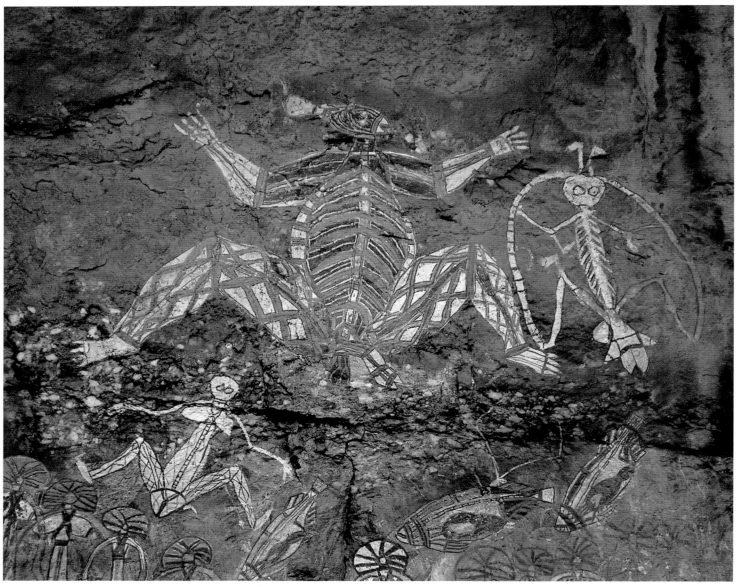

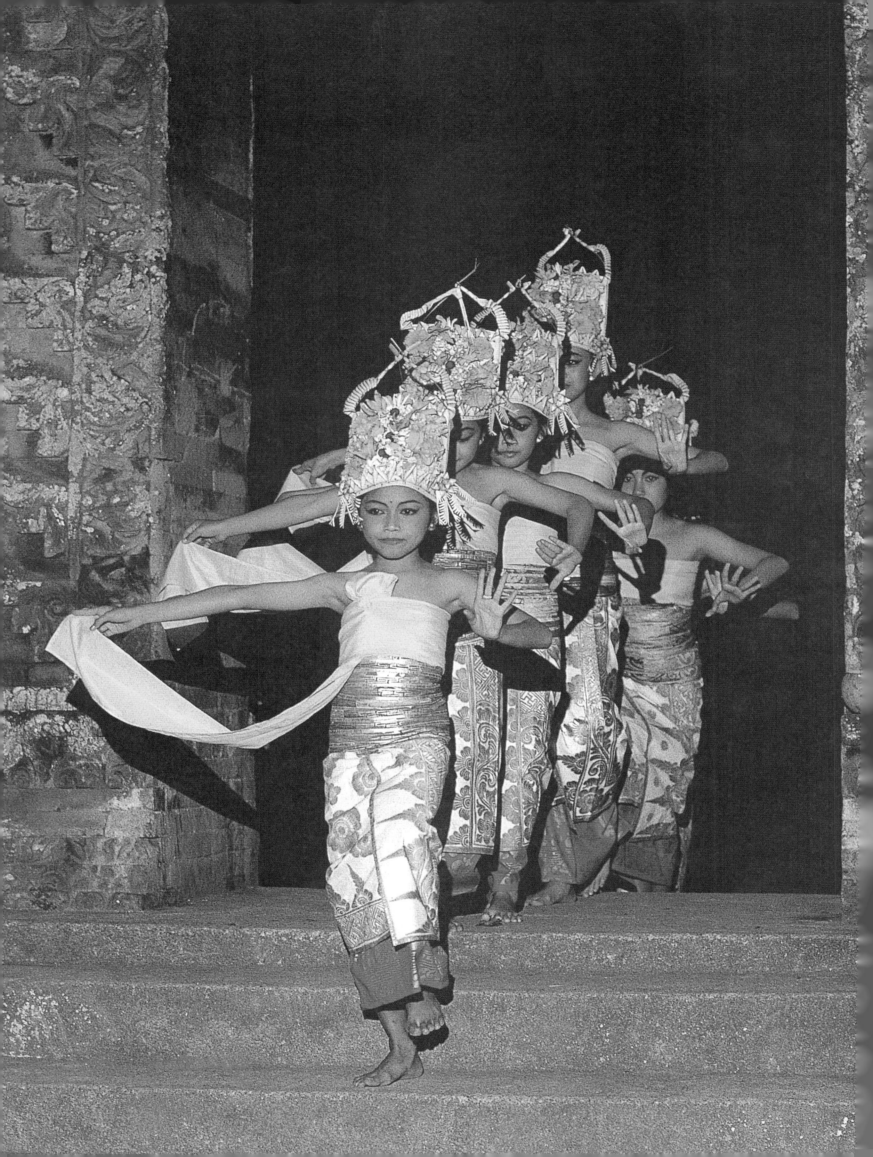

THE PACIFIC ISLANDS

Indonesian culture on the island of Bali, whose children perform the ritual *Rejang* at Pura Desa Temple (*opposite*), centers upon a syncretic blend of Indian Hinduism and Buddhism with the ancestor cults and spirit worship of Melanesia. The haunting monoliths, or *moai*, of Polynesia's Easter Island (*below*), carved from volcanic rock, range in height from thirteen to sixty-five feet and were built in honor of dead chiefs descended from the gods. This tribal society succumbed to internal warfare by the early eighteenth century.

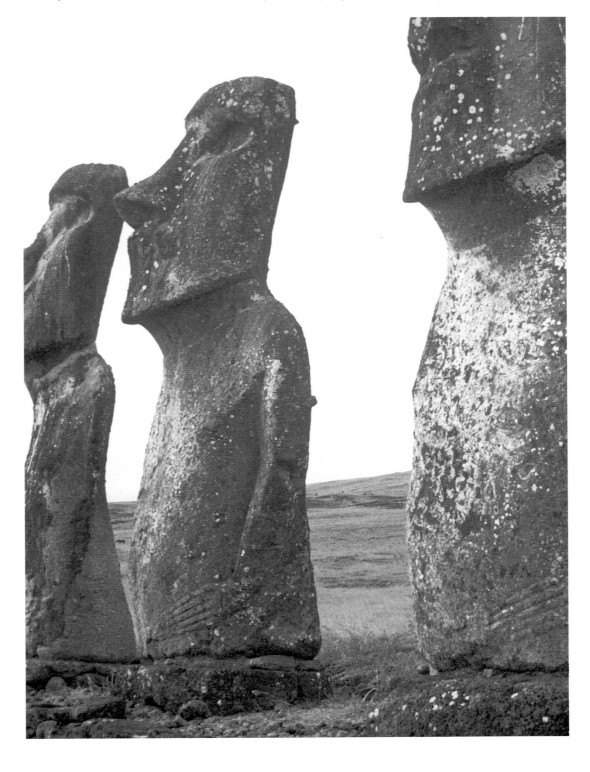

JEANNE WALKER ROREX

IMAGES FROM EASTERN NATIVE AMERICA

Almost 2,000 years separates these icons from two powerful Eastern cultures. *Left:* In *The Water Bucket*, contemporary Cherokee artist Jeanne Walker Rorex combines age-old symbols of human and agricultural fertility—the pregnant woman, life-giving corn, the sun and the water of life. *Below:* This prehistoric effigy pipe from the Adena mound culture of the Ohio River Valley, made of red and yellow pipestone, was associated with burial rites.

THE GREAT PLAINS COSMOLOGY

At right, the Plains Sioux Hoop Dance still celebrates the Sacred Hoop or Circle of Life, reflected also in the circular shape of Mandan lodges and the tipi encampment of nomadic buffalo hunters. *Below:* Plains "ledger art" from the late nineteenth century was produced mainly by native captives in notebooks supplied to prisoners. This pictographic style captured the last great conflicts between Plains warriors, who carry shields adorned with sacred tribal symbols for protection, and with government forces intent on confining the native peoples to reservations.

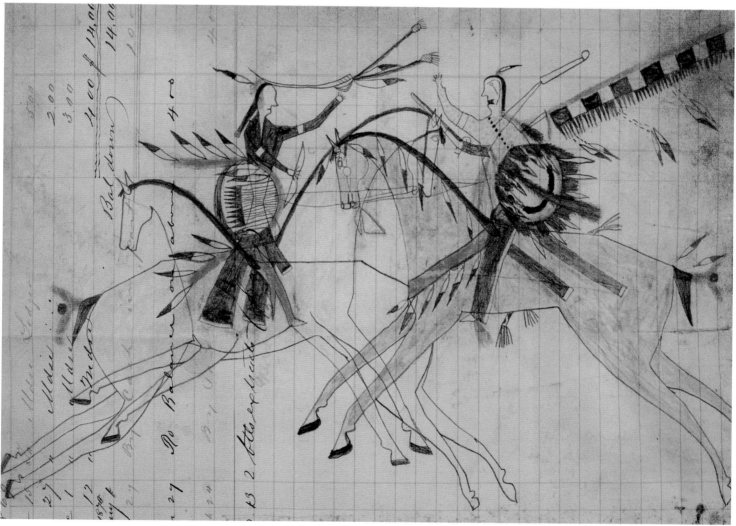

SOUTHWESTERN SACRED IMAGES

The planters and herdsmen of the American Southwest have enshrined their beliefs in artefacts ranging from the intricate basketwork at right, with its cosmic nature symbols, to the ephemeral Navajo sand painting below, which must be destroyed as soon as the healing ritual for which it was made is completed. *Opposite, clockwise from top left:* The webbed dreamcatcher, which captures the messages received from the spirit world in sleep; a Hopi Kachina doll representing the masked dancers who will embody the spirits in sacred ceremonies; contemporary Pueblo pottery in the style of the renaissance engendered by San Ildefonso potters Maria and Popovi da Martinez.

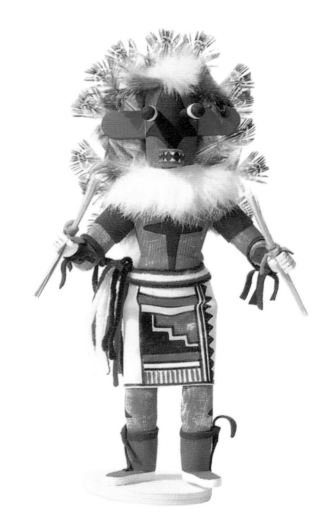

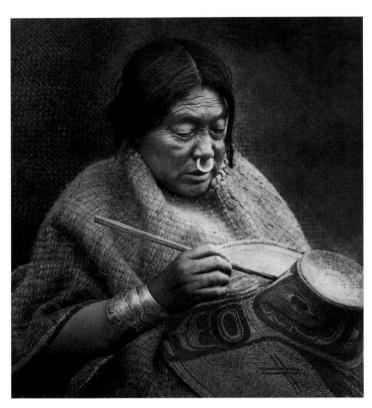

NORTHWESTERN TOTEMS

A Nakoaktok elder (*left*) paints traditional eyelike designs on a basketry hat—a conventionalized style common to the tribes of this culture area, who often combine several animal body parts like a beak and a tail to suggest the whole. *Below:* Elaborately carved canoes of cedarwood, as seen in this nineteenth-century photograph by Edward S. Curtis, often featured a totem animal on the prow to identify kinship groups among these seafaring peoples.

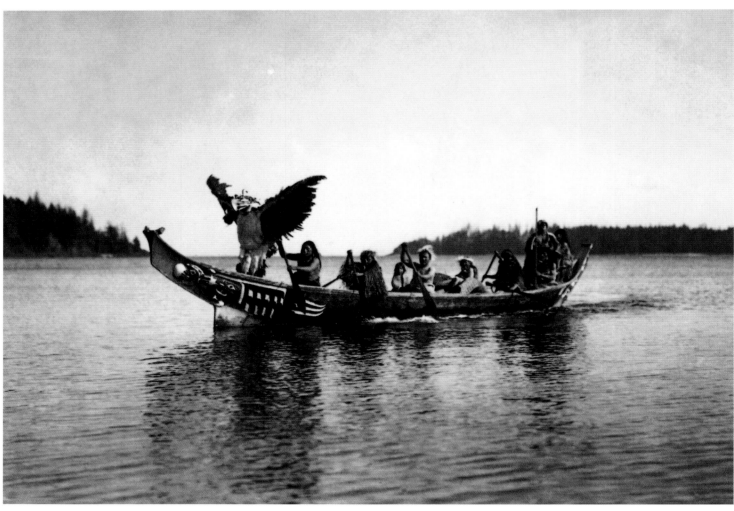

NORTHWESTERN CEREMONY AND RITUAL

In the Curtis photograph below, a Wisham bride wears her ceremonial regalia of shell beads, a bone choker, porcupine quillwork and a nose ornament of abalone shell. *Left:* A Tsimshian mask of carved and painted wood and human hair was used to impersonate supernatural beings in shamanic rites. The Kwakiutl carved frightening masks of such legendary demons as the Wild Man of the Woods and the Cannibal Woman.

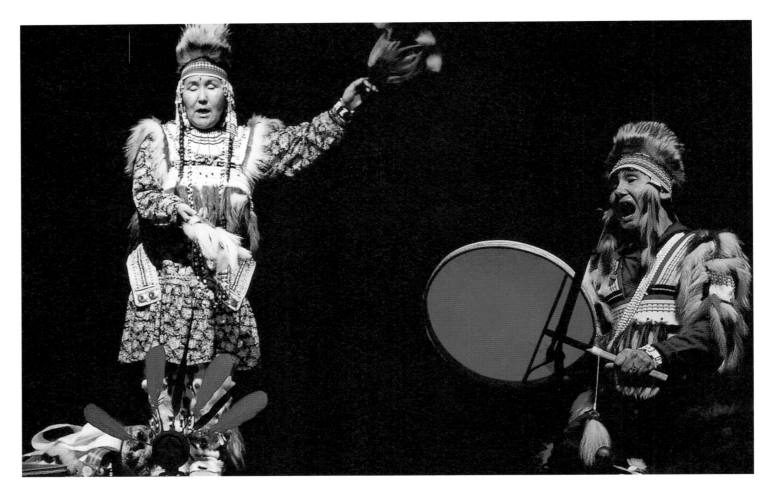

INUIT RITES OF THE ARCTIC COAST

A shamanic dance performed by descendants of the Yup'iks from the Bering Sea. The Inuit (Eskimo) comprise a distinct cultural group that originated in eastern Siberia some 2,000 years ago. Their religious practices evolved around the mythology of game animals, and shamans were revered as healers, controllers of the weather and ensurers of an adequate food supply.

BIBLIOGRAPHY

Baring, Anne and Jules Cashford, *The Myth of the Goddess: Evolution of an Image*, Penguin Arkana, 1993.

Bowker, John, *World Religions*, Dorling Kindersley, 1997.

Burkhardt, Titus, *Art of Islam: Language and Meaning*, World Festival of Islam Trust, 1976.

Burton, T. Richard, *Hindu Art,* British Museum Press 1992.

Campbell, Joseph and M.J. Abadie, *The Mythic Image*, Princeton University Press, 1981.

Carr-Gomm, Sarah, *The Hutchinson Dictionary of Symbols in Art*, Helicon Publishing, 1995.

Caruana, Wally, *Aboriginal Art*, Thames & Hudson, 1993.

Copplestone, Trewin, *The Macmillan Art Informer*, Macmillan, 1983.

Cotterell, Arthur, *Oxford Dictionary of World Mythology*, Oxford University Press, 1986.

Duchet-Suchaux, G. and M. Pastoureau, *The Bible and the Saints*, Flammarion, 1994.

Erlande-Brandenburg, Alain, *The Cathedral Builders of the Middle Ages*, Thames & Hudson, 1995.

Feest, Christian F., *Native Arts of North America*, Thames & Hudson, 1994.

Fry, Nicholas, *Treasures of World Art*, Hamlyn, 1975.

Gibson, Clare, *Goddess Symbols*, Barnes & Noble, 1998.

———, *Sacred Symbols*, Barnes & Noble, 1998.

———, *Signs and Symbols*, Grange Books, 1996.

Marija Gimbutas, *The Language of the Goddess*, Thames & Hudson, 1992.

Grimal, Pierre, *The Penguin Dictionary of Classical Mythology*, Penguin, 1991.

Hinnells, John R. (ed.), *A Handbook of Living Religions*, Viking, 1984.

——— (ed.), *The Penguin Dictionary of Religions*, Penguin, 1995.

Gombrich, E.H., *The Story of Art*, 15th ed., Phaidon Press, 1991.

Hall's Illustrated Dictionary of Symbols in Eastern and Western Art, John Murray, 1994.

Jordan, Michael, *Myths of the World*, Kyle Cathie Ltd, 1995.

Knappert, Jan, *Pacific Mythology: An Encyclopedia of Myth and Legend*, Diamond Books, 1995.

Lewis, Bernard (ed.), *The World of Islam: Faith, People, Culture*, Thames & Hudson, 1994.

MacCana, Proinsias, *Celtic Mythology*, Chancellor Press, 1981.

Mann, A.T., *Sacred Architecture*, Element Books, 1993.

Miller, Mary and Karl Taube, *The Gods and Symbols of Ancient Mexico and the Maya: An Illustrated Dictionary of Mesoamerican Religion*, Thames & Hudson, 1993.

Putnam, James, *Egyptology,* Quantum, 1990.

Rice, David Talbot, *Islamic Art*, Thames and Hudson, 1993.

Shearer, Alistair, *Buddha: The Intelligent Heart* , Thames and Hudson, 1992.

Unterman, Alan, *Dictionary of Jewish Lore and Legend,* Thames & Hudson, 1991.

Watkin, David, *A History of Western Architecture*, Thames and Hudson, 1992.

Walters, Derek, *Chinese Mythology: An Encyclopedia of Myth and Legend*, Diamond Books, 1995.

ACKNOWLEDGEMENTS

The publisher would like to thank the following individuals for their assistance in the preparation of this book: Robin Langley Sommer, editor; Nicola J. Gillies, production editor; Charles J. Ziga, art director; Wendy Ciaccia Eurell, graphic designer; Jay Olstad, for photographs as listed below and additional research; Jeanne Walker Rorex, for artwork as listed below. The publisher also gratefully acknowledges the following individuals and institutions for permission to reproduce images on the pages listed here:

AKG, London: 23, 30t, 32bl, 33b, 36, 37, 66, 67, 75, 76, 96, 100, 101, 103t, 111, 112, 113, 114, 115, 117, 125, 126, 127, 129r, 133; **Art Resource:** 16 (© Erich Lessing), 35b, 60 (SEF), 74 (SEF), 110 (Girardon), 116 (SEF), 118 (Werner Forman Archive), 129bl (Girardon); **Corbis:** 14 (© Jeremy Horner); **CorelDraw:** 8t, 11, 12b, 13, 15, 24b, 31br, 33t, 38t, 39t, 55t, 69tr &tl, 83, 88tl, 94bl, 109 tl, bl, & br; **FPG International:** 38b (© Christian Michaels 1994); **Historic Scotland, Ancient Monuments Division:** 39b; **Library of Congress, Prints and Photographs Division:** 12t, 108, 138, 139r; **Planet Art:** 8b, 19, 30b, 31t, 31l, 32br, 53, 57r, 79, 80, 81, 82, 85, 86, 87, 88tr, br, & bl, 89, 90, 91, 92tl, 93, 94tl, 94tr, 95, 97, 98, 99, 102tl & bl, 104, 105, 107, 109 br, 120, 123, 124, 134r, 139tl; **Saraband Image Library:** 9, 10, 24t, 25, 26–27, 40, 41, 45, 57tl, 72, 73, 78, 84, 92tr, 92b, 103b, 135b; © **Jay Olstad:** 20, 21, 28, 29, 34, 35, 42, 43; © **Jeanne Walker Rorex:** 134l; © **Michael Tincher:** 136, 137b; © **Jack Vartoogian:** 128, 132, 135t, 140; © **Charles J. Ziga:** 6, 22, 44, 46, 48, 49, 50, 51, 52, 54, 55b, 56, 58, 59, 61, 62, 63, 64, 65, 68, 69b, 70, 71, 102r, 106, 121, 122, 130, 131, 137tr & tl.